Mountains & Mesas

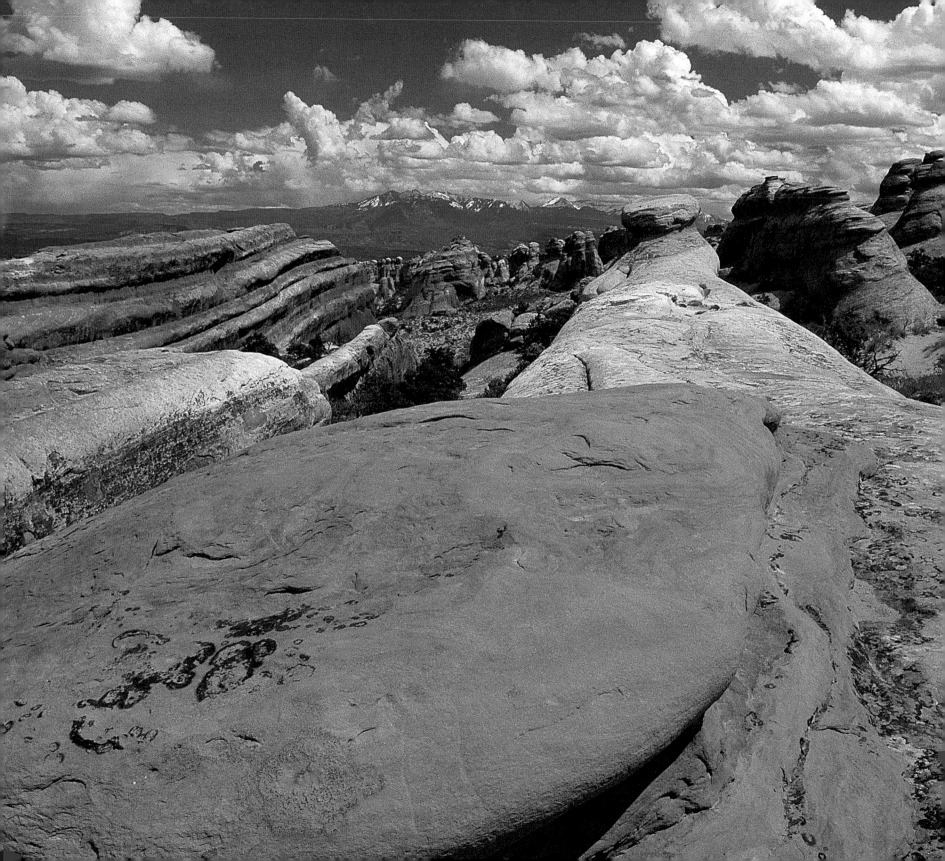

Mountains & Mesas

THE NORTHERN ROCKIES AND THE COLORADO PLATEAU

by
Pete Bengeyfield

photographs by
Pete and Alice Bengeyfield

foreword by
Luna B. Leopold

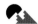

NORTHLAND PUBLISHING

Photographing the landscapes and wildlife of the American West has led to some incredible experiences over the last twenty years, experiences that have been enriched by the people we've been fortunate enough to share them with. So for all of you who have carried packs that are too heavy up hills that are too steep, who have fumbled with cold tripods on frosty mornings, and who have bounced through any number of rapids—thanks for coming along.
 —P.B. and A.B.

The text type was set in Adobe Garamond
The display type was set in Adobe Garamond Semibold Italic
Composed in the United States of America
Designed by Nancy Rice, Nancy Rice Graphic Design
Edited by Nicky Leach
Production supervised by Lisa Brownfield

Manufactured in Hong Kong by Regent Publishing Services

Front Cover: Mount Wilbur in Glacier National Park, Montana, and sunset near Mexican Hat, Utah. Back Cover: Arizona's Antelope Canyon, and Granite Rapid in the Grand Canyon. Half-title page, left: Yellow-headed blackbird, Beaverhead National Forest, Montana; center: Delicate Arch, Arches National Park, Utah; right: Reynolds Mountain, Glacier National Park. Frontispiece: The red of the Entrada Sandstone overlies the creamy rocks of the Navajo Sandstone. Both are capped by blue sky and white clouds. It's not called Color Country for nothing. Contents: Double Arch, Arches National Park, is the product of water, frost, and wind.

FIRST IMPRESSION 1996
ISBN 0-87358-608-5

Library of Congress Catalog Card Number 95-48042
Library of Congress Cataloging-in-Publication Data
Bengeyfield, Pete.
 Mountains & mesas : the northern Rockies and the Colorado Plateau / by Pete Bengeyfield ; photographs by Pete and Alice
Bengeyfield : foreword by Luna B. Leopold.
 p. cm.
 Includes bibliographical references (p -) and index.
 ISBN 0-87358-608-5
 1. Rocky Mountains. 2. Rocky Mountains—Pictorial works. 3. Colorado Plateau. 4. Colorado Plateau—Pictorial works.
5. Natural history—Rocky Mountains. 6. Natural history—Rocky Mountains—Pictorial works. 7. Natural history—Colorado
Plateau. 8. Natural history—Colorado Plateau—Pictorial works. 9. Mesas—Rocky Mountains. 10. Mesas—Rocky Mountains—
Pictorial works. 11. Mesas—Colorado Plateau. 12. Mesas—Colorado Plateau—Pictorial works. I. Title.
F721.B46 1996
 978—dc20 95-48042

0539/5M/3-96

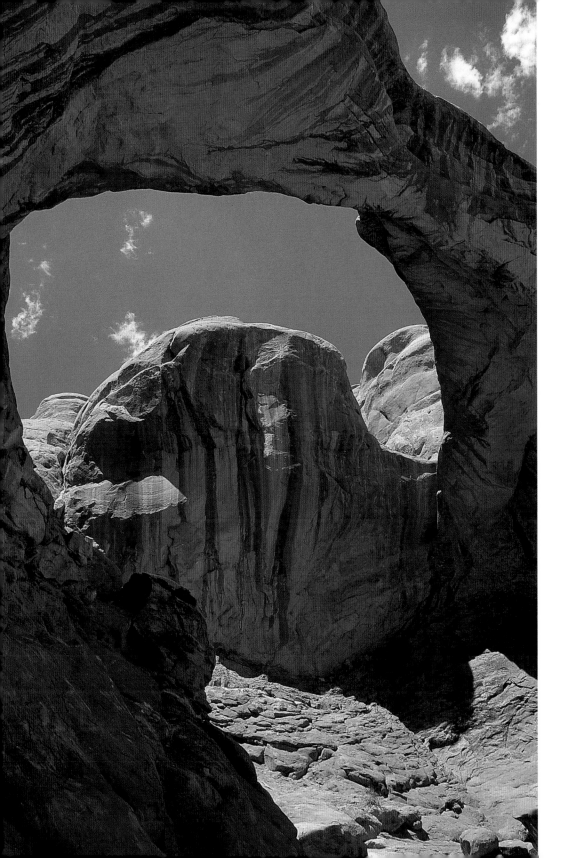

CONTENTS

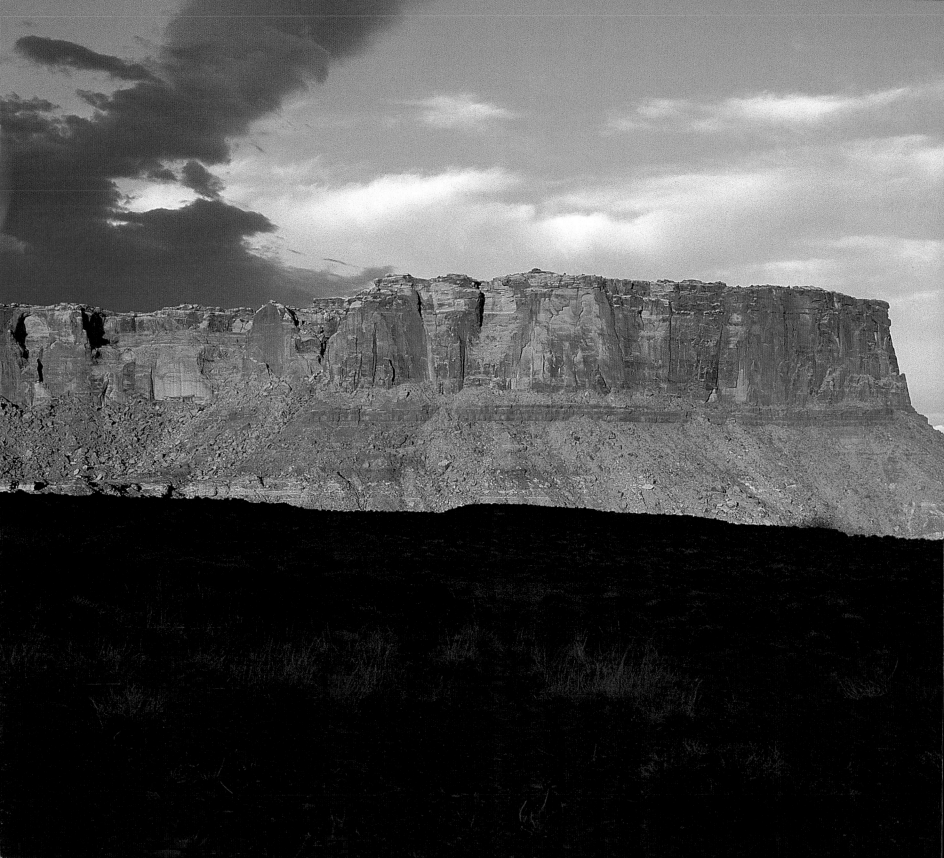

FOREWORD

This is a decade in which every aspect of government is under fire. Particularly the federal employees are criticized even though they are carrying out the tasks assigned to them by acts of Congress. It is also the critics who want to extract every monetary value from the public trust, the land on which all of us depend. It is as if anything public is open to exploitation—the forests, the range, the wilderness, the mineral wealth—everything is up for grabs. The ancient forests are nearly gone. The range lands are depleted. Mineral resources are given away virtually for free. The resource agencies of the federal government appear to be impotent to moderate this exploitation of the public good.

It gives one inner satisfaction to see a few consistent defenders of the common, a few who will stand up to be heard, who will go against the grain of the bureaucracy. It is only a few who will try to explain to their cohorts and to the public that they are losing the game of protecting the public interest.

Pete Bengeyfield is one of those few. He is a public servant, dedicated to the task of managing the resources in an enlightened and scientific way, and at the same time he understands the processes in the natural world and how to prevent the long-term value from being compromised by over-exploitation.

He is at home in geology, in silviculture, in wildlife ecology, and several other fields in the natural sciences. He both educates the reader and delights his eye. He does this by a particular grace in writing and by his equally eloquent photography. This book is an unusual blend of science and heartfelt reverence.

—*Luna B. Leopold*

Opposite:
Horse Thief Canyon, Utah

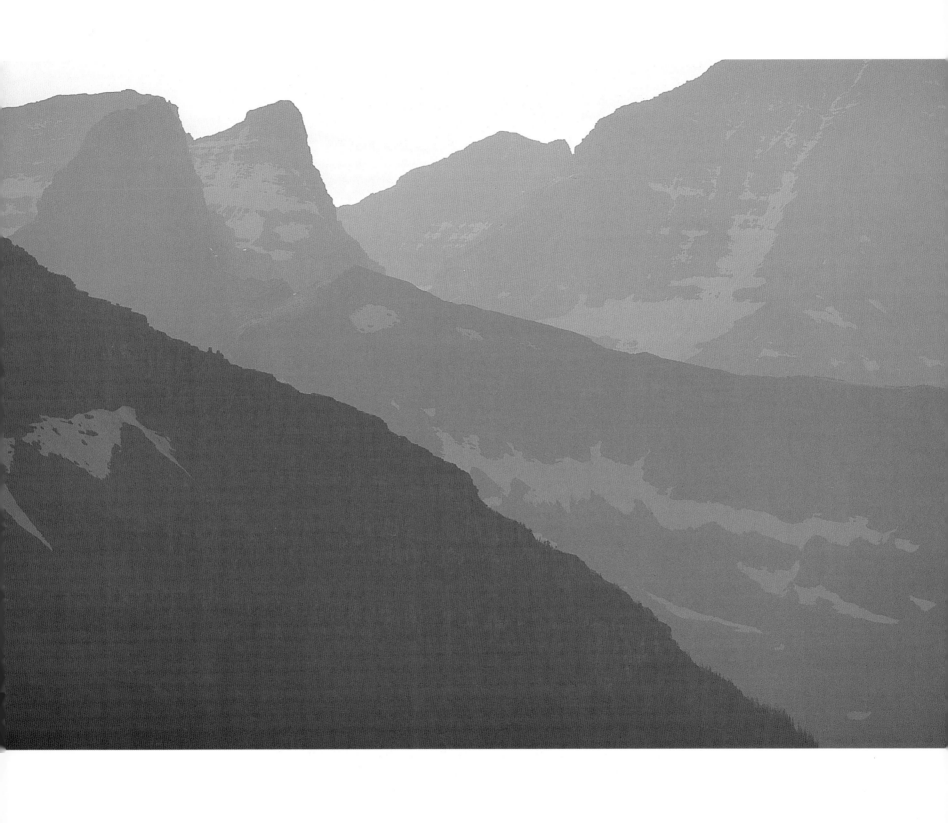

PREFACE

When I was a boy, probably junior high school age or so, I sat on the roof of my home in suburban Long Island and pretended I could see the Tetons, such was my enchantment with the American West. I daydreamed of red rocks and white peaks, of trackless forests and prairies, of thrashing rivers and parched deserts. I saw myself in all these western places, and more. Fueled by the writings of Stewart White, A. B. Guthrie, and Vardis Fisher, my imagination led me through twisting canyons and over serrated ridges. I wanted to see it all. After twenty years here, I still do.

Wallace Stegner referred to the West as the "Native Home of Hope," and Bernard DeVoto labeled it a "Plundered Province." The West is William Kittredge's "Last Best Place" and Eliot Porter's "The Place No One Knew." Today it is best defined by the paradoxes it generates. Parts of seven states—Arizona, Utah, Colorado, Nevada, Idaho, Wyoming, and Montana—contribute to its area, but no surveys mark its boundaries. It is an area of unrivaled grandeur yet must often rely on support from people outside its boundaries to maintain that grandeur. For some, the area has produced unlimited wealth, but for most it has spawned great expectations and delivered on few. The West has limited physical capabilities, yet it is one of the fastest growing areas in the United States. And, because of its unique history, it is as much a state of mind as it is a piece of topography. So there are many images of today's West.

No other region has played such a large part in determining our national character, and no other has been so indelibly imprinted on American thought. Much of this derives from the fact that, just a little more than a century ago, the American West was emerging from the frontier. Unlike the nations of Europe, our connection with frontier times is not even two hundred years old. My generation, sitting as children at the knees of our grandfathers, could easily have heard family stories of homesteading land or working in logging camps. Today's Americans, especially those who live in the region, still easily relate to their forefathers "taming" the wilderness. The fact that our brief history in the West was a colorful one, and has been dramatized in the movies for almost as long as it took to happen, further crystallizes our identity with the region. The myth of frontier wealth and personal freedom still seduces many Americans. Like a diamond, the West has many facets, each clearly proportional if viewed directly, but somewhat oblique as the angle of viewing changes.

Most of us have viewed our own particular image of the West from a single perspective. Our inability to differentiate between myth and reality has kept the other facets out of proportion. To those people who have grown up here, the West is a tough place to make a living. It is a country to be loved, to feel right in, but also a country to be worked. Its natural resources have supported their forefathers, and will, they believe, continue to support them. To live any other place would be unthinkable. To others, like myself, the West represents the end of a pilgrimage. It offers an almost sacred landscape—a harsh, stark beauty that brings into sharp focus our precarious existence on this planet. I live here because of a personal commitment to

Opposite:
Dawson Pass, Glacier National Park, Montana

the West, believing that a society that is supported by the land must conform to the land's constraints. For me now, living any other place will always be unthinkable.

There are those who look at the West as a source of wealth. From beaver fur to oil, the West has yielded riches to those bold enough to wrest them from the earth. It has cyclically been a cornucopia of jobs and high wages. These people live here because it is where they believe the easy riches will again be found. Finally, romance and adventure define many views

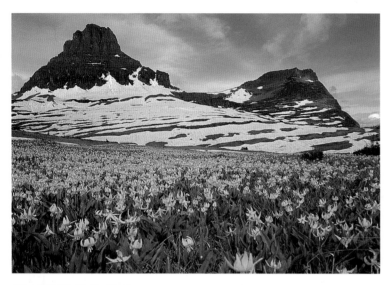

Reynolds Mountain, Glacier National Park

of the West. It is a place of the imagination, to visit for the experience, but not to reside in; a two-week vignette encompassing thirty years of TV. All of these images intertwine in the legacy of America's western experience. All of them provide their unique version of wildness, wealth, and personal freedom. All of them contain their own mixture of myth and reality.

But what of the future? Which image of the West will survive? Ultimately, the lasting image we have of the West will be defined by its physical capability, judged against the demands of our time. That in itself is not particularly prophetic, for the same can be said for any region; however, it is likely that this particular truth will be realized first in the shrinking vastness of the American West. No other region of the country is presently operating so close to the limits of its capability, while trying to accommodate so many opposing images: homeplace, ecosystem, storehouse, playground. Images that were clear in the past may well fade when forced to compete with images that are now coming into focus. In the future West, reality will need to be separated from myth. That separation will be based on the capability of the land. Inherent capability is the bottom line, and it is determined by factors that are not subject to modification. Geology, climate, elevation, precipitation, soil, and vegetation are its uncompromising building blocks. The final image of the American West—the one that brings the oblique facets into perspective—will rest on the ability of its inhabitants and their economies to adapt to the region's capability.

In this book, I describe that capability. Featuring the Northern Rockies and the Colorado Plateau as representative landscapes of the American West, the natural history of each is described in terms of its geology, hydrology, vegetation, and wildlife. The physical and biological factors that make up today's West are the evolutionary products of billions of years of random interactions. They have created a landscape with very definite constraints. Next, a look at our record on those same landscapes reveals how we have either adapted to or ignored those constraints, and what the ensuing effect on the capability of the region has been. Finally, some options for the future are discussed.

A WORD ABOUT THE PHOTOGRAPHS

The Navajo Sandstone turns impossibly golden during sunrises at Capitol Reef. Standing in the saddle between the Grand and Middle Tetons at sunset, you can watch the shadows of the peaks creep across the flat floor of Jackson Hole. The standing waves in Cataract Canyon become lavender in twilight, resembling a pod of whales rising out of the Colorado River. The brown eye of a bighorn ram follows you warily. The way a grizzly raises its head to sniff the wind brings to mind not a ferocious bear, but your labrador retriever. The West is full of pictures.

Mule deer fawn on the Beaverhead Forest

No other landscape on earth brings together such a variety of forms, colors, and inhabitants as the Intermountain West. Other continents have higher mountains, more expansive deserts, equally diverse wildlife; but the region between Canada and central Arizona offers an unequaled mixture of landscapes, flora, and fauna for photographic subjects.

It's our privilege to travel and photograph in this region. The experiences my wife Alice and I have had making these photographs are beyond price, which is why the process transcends the product. The results displayed on film are only a small taste of the total experience, for no mixture of silver and celluloid can convey what it is to make eye contact with a bull moose, or smell the wind off a glacier, or hear the delicate waterfall of the canyon wren's song, or peer over the heart-stopping vertical drop behind Delicate Arch. A photograph can only suggest such moments.

Nevertheless, the photographs reproduced here do represent a personal vision of the landscape and inhabitants of the Intermountain West. They are, admittedly, a single perspective of the complex image. They are made only on public land and only in places that have been protected with the idea of maintaining the natural landscape—our national parks and wilderness areas. Photographs like these are generally not possible where there is grazing, logging, mining, dammed rivers, polluted air, and—in the case of wildlife—hunting. It is fitting and proper that these wild protected places exist. As the world becomes more crowded and the opportunity for personal seclusion and adventure diminishes, the need for them will increase. We offer the photographs as a reminder of the values that are compromised by allowing development in the present to close out opportunities to experience wildness in the future.

Mountains ~ The Northern Rockies

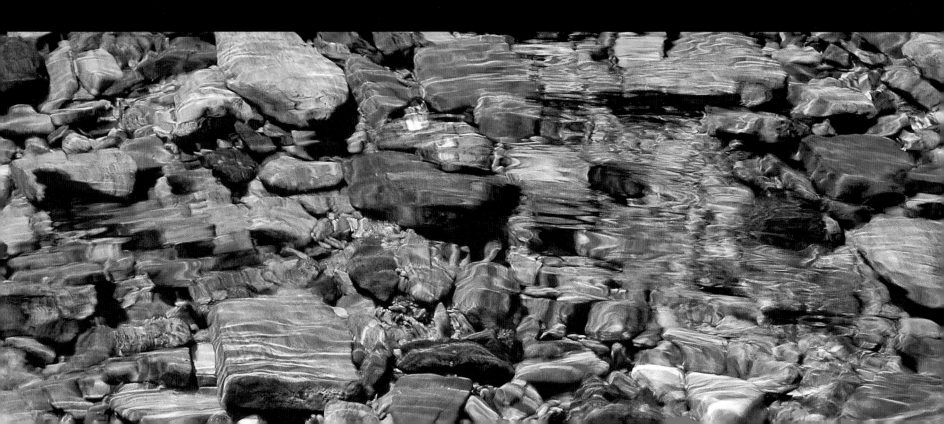

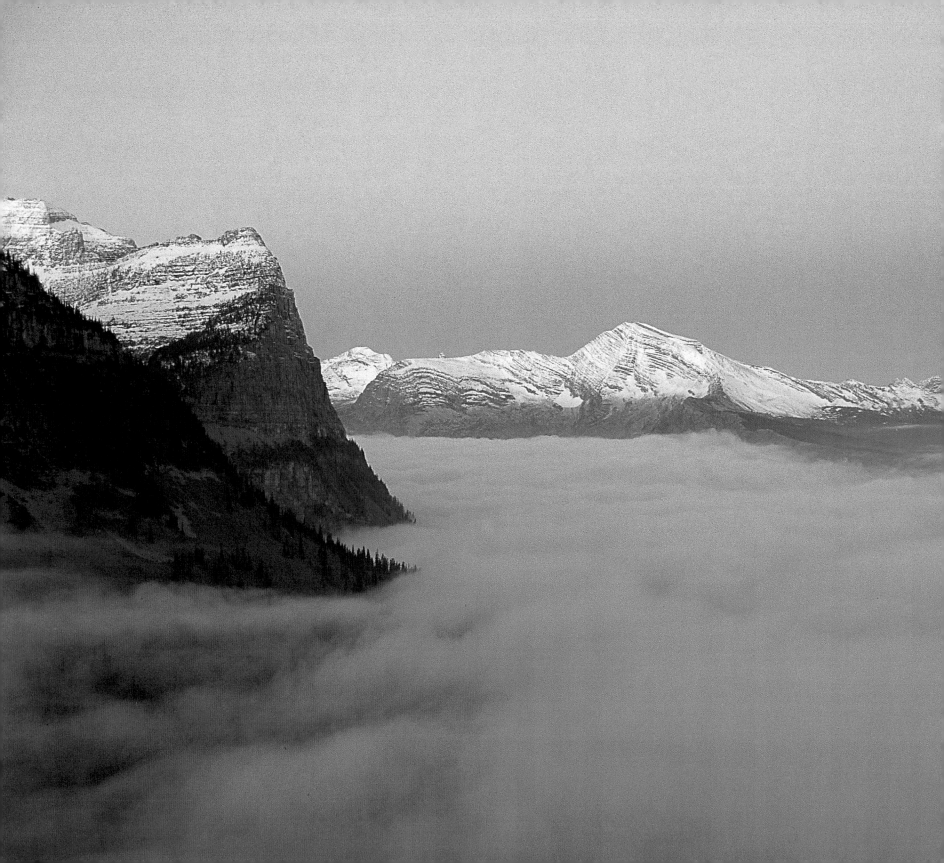

FOUNDATION: UP FROM THE BASEMENT

The trail between Gunsight Lake and Gunsight Pass in Glacier National Park gains roughly 2,000 feet of elevation in two miles. It is not a difficult trail, but it climbs steadily. At one point, the slope below the trail drops almost vertically to the valley below, and if you're lucky, you can look down on the back of a soaring golden eagle. This scenery, like most of Glacier, is superlative. Waves of mountain peaks toss in all directions, rainbows of wildflowers span the trail, and there are likely to be mountain goats at the pass. This is the quintessential mountain wilderness.

Amid all the grandeur, though, there are sights worth contemplating for more than their beauty. Across the valley, the rock face that is Gunsight Mountain, totaling almost a thousand vertical feet, has been tilted, twisted, and deformed. The entire exposure— thin parallel strata of purples and grays obviously laid down horizontally—is now diagonal from left to right. Across this face is a slash, formed by a doubling over of the strata, as if the entire mountain had been shoved upward from below, before it collapsed upon itself. The slash is now occupied by a stream, rushing over a series of waterfalls to the valley floor.

The series of events that had to occur to create such a mountainside is worth consideration, for that scenario is the key to understanding the capabilities and constraints of the landscape.

Gunsight Mountain is as good a place as any to consider this, for it represents much of the geologic history of the earth. The rocks visible across the valley are close to a thousand million years old and were formed deep within the earth, hundreds of miles from where they now rest. How they got here, and why they look the way they do, is the first chapter in the story of the Northern Rockies.

Gunsight Mountain in Glacier National Park: the current product of the geologic process.

Opposite:
Early morning fog enshrouds Glacier National Park's Logan Pass.

Perhaps someday a computer program will have the ability to display all of the region's geologic history in an hour's video. Then, in the comfort of our living rooms, we could witness the extraordinary development of one of the most diverse and spectacular regions on the planet. But the video would start slowly. In fact, if you were to go to your refrigerator for the first fifty-six minutes of such a video, you would only miss seeing tens of thousands of feet of sediment being deposited in an underwater world. This process took place during the Precambrian and Paleozoic eras—the first 3,000 million years of the earth's existence. Understandably, our knowledge of those years is somewhat imperfect.

Ah, but those last four minutes! What a show that would be! For, in that span of time, representing a scant 225 million years, the region that eventually became Idaho, Wyoming, and

Montana thrust, slid, exploded, eroded, boiled, froze, and flooded in an orgasm of geologic activity that created the distinctive landscape that exists here today. Floating continents, sliding mountain ranges, vast bubbles of molten rock, cataclysmic volcanic eruptions, dramatic shifts of climate, continent-covering glaciers, and spectacular floods are all part of the script. For sheer spectacle and excitement, it would dwarf anything Hollywood has yet produced.

Science serves to stretch the bounds of comprehension and imagination. For example, astronomy challenges our perceptions of distance by measuring it in light years, while chemistry mocks our notions of size with structures as small as atoms and molecules. So, too, geology makes us stretch our concepts of time. Four and a half billion years is a lot of birthdays. But, give or take a few million years, that is roughly the age of the oldest rocks within the crust of the earth. The history of the present-day landscape in the Northern Rockies is one of long periods (thousands of millions of years) of relative quiet, punctuated by brief periods (tens of millions of years) of intense movements of the earth's crust that formed mountain ranges and valleys. Throughout time, the forces of building are continually opposed by the forces of erosion, which, ultimately, have the final word. Erosion has many tools, and those in use at any given time are determined by climate. Water, ice, wind, and gravity are constantly at work, but at any specific point on the earth, the combinations may change on time scales of millions to hundreds of thousands of years.

Geologic history is an ongoing process, of which man has witnessed only a microcosm (thousands of years). It is unknown where it will end, and whether or not man will be there to witness that ending, or, like dinosaurs one hundred million years ago, we will be just a chapter in the process.

Geologists have divided earth history into segments, which can be loosely described by the fossil remains of the creatures that lived during each particular time. The largest of these segments, representing hundreds of millions of years, are called eras. The first era to show evidence of fossils is the **Paleozoic** (350 million years long). During this time, life evolved from simple invertebrates to fishes. Late in the Paleozoic, some of these creatures lost their gills and crawled onto land as amphibians, and into the next era: the **Mesozoic** (155 million years long). Dinosaurs dominated the Mesozoic, but were eventually replaced by mammals, and the calendar of eras turned to the present one: the **Cenozoic** (65 million years and counting). An era is still an intimidatingly large interval though, so eras are further divided into periods, which represent tens of millions of years. When geologic time was first divided into eras and periods, it was assumed that any sedimentary rock in which no trace of life has ever been found must have formed before the earliest period of the Paleozoic Era, the **Cambrian.** These earliest rocks were named the **Precambrian,** and represent the longest span of geologic time: 3,200 million years. Recently, however, trace fossils dating back one billion years have been found in Precambrian rocks, establishing the beginning of life on earth much earlier than previously believed.

In the short-term perspective of the human mind, the skin of the earth seems to be made of static areas of land and water. In reality, this skin is in constant motion, as vast plates of rock

ERA	AGE (IN MILLIONS OF YEARS)	IMPORTANT PROCESSES	WHEN ROCKS WERE FORMED	WHEN FEATURES WERE FORMED
CENOZOIC	Present	Glaciation		
		Caldera eruptions	Yellowstone National Park	Yellowstone National Park
		Erosion, valley filling		Teton Mountains Madison Mountains
		Vulcanism	Absaroka Mountains	Absaroka Mountains Wind River Mountains
		Mountain building (Laramide Orogeny)		
MESOZOIC	66	Batholith Intrusions	Yellowstone National Park Idaho Batholith, Pioneer Mountains	Idaho Batholith Pioneer Mountains Beartooth Mountains Glacier National Park Mission Mountains Coeur d'Alene Mountains Bob Marshall Wilderness
		Mountain building (Sevier Orogeny)		
		Pangaea breaks up	Madison Mountains Bob Marshall Wilderness	
PALEOZOIC	245	Pangaea forms		
		Sedimentary deposition	Madison Mountains Bob Marshall Wilderness	
PRECAMBRIAN	570	Sedimentary deposition	Mission Mountains, Glacier Park Coeur d'Alene Mountains	
	2700	Metamorphism	Beartooth Mountains Wind River Mountains Madison Mountains Teton Mountains	
	4500			

Geologic time scale for the Northern Rockies

move ponderously about the globe. The plates are comprised of a dense material called basalt, which formed as the earth's surface cooled from its early molten state more than four billion years ago. The portions of this basalt that were exposed to the primitive atmosphere were chemically altered, eventually forming a less dense rock called granite. Today, the granite makes up continents, which float on the heavier basalt much the way icebergs float on water.

The plates themselves are, in turn, floating in a semi-liquid mantle of melted rock created by heat rising from deep within the earth. Their direction and rates of speed as they move about the globe are determined by mechanisms that are only beginning to be understood. Throughout time, they have produced a number of configurations of continents and oceans. The collision and separation of plates have played an important role in the creation of the Northern Rockies. For although the region has always been located on what has become known as the North American Plate, many of its formative years were spent tripping around the planet.

The earliest rocks exposed on today's earth were formed at the beginning of the Precambrian Era (3.98 billion years ago). They began, as most rocks do, as particles known as sediments. These sediments, formed by erosion of mountain ranges that have long since vanished, were carried by rivers and deposited in oceans and lakes. Eventually, as the sediments piled up, they formed bands of soft rock, much like the layers in a cake. Over time, heat moving upward from the earth's core combined with downward pressure from additional layers of sediments, to completely alter the rock at the bottom of the sedimentary pile. The twin forces of heat and pressure, in a process called metamorphosis, changed the physical and chemical makeup of the sediments, creating a new rock that was much harder and unlayered. The magnitude of force and length of time required to accomplish this far exceeds any form of conventional measurement. Metamorphosis occurred throughout the hundreds of millions of years of the Precambrian Era (the first fifty-six minutes of the video), and today the rocks that were formed during that time are the "basement" of the Northern Rockies.

During Precambrian time, the area that was to become northern Idaho and western Montana continued to be covered by sediment deposits for approximately 600 million years. A lot of sediment can build in that amount of time, and the thickness eventually reached tens of thousands of feet. The combined weight of these layers of sediment exerted a tremendous pressure on the layers below. As the sedimentary pile continued to build, and the uppermost layers began to be more and more distant from the earth's core, heat played less and less a part in metamorphosis. The weight of additional sediments was still present, however, and pressure alone transformed the softer sedimentary layers into extremely hard mudstone or siltstone known as argillite. Because heat did not play as great a part in this process, these rocks retain their layered, banded appearance. The particles of mud that would one day become Gunsight Mountain were part of this process.

Toward the end of Paleozoic time, the roaming plates coalesced so that the continents formed a single land mass, which scientists have called Pangaea. This conglomeration held together for some twenty to thirty million years and began to break up during early Mesozoic

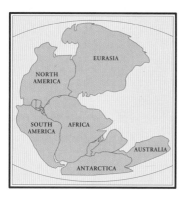

The supercontinent of Pangaea, which formed at the end of Paleozoic time, about 250 million years ago. When Pangaea broke up, the continents gradually moved to their present positions.

time. Again, shorelines and rivers took turns submerging the future Northern Rockies, all the while building additional layers of sediment.

Then, as cracks started to form between the plates that comprised Pangaea, the continents began to drift toward their current locations. The crack destined to become the Atlantic Ocean sent the North American Plate westward to collide with the Farallon Plate, thereby setting in motion the chain of events that would eventually rearrange the accumulated sediment of 2,500 million years into the current Rocky Mountains.

The collision of two plates calls to mind a pair of sumo wrestlers straining against each other until one gives way. In geologic reality, although much energy is focused and released, the process is gradual, a continual disintegration of one plate as it is overridden by the other. Basalt, being more dense and floating lower on the earth's mantle, passes under the lighter continental rock at the point of collision in a process called subduction.

As the Farallon Plate began to be subducted beneath the immense sedimentary pile that was the western edge of the North American Plate, two simultaneous forces were set in motion.

Ocean floor sediments that were lying on the Farallon Plate as it subducted were too light to be dragged downward into the earth's mantle. Consequently, they were scraped off and jammed under the crust of the North American Plate, forcing it upward and tilting it to the east. At the same time, the plate collision buckled the crust of the North American Plate upward, forcing a series of fractures in its surface. The combination of these two forces—one pushing upward, the other thrusting eastward—caused North America to compress and shorten. The surface rock folded and was thrust to the east, laying the foundation of the future Gunsight Mountain.

The result of the eastward thrusting of the earth's crust was that older rocks rested on top of younger ones. The mountains of Glacier National Park, the Mission Mountains, and other ranges in western Montana were formed in this manner.

Glacier National Park. My hat was of little help. Sweat poured into my eyes and dripped onto my glasses. Blinking, I vainly searched for a dry place on my T-shirt to wipe my eyes. Once again I wrestled out of my backpack and retrieved the bandanna I'd attached to the pack to dry. I wiped my face and cleaned my glasses. Replacing them, I looked around, discouraged. I couldn't even see beyond the immediate tangle of head-high alders, much less locate the pass. Fortunately, the yet-to-be-experienced switchbacks were also obscured. Swinging the pack onto my back again, I began plodding upward. Favored haunts of grizzlies, alder thickets are no place to tarry.

Boulder Pass sits just east of the Continental Divide and just south of the Canadian border. When I finally reached it and set up camp, the exertion of the long climb evaporated like the sweat from my shirt. All these passes are worth the effort—you just have to keep reminding yourself of that on the way up. Here, peaks clawed at the sky in all directions. Late-season snowdrifts hung below shaded cliffs. Chunks of rock of all sizes were randomly scattered over the landscape. At lower elevations, rocks like this were rounded, mute evidence of the ice or water that had moved them. Here in the pass, their edges were straight, their

corners angular. Separated by frost action from the surrounding cliffs, they could have come to rest yesterday. Maybe some of them had.

One rock in particular caught my attention. About the size and shape of a large freezer, it lay tilted along the side of the trail. Most of the surrounding rock was limestone—a drab tan. This one was a dull, reddish purple. But it wasn't so much its color that set it apart as its texture. Instead of a smooth plane, the face of the rock was rippled, like the surface of a pond in a light breeze. Incongruously, here a thousand feet above the closest lake and surrounded by almost vertical peaks, an image of flat water leaped into my mind.

Part of a formation called the Kintla Mudstone, the grains that make up this rock were deposited by shallow rivers emptying into Precambrian seas. Shifting currents along the sea floor caused the mud to form small dunes, or ripples. Thousands of feet of sediment laid down on top of the ripples pressured them into stone. This rock was a minute slice of that enormous sediment pile. Formed at sea level in a vast ocean, today the ripples are exposed at 7,000 feet in the middle of a spectacular mountain range.

I looked at the rock and the surrounding peaks for a long time, trying to comprehend what I knew to be true.

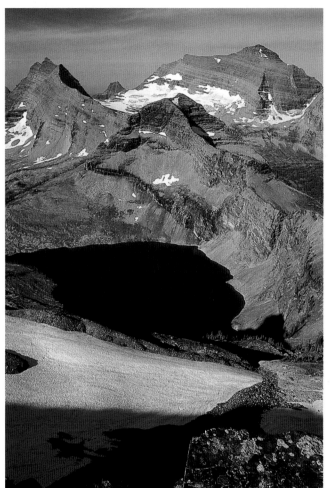

Pocket Lake from Glacier
National Park's Boulder Pass

The buckling of the earth's crust as a result of the subduction of the Farallon Plate formed mountains from the Yukon to Mexico, as the two plates ground together in a 20-million-year spurt known as the Sevier Orogeny (the term *orogeny* means "mountain building"). Depending on the level to which the North American Plate was raised by the ocean floor sediments, and the amount of pressure pushing the blocks eastward, different ages of sedimentary rock are today exposed at the surface. Glacier Park is at the eastern end of the thrusted rock, and here the mountains are made up of the ancient Precambrian sediments that had been pressured into mudstones. The same is true for most of western Montana and the panhandle of Idaho. The Mission Mountains, Cabinet Mountains, Swan Range, Whitefish Range, and Coeur d'Alene Mountains are all eastward-thrust blocks consisting of rocks that are up to 100 million years old. South of Glacier Park, the Precambrian formations were not thrust as far to the east, and the rocks in the Bob Marshall and Scapegoat wilderness areas are those of the younger, less-metamorphosed formations from Paleozoic and Mesozoic times. This entire front, where the mountains seem to rise out of the plains, has been named, quite aptly, the *Overthrust Belt.*

Meanwhile, as the Overthrust Belt was creating many of the mountain ranges we see in the Northern Rockies today, other processes were keeping pace. Not the least of these was the creation of *batholiths*, which form when hot, molten rock, called *magma*, rises from deep in the earth and pushes up the rock above it. Without actually breaking the surface, the magma forces the rocks above it to hump upward.

The formation of batholiths in the Northern Rockies began with the collision of the North American and Farallon plates. As the ocean floor was being drawn beneath the continental crust, heat from within the earth melted the subducting basalt, releasing large amounts of steam and forming magma. The magma began to rise, much like a heated air bubble from the bottom of a pan of boiling water. Like the bubble displacing the cooler water above it, the rising magma displaced the rock layers with which it came into contact. About seven to ten miles below the surface, the magma cooled enough to stop its ascent, forming a massive granite *intrusion*. Like a fist shoved partway up through a layer cake, the intrusion caused a gigantic bulge in the sedimentary rocks above it.

The rising magma did not end its influence on mountain building when it cooled into granite. The cooling process released heat, weakening the sedimentary layers above. These weakened layers provided planes on which the surface rock could slide away from the center of the rising granite. As these strata slid, they not only created mountain ranges themselves but also bulldozed other mountains out of the strata in front of them. As the massive weight of the sedimentary layers slid off the rising granite, it became the surface rock that is exposed today.

Trapper Peak, in Montana's Bitterroot Range, provides an opportunity for anyone to climb a 10,000-foot mountain and look down on everything in all directions. However, from the floor of the Bitterroot Valley, the climb looks impossible. The dominant portion of the immense granite mass that pierces the Big Sky to the west of the town of Darby is the pinnacled tower of North Trapper—obviously a climb that requires technical gear. The much gentler, inclined slab that sits behind North Trapper is actually a few hundred feet higher. A primitive road reaches well up its flanks, and a well-marked trail leads to the summit. What better place to take our nine-year-old on her first overnight backpacking trip.

After camping at the trailhead, we got an early start, well prepared with extra juice, candy, and other incentives to stimulate flagging interest. The morning was cool and dry as we followed the trail upward through the generally open stands of lodgepole pine. The early sun backlit the bright green leaves of grouse whortleberry and provided an excuse for a number of rest stops to take pictures. As we climbed, the gain in elevation was offset by the day's gathering warmth. The forest canopy thinned as we approached timberline, with the narrow, straight trunks of the forest-grown lodgepole giving way to the wind-blasted, skeletal claws of timberline survivors. It was here that we were faced with our first mutiny.

The Overthrust Belt. As the Farallon and North American plates collided about 200 million years ago, the earth's crust lifted and slid eastward, overriding itself. This thrusting occurred on a large scale, producing mountains from Alaska to Wyoming.

The formation of a batholith. Magma rising from beneath the earth's crust displaces the rock above it. Heat melts the overlying rock and causes it to slip off the dome. Central Idaho was once one of these domes, but it has since been reduced through erosion. The mountains of the Selway-Bitterroot Wilderness are what remain.

*"I'm going back to the car," Shannon announced, "and I'm taking the juice with me."
She was already skeptical of the assurances that it wasn't much farther, and no amount of
goodies was going to entice her another step. So, biting our tongues to keep from smiling, we
let her go. Clutching her water bottle, she headed resolutely down the trail and disappeared.*

*About ten minutes later she reappeared, trudging up the trail toward us. Wordlessly,
we fell in behind her and continued to our campsite.*

*The next morning, scrambling over lichen-splotched boulders, we reached the summit
and were able to see to the west. Like a storm-tossed sea frozen in time, the Idaho Batholith
spread out before us. Granite dominates the batholith, and there is no better example of it
than the Selway-Bitterroot Wilderness of Montana and Idaho. Grays and tans are exposed
in giant walls where water and ice have sliced and gouged the once-molten rock from the
earth's core. Distant peaks serrate the horizon, while closer mountains are diminished by the
sheer expanse of rock. Cracks and fissures pattern all faces and planes, testifying to monu-
mental changes in temperature as the massive body of granite shrank and expanded. Truly
a tortured landscape!*

*We returned to a saddle at the base of the peak to photograph sunset and sunrise, the
deep shadows and low light softening the harshness of the scene. The pictures were much
more pleasing than those taken at midday, but it is the noon image of endless miles of
unyielding, stark, vertical granite that always stays with me.*

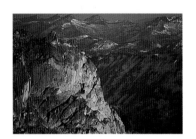

The Idaho Batholith from
Trapper Peak

Batholiths are common in the Northern Rockies. The largest example covers most of central
Idaho, but other major ones are the Kaniksu Batholith in the panhandle of Idaho, and the
Boulder Batholith near Butte, Montana. Farther to the east, batholiths did not figure in moun-
tain building, for the heat from the subducting Farallon Plate was too deep beneath the surface
of the present-day Wyoming and eastern Montana.

While crustal thrusting and batholith building were creating many of the ranges in Idaho
and Montana, the future Wyoming was undergoing a mountain-building process of its own:
faulting. As plates roam about the globe, the movement causes tension at various points on
their surfaces. In response, the earth's crust either extends or compresses, the surface weakens,
and cracks form, allowing adjacent sections to rise and descend in relation to each other.
Extension of the crust creates a zone of tension that pulls sections apart. Generally, one section
will rise while the other drops. The rising section will pull rocks with it that were buried deep
beneath the former surface, while the dropping section buries those same formations even
deeper. This process is called *normal faulting.* Conversely, forces of compression at the surface
create a zone of weakness that buckles the crust, sometimes pushing one side up and over the
other one in a process called *reverse faulting.*

About 65 million years ago, as Mesozoic time marched toward Cenozoic time, the flurry of mountain building resulting from the Overthrust Belt and batholith formations was drawing to a close. Yet some of the most magnificent mountains of today's Northern Rockies had yet to appear. Many of these popped to the surface along faults during the second great orogeny to affect the Northern Rockies: the Laramide. This episode was brought on by a shift in the direction of the subducting Farallon Plate, which caused both normal and reverse faults to thrust significant new mountain ranges to the surface.

Seventy million years ago, Montana's Beartooth Mountains rose about 25,000 feet out of the earth's crust on almost vertical faults. The Beartooths are the largest of the isolated ranges and expose some of the oldest rocks on the planet. They are composed of rocks called *schist* and *gneiss,* which were metamorphosed at the very bottom of the Precambrian sedimentary pile 3,300 million years ago.

About 50 million years ago, compression in what is now central Wyoming forced the Wind River Mountains to the surface. Again, Precambrian basement rocks, although not as old as those of the Beartooths, form the core of the range and are exposed today throughout the high peaks.

Faults come in all sizes, with most being smaller than those that result in mountain ranges. The earth's crust is rarely static, and all along the Overthrust Belt, minor adjustments in response to the shifting pressures of moving plates took place for dozens of millions of years. Individual sections of the earth's crust—some of them as large as tens of square miles, others as small as a couple of hundred acres—shifted, twisted, tilted, and settled. One of the sections of crust that underwent these relatively minor adjustments was the block of mudstones that contained the future Gunsight Mountain.

For millions of years the upheavals of the Sevier and Laramide Orogenys created much of the West we see today. But when it drew to a close, other mountain-building processes took up the slack. The eruption of the Absaroka Volcanic Field in the northwest corner of the future state of Wyoming built a series of *stratovolcanoes,* much like those in today's Cascade Range. Once again the driving force was the release of heat as a result of the subducting Farallon Plate. A change in the angle at which the magma was pulled beneath North America allowed heat to reach the surface. In this case, volcanoes instead of batholiths were the result. For five million years these volcanic giants, some more than 5,000 feet higher than the present peaks, spawned fiery ash flows and rivers of molten lava over a 9,000-square-mile region. Erosion and glaciation have reduced these peaks to the rugged landscape on the eastern edge of Yellowstone National Park.

By the middle of the Cenozoic Era, the basic structure of the present-day Northern Rockies was in place. It remained only for other forces to mold the region into its current shape. Erosion, the process of the wearing away of earth's surface, operates through many agents. Water is the most obvious, and in most locations, the dominant agent. But wind, frost, ice, gravity, and subtle chemical changes within rocks all play a part. The rate at which erosion succeeds is generally driven by changes in climate, as shifts in precipitation and temperature

Faulting. The direction a fault moves is determined by the direction from which the pressure comes.

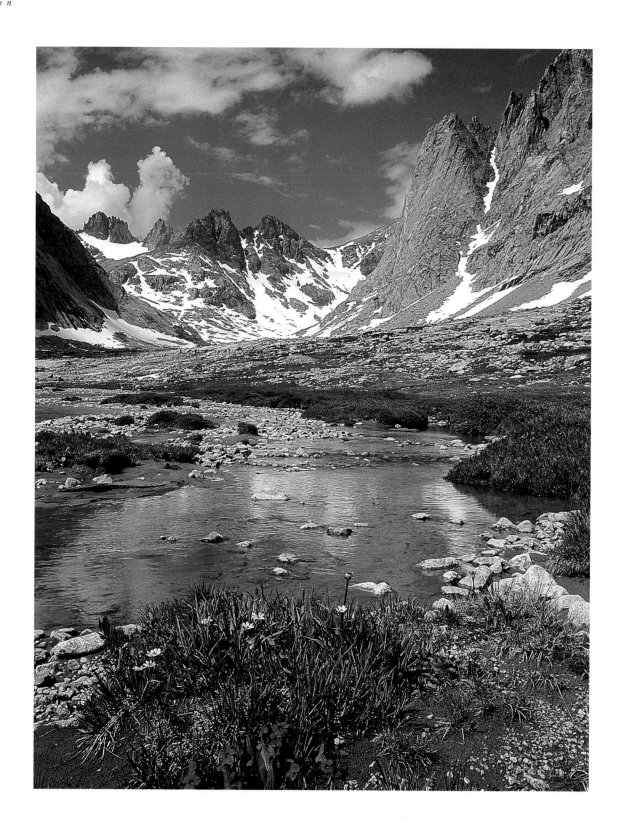

Titcomb Basin, Wind River Range, Wyoming. Compression of the earth's crust 50 million years ago forced these Precambrian granites upward. Water and ice eventually uncovered them.

control the longevity of the earth's surface. However, all the erosional forces have a common trait: they are relentless. Sometimes violently, most times imperceptibly, they are constantly reshaping the planet.

A warm, dry climate, much like today's Desert Southwest, prevailed in the Northern Rockies during the late Cenozoic Era. Limited rainfall allowed only sparse vegetation, which translated into little protection for the soil when infrequent rains did occur. Desert rains were intense for short periods, hence erosion was a dominant, if sporadic, process.

The sediments deposited in the warm, shallow Paleozoic and Mesozoic seas, which, during the Laramide Orogeny had been transformed into steep, unvegetated mountains, were ripe for the erosion process. For 20 million years, as desert thunderstorms swept across the landscape, as the cycle of freezing and thawing loosened soil particles and wind tore at sand grains, the rock of the newly formed mountains was reduced to tiny particles of soil and moved into adjacent valleys. The older batholiths and the relatively young Beartooth and Wind River mountains were all diminished by thousands of feet, as the agents of erosion stripped sediment from their summits. As the mountains eroded and the valleys filled, the stark relief of the landscape became considerably subdued. Today, deposits from this period of intense erosion fill virtually every valley in the Northern Rockies with the material washed from the surrounding peaks.

Climate shifts, from dry to wet and back to dry, occurred during Cenozoic time, with each successive cycle piling up sediments on the valley floors. However, only the soft sediments from Paleozoic and Mesozoic time were stripped from the summits. The hard Precambrian schist and gneiss that formed the core of most of the ranges proved more resistant to erosion. When that became exposed, the rate of valley filling slowed.

Some mountain building continued throughout the Cenozoic Era. Montana's Madison Range began faulting upward about 17 million years ago and continues rising today. And, only 9 million years ago, the Tetons began rising, creating one of the most striking landscapes on the continent. Vertical displacement along the Teton fault is almost five miles, because the floor of Jackson Hole is dropping at a rate to keep pace with the rising of the mountains. Many fault-block mountain ranges exhume basement rocks from deep within the earth's crust, and the Tetons are no exception. This youngest and most spectacular of the Northern Rockies great ranges dramatically displays rock that was formed through heat and pressure in the far distance of Precambrian time.

I looked down between my feet, and it seemed I could see forever. Garnet Creek was a faint, dark thread, still in the predawn shadows at the bottom of the canyon. On the other side of an impossible gulf, the Middle Teton was beginning to transform from dull gray to salmon pink. It would eventually become, for fleeting seconds, a brilliant gold as the sun inched over the eastern horizon. Although photographing it was not the farthest thing from my mind, it might well have been the farthest thing from my capabilities. My climbing partners and I had just roped up for an ascent of the Grand Teton.

Leaving the saddle between the Grand and Middle Tetons in the pitch black of predawn, we used headlamps to get most of the way to this point. Now it was time to start the real climb. For the next couple of hours we would negotiate eight 150-foot rope-lengths of technical climbing, attached to the granite by hand and foot holds, and sometimes by only the friction of boot soles. Fortunately, the rock of the Tetons is hard, "competent" in climbers' lingo, and on this route the handholds were adequate both in number and spacing. The climb was a joy. We reached the end of the technical part of the climb and, after traversing a snowfield that seemed to fall away to the center of the earth, we stepped onto the summit.

The day was windless, and the sky a deep indigo, like the waters of Oregon's Crater Lake. I have stood on many peaks, but none has given me the expansive feeling of this one. The earth fell away vertically in all directions.

From the top of the Grand Teton, it is easy to see how the mountain range rose from the earth along the Teton fault. To the north and south, mountains stretch away to the horizons. To the east the flat floor of Jackson Hole, speckled with ponds and lakes, seems to be directly below. To the west, the ridges slope downward much less abruptly to the equally flat floor of Pierre's Hole, ten miles away. To visualize this, imagine opening the door to a root cellar. The side of the door with the hinges represents the rising of the mountains along Pierre's Hole, while the summit of the Grand Teton is on the other edge of the door.

Over time, Ice Age glaciers ate away at the rising slab of granite that was the Teton Range. Looking down, you can visualize how they once almost surrounded the Grand. To the north, the long valley of Cascade Creek looks as though it was formed with a giant ice cream scoop.

We spent a couple of hours on the summit, exulting in the experience and marveling at the view. Taking an easier route down, we were back at the saddle by noon. With words, or even photographs, it is difficult to convey the immense geologic forces that shaped today's landscape. Fortunately, there are some vantage points where the results can be seen and appreciated in "real" scale. It is also fortunate that most are not so difficult to get to.

And so in the Northern Rockies, after 2,600 million years of Precambrian deposition and alteration, and another 550 million years of mountain building, erosion, and additional deposition, the earth would make one final wrinkle. As if saving the best for last—only two million years ago—a series of cataclysmic volcanic eruptions created the Yellowstone region.

The origin of the forces that created Yellowstone is still somewhat obscure. There is general agreement that a "hot spot" exists within the earth's mantle, and that the crust of the earth is periodically weakened, leading to immense volcanic eruptions. One theory holds that the heat

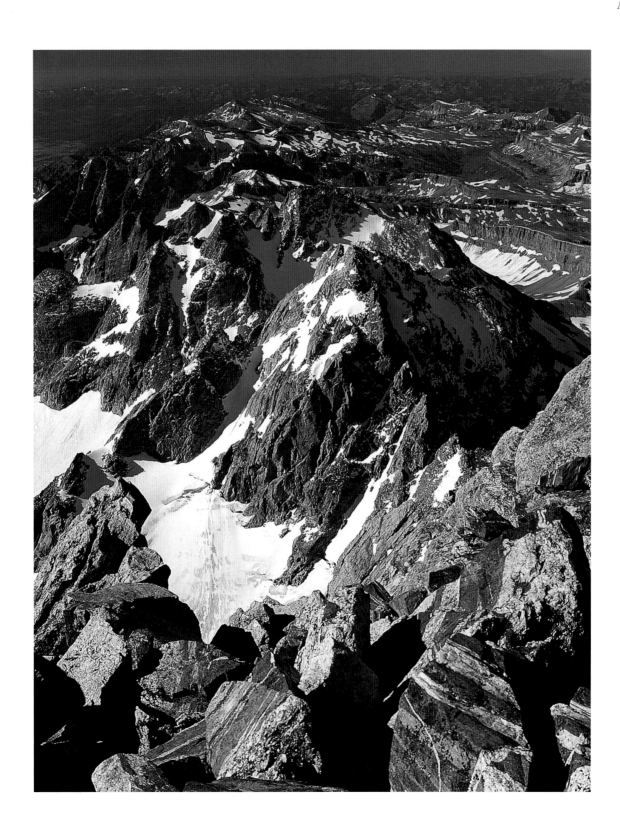

The Tetons from the top of the Grand Teton, Grand Teton National Park, Wyoming

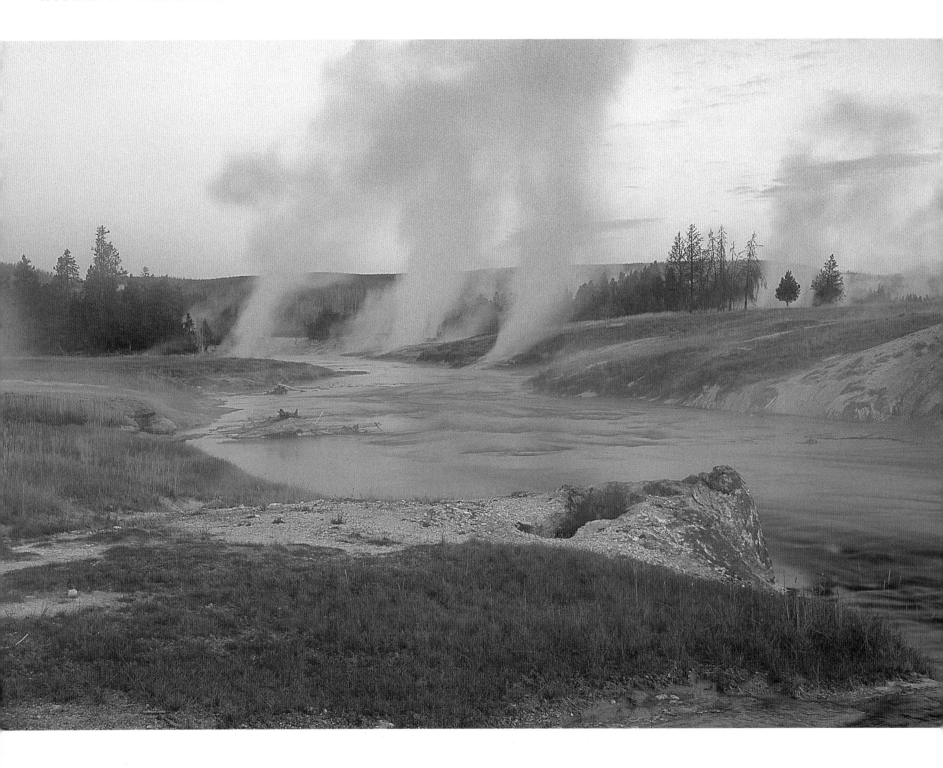

released by the subducting Farallon Plate is responsible for the hot spot. However, the most widely accepted theory is that a hot spot is formed by a plume of heat rising through the earth's mantle, probably as a result of radioactive decay of rock near the earth's core. The rising plume remains stationary as the North American Plate moves over it. Periodically, eruptions have occurred that were many hundreds to thousands of times greater than the one at Mount St. Helens, Washington, in 1980. Evidence of these eruptions exists across southern Idaho—a tracing of the plate's drift westward. Present-day Yellowstone area sits over the hot spot in the mantle.

Regardless of how the hot spot came to be, the overriding importance of vulcanism in Yellowstone's history is indisputable. Three gigantic eruptions have occurred, at intervals of about 600,000 years. An immense crater created by the last eruption, thirty miles across, contains most of Yellowstone National Park's famous thermal features. A magma reservoir remains at a shallow depth and maintains heated ground water close to the surface, allowing the formation of hot springs throughout the crater. If a hot spring is underlain by the right plumbing system, it periodically erupts as a geyser. It is these unique "spouters," many predictable in their regularity, that have enchanted Yellowstone visitors for generations.

Following the last Yellowstone eruptions, 600,000 years ago, only one agent remained to shape the Northern Rockies as we know them today: *glacial ice.* The exact causes of the climatic changes that led to the great ice ages that began about three million years ago are still somewhat uncertain. Scientists speculate that they may arise as a result of either shifts in the earth's orbit or in the inclination of its axis, changes in solar radiation or carbon dioxide in the atmosphere, or movement of the continents. Likely, it is a combination of a number of these factors. Four different times, great sheets of ice, thousands of feet thick, have covered much of Canada and parts of the Northern Rockies. Mountain areas that escaped these large ice masses were host to smaller, localized glaciers that also advanced and retreated in response to the changing climate.

Glaciers put the finishing touches on the work of hundreds of millions of years. Propelled by gravity and fueled by accumulating snow, they flowed downhill at rates measured in inches or feet per year. Carving valleys out of mountainsides, smoothing large valleys between mountain ranges, bulldozing material ahead of them, plucking rocks from the valley walls and floor, they have created the landscape that is familiar to anyone who has driven through the region today: the serrated peaks of Glacier Park, the sculpted crags of the Tetons, the spire of Pilot Peak in the Absarokas. But many lowland features also resulted from advancing and retreating ice. In Montana and northern Idaho, Flathead and Pend'Orielle lakes owe their existence to giant icebergs left buried by melting glaciers. River terraces, such as those along Montana's Madison River, speak of streams that eroded Cenozoic valley fill as successive ice ages waxed and waned. Advancing glaciers bulldozed today's countless nondescript hills throughout the region.

The climate of the ice ages was quite a bit wetter than today, and somewhat colder. A drop of only a few degrees in the average annual temperature would allow for increased snow accumulation, while proportionally greater increases in precipitation would provide the needed snow. Consequently, when climatic conditions were right, large glaciers occupied the valleys between existing mountain ranges as far south as Polson, Montana, and Sandpoint, Idaho. Although the

Continental Glaciation. Immense ice sheets covered all but the highest peaks up to 10,000 years ago. Their melting put the finishing touches on the Northern Rockies.

Opposite:
Steam rising in Upper Geyser Basin, Yellowstone National Park, Wyoming

true continental ice sheets never advanced much below what is now the border between Montana and Canada, the climate was wet enough to create local glaciers in the major mountain ranges as far south as the Sangre de Cristo Mountains in New Mexico. The Beartooth and Yellowstone plateaus were covered with mountain ice caps during the most recent ice age. The crags and spires of the Tetons are what the glaciers left standing after working over the rest of the range. The granite domes of the Wind River Mountains were sculpted by advancing and retreating ice.

A retreating glacier is a melting glacier, and the meltwater has to go somewhere. In the Northern Rockies, the destination was often a series of immense lakes. One such lake formed on

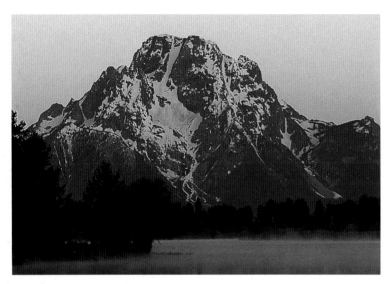

Today, glaciers in the Northern Rockies are relatively small. Skillet Glacier still lingers on Mount Moran in the Tetons.

Opposite:
Flinsch Peak, Glacier National Park. A glacier formed the valley now occupied by Young Man Lake.

the margin of the continental ice sheet to the east of the mountains, submerging the present site of Great Falls, Montana, to a depth of 600 feet. But by far the most spectacular of these lakes inundated much of the heart of the Northern Rockies. Over tens of thousands of years, there were thirty to forty versions of glacial Lake Missoula—each one backed up by huge dams of glacial ice near the present Lake Pend'Orielle. From there, lake waters eventually filled the entire valley of the Clark Fork and Bitterroot rivers. At the dam, Lake Missoula was almost half a mile deep, and its volume approximated present-day Lake Ontario. When the ice dam melted, the lake drained in a matter of days, producing the largest floods of geologic record. A 2,000-foot wall of water can do more than a little rearranging, and much of the surface of northern Idaho and eastern Washington is a result of the cataclysmic draining of Lake Missoula. Today, there are boulders of Montana argillite resting in Salem, Oregon. Think about that!

About 10,000 years ago the glaciers retreated for the final (so far) time. What was left behind, modified somewhat by wind and water, is pretty much the landscape we see today. One legacy is Gunsight Mountain. As ice advanced and retreated during the various glacial pulses, tearing chunks of rock from the mountain and washing them into the valley below, it exposed the events of the previous 900 million years. The river-deposited sand and mud from Precambrian time that had been pressed into solid rock, the eastward thrusting of the earth's crust as the continental plates ground together, and the pattern of the subsequent faulting and folding can all be seen from the Gunsight Pass Trail. Today, streams flow along the folds in the rock, cutting furrows into the face of the mountain.

All of this only serves to underline the fact that the singular creation that is the Northern Rockies is not static and will never be completed. Will subsequent millions of years bring more glaciers or more deserts? Is another Yellowstone eruption imminent? Will one of the meteors or comets traveling the galaxy smash into the earth? Will humankind's effect on the atmosphere lead to global warming? Or will acid rain denude vegetation and strip the soil of its protective

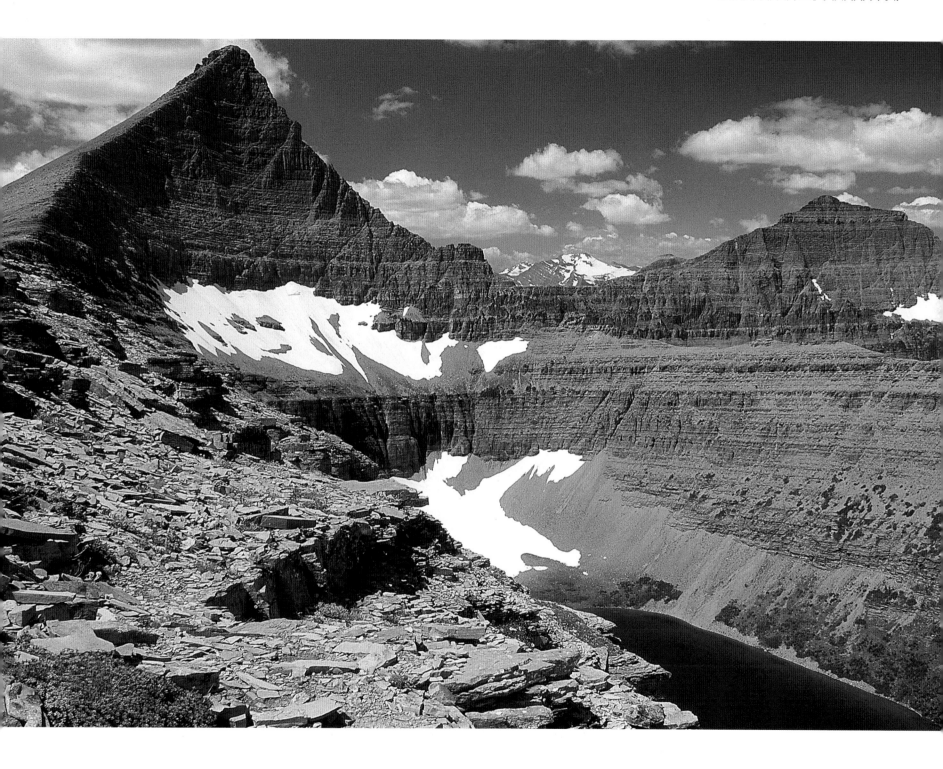

covering? One thing is certain: all of the forces that have contributed to today's landscape are still active—waiting to fashion the next version of the Northern Rockies.

The current version is the one we live with, though. It is the version that modifies our environment and dictates the constraints under which we must live. The events that have rearranged the crust of the earth throughout geologic time have laid the groundwork for our climate, our weather, and the variety of soils that determine the productivity of our land. These distant events, many only dimly perceived and understood, have an enormous effect on what we can do and where we can do it.

LIFEBLOOD: THE GRIP OF ARIDITY

The clarity of Rocky Mountain water is a signature of the entire region. Because I attended college in West Virginia, where the streams are a rusty orange due to acid pollution flowing from coal mines, the water of the Rocky Mountains has always astounded me.

As a hydrologist, I'm supposed to be able to integrate all the physical factors dealing with light transmissivity, depth, turbidity, and all the other technical stuff, in order to explain rationally why you can watch trout lounging beneath twenty feet of water in a high mountain lake. I guess I can do that, but it still doesn't dispel my wonder that it's actually true. Similarly, in Montana's Beartooth Mountains, I recall being able to photograph lichens on a rock covered by the streaming waters of early runoff. There are interlocking gravels on the bed of Glacier National Park's McDonald Creek—smooth, multihued pieces of Precambrian mudstone whose colors show up brighter underwater than they do dry in sunlight. On the Yellowstone River, pods of cutthroat trout are easily visible as they rest in pools before cresting the rapids.

Opposite:
Limestone and argillite pebbles color the bed of Glacier National Park's Olson Creek.

Climate is the strongest determinant of an area's capability to sustain life, for it is climate that distributes water. But climate does not act alone. The landscape of today's Northern Rockies, the product of geologic millennia, works in concert with the atmosphere to determine not only how much water the region receives but also how it is collected, stored, and used. Together, climate and geology dictate what the region looks like, and what can live there.

Conjure up an image of the Northern Rockies. Craggy peaks draped with snowfields tower over high mountain lakes. Streams froth down rocky chutes or meander through verdant meadows. Colored swatches define species of wildflowers. Shaggy pines cover the lower slopes. Mushrooming thunderheads fill the afternoon sky. These are images that may seem dominated by water. But, it is the absence of water, not its presence, that dominates most of the region.

The Continental Divide, the long ridge down the center of the Rocky Mountains that separates the waters of the Pacific Ocean from those of the Gulf of Mexico, is the product of

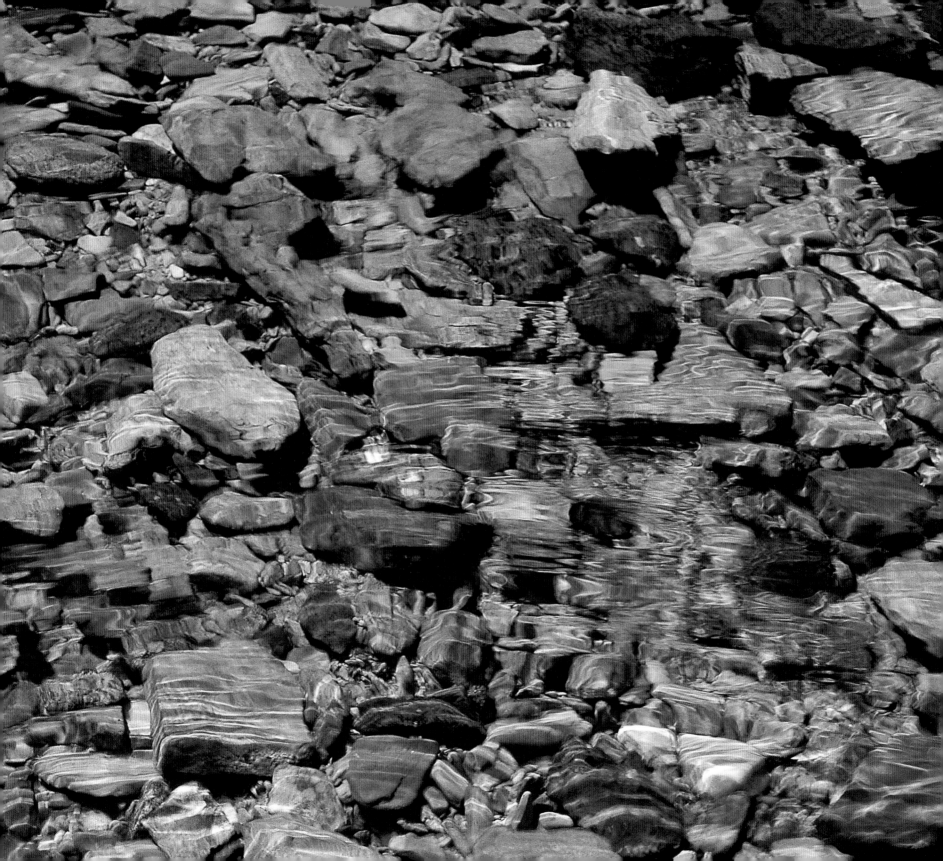

colliding continents and gouging glaciers. And it is this feature, bisecting the region on a north-south axis, that controls the supply and distribution of water. The Divide separates adequate moisture from inadequate, and so determines which methods of human livelihood can be sustained and which cannot.

In reality, much of the Northern Rockies is a desert. Throughout the region, valley bottoms generally receive less than twenty inches of precipitation in a year. Although ten inches of annual precipitation is the figure most accepted as the qualifier of desert status, twenty inches defines the level below which agriculture cannot exist without the aid of irrigation. In fact, very little of the Northern Rockies that is flat enough to grow crops has adequate water to sustain them. Additionally, valley bottoms between Wyoming's Wind River Mountains and Canada are generally around 5,500 feet in elevation, with growing seasons of only about seventy-five days. The great river valleys of the West—the Missouri, the Yellowstone, the Snake, the Green, the Bighorn—are vast semi-arid deserts.

Throughout the world, mountainous regions are known as "weather breeders," and the Northern Rockies are no exception. The geologic upheavals of the previous millennia have wrinkled the skin of the planet to the extent that moving weather systems must adapt to this uneven surface. Mountain ranges cause large air masses to rise and cool, thereby initiating precipitation over many hundreds of square miles. On a smaller scale, sloping terrain causes the sun to heat the ground unevenly. Parcels of air warm and cool in response to ground temperatures, resulting in localized winds and thunderstorms. Topography also plays a role in funneling and arranging both local and large-scale weather systems. The virtually endless combinations of slopes and elevations spawn a collection of weathers that is as various as it is violent. The old saying that if you don't like the weather, wait an hour, should be well heeded in the Northern Rockies.

On three occasions, I have hiked to Glacier National Park's Gunsight Pass in early October to photograph mountain goats. One such trip was fantastic, both in terms of weather and the photographs that resulted. On another of the trips, snow and icy trail conditions forced a retreat short of the pass.

I call the third trip Hypothermia Holiday. My friend Karl and I were able to spend two days at the pass with some cooperative goats, before an approaching shift in the weather prompted a decision to descend 2,000 feet to spend our last night at the campground before hiking out. Under fading skies, we dropped to the base of Gunsight Lake and set up camp late in the afternoon. As the cloud ceiling lowered and the wind increased, we hastily ate dinner, hung our food bags back in the trees, and settled into our sleeping bags for what looked to be a pretty grim evening. In the last couple of hours, the weather had gone from reasonably acceptable to downright miserable.

The first bullets of wind-driven rain smacked into the ripstop nylon with enough velocity to be heard over the snapping of the tent fly. We gave each other resigned looks and

mumbled something along the order of "This ought to be interesting." We had an old tent, and we piled our camera gear between us to keep it as dry as possible. For the next couple of hours the wind and rain assaulted the tent, plastering the fly to the walls as they bowed inward, reducing what cramped space we had.

The temperature must have been in the high thirties, for the rain never turned to snow. But we would have been better off if it had. The leaks came not long after dark, and we began shifting around trying to keep most of what we had dry.

The weather never let up. We lay scrunched in our bags, trying to be as small as possible, when a blast of wind engulfed us in wet nylon. Once one stake went, the entire tent lost support. We scrambled blindly. I couldn't find my clothes. Karl was the one who went out in the storm to reset the tent. I still owe him for that. Now our sleeping bags were partially wet, and the tent was leaking pretty badly. It was barely 10 PM. We huddled together on whatever island of dryness we could find and waited for dawn.

We may have dozed some but not much. Although the storm continued, the tent made it through the rest of the night in one piece. We shivered, constantly looking out the door, anxious for the sight of trees appearing out of the darkness across the meadow. We didn't need much light to be up and moving.

The wind died by dawn, but we still had a steady rain to contend with. As wet and miserable as we were, getting out of the tent was like being liberated. We looked at the soggy mess that was our gear, knowing we'd need two trips to carry it out. A total of eighteen wet, squishy, blister-filled miles later, we piled everything into the car and began the long drive home.

Photography trips are usually more fun.

Weather systems that eventually reach the Northern Rockies can originate from any of the compass points. However, definite general patterns occur on a seasonal basis, as changes in the upper atmosphere direct weather systems into and around the region. The dominance of any particular system at a given time depends to a large extent on how it is driven by the often shifting jet stream and how it reacts to the soaring peaks of the Continental Divide.

In winter, the Gulf of Alaska generates many of the weather systems that move into the region, while during summer months north-moving systems from the Gulf of Mexico dominate. In winter, just to make things interesting, Arctic air masses periodically zip down the east face of the Continental Divide. The often violent mixing of these systems produces the variety of weathers for which the Northern Rockies are famous.

Idaho, north of the Salmon River, and that portion of Montana lying west of the Continental Divide provide an exception to the aridity that grips the remainder of the region. From

October to March, warm maritime weather systems move in from the west, bringing with them moisture enough for annual precipitation to average thirty-one inches. As these systems move east from the Pacific, immediate contact with the Coast and Cascade mountain ranges forces them upward. As the air rises, it cools, causing water droplets to condense and eventually succumb to gravity as precipitation. The west-facing slopes of these mountain ranges get most of the benefit of this rainfall, and by the time the air mass is lifted over the crest of the Cascades, it has been wrung virtually dry. Descending the eastern slope of the mountains, the precipitation process reverses itself. The air mass warms and expands, sucking moisture from the land's surface for the next 400 miles—until the Northern Rockies provide another opportunity for lifting and cooling.

Elevation increases imperceptibly across the dry eastern basins of Oregon and Washington until, along the Idaho border, mountain ranges thrust the surface of the earth skyward, directly in the path of the eastward-moving air mass. The Selkirks, Purcells, Coeur d'Alenes, Wallowas, and the massive swelling of the Idaho Batholith all reinitiate the precipitation cycle as the moisture gained by air masses is once again lost through rising and cooling. Unlike the Cascades, however, there is no basin of lower elevation beyond this first phalanx of mountains. This time, air masses must continue to rise for the next 200 miles, until they reach the crest of the Continental Divide. The eastward path is a tortuous one, as dozens of mountain ranges and hundreds of ridges force continuous shifting of air currents in response to topography. Moisture is lost along the entire course, and when the Divide is reached, a dry air mass is again ready to descend the leeward slope.

These maritime weather systems produce a winter that is dreary at best. Many residents of towns tucked in the bottom of the steep-sided valleys of northern Idaho and northwest Montana speak wistfully of being able to "pipe in" sunshine. From October to March, the days are often marked by low clouds that force people to depend on memory to recall the surrounding landscape. Rain is common at the lower elevations, while snow falls on the invisible ridges and peaks. It is a long, glum season. Skiing is possible, but it's work. Instead of floating down slopes of champagne powder, you spend the day cranking turns through cold mashed potatoes. But all the wet and drizzle has a flip side. For it is the winter precipitation that allows the area bordered on the east by the Continental Divide, the west by Oregon and Washington, and the south by the Salmon River to escape the aridity that controls the rest of the region.

East of the Divide it's another story, as annual moisture drops off sharply. The annual precipitation totals for locations just east of the Continental Divide underscore the immediacy of the transition from adequate water to not enough: Augusta, Montana: 13.6 inches; Helena, Montana: 9.8 inches; Twin Bridges, Montana: 9.1 inches; Cody, Wyoming: 9.4 inches; Lander, Wyoming: 13.2 inches, Kemmerer, Wyoming: 8.9 inches. These are the figures that describe the true West. But it is the more subtle descriptors that continually reinforce the all-pervasive dryness: the static electricity that shocks your dog's nose whenever it sniffs something in the winter, the bread in your sandwich turning the consistency of croutons if you linger over lunch, the short amount of time it takes a sweat-soaked shirt to dry, the clarity of features on

the horizon. These reminders are just as telling as the precipitation. Life east of the Divide must come to grips with the West's common denominator: aridity.

Weather patterns east of the Divide are characterized by the mixing of air masses from three directions. Often, during the winter, the relatively warm, eastward-moving Pacific fronts are blindsided by blasts of arctic air screaming south along the east slope of the mountains. The result is the Norther, for which the high plains are justifiably infamous. The dense, frigid northern air acts like another mountain range, forcing the Pacific air farther upward and wringing from it even more precipitation, this time as snow. Winds slide down the edge of the cold air mass, mixing the flakes into a frothing, freezing vortex. On January 23, 1916, at Browning, Montana, these conditions produced a twenty-four-hour temperature drop from forty-four degrees Fahrenheit to minus fifty-six degrees Fahrenheit.

Only someone who has stood on the high plains and looked to the north at steel gray skies, as the temperature plummets like a rock, can appreciate the immediacy of these approaching storms. Skies darken, the wind increases in pitch, and snow begins to move horizontally across the sky. You know a storm is coming, but the suddenness with which it happens is sobering. In a matter of a few minutes, your relatively calm, clear world is transformed into something both howling and white. You feel incredibly insignificant. The storm can go on for days, building snowdrifts and maintaining wind chill factors well into minus double digits. After the storm passes, the skies clear, the winds calm, and the temperature really drops. The complete stillness of cloudless days at minus thirty-five degrees Fahrenheit is a blessing, for any wind would be too cruel to experience. There seems to be warmth in the sun, but that is largely illusion. At night, even illusory warmth disappears. But the nearness and brilliance of the stars offer some compensation.

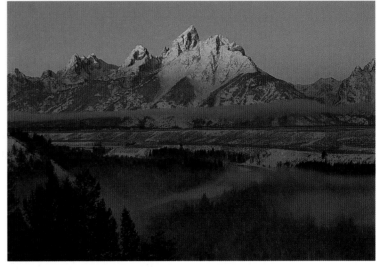

The Tetons during a minus-25-degree-Fahrenheit sunrise

Incredibly, the process frequently reverses itself, and often just as quickly. After prolonged periods of snow and cold, the westerly weather pattern reasserts itself, causing warm, dry air to descend the eastern slopes of the Rockies. The resulting chinook, or "snow eater," winds raise temperatures and reduce snowpacks in a matter of hours. On January 11, 1980, in Great Falls, Montana, not far from Browning, chinooks caused temperatures to rise from minus thirty-two degrees Fahrenheit to fifteen degrees Fahrenheit in a span of seven minutes.

During the spring, the low pressure over the Pacific Ocean weakens and westerly flow declines. Weather begins to approach the region from the south, as moist air masses move up from the Gulf of Mexico. Although "moist" is a relative term, it is during May and June that the east side receives about 40 percent of its annual moisture. Spring comes late to the Northern Rockies, but when it does, it seems to happen overnight. For a few short weeks, the winter browns and grays of the valleys east of the Divide erupt in a multitude of greens. Suddenly the

hill outlines seem indistinct and fuzzy, as previously dormant twigs and branches sprout buds and leaves. It is as though the whole world has come alive, ready to frolic.

Spring's verdant interlude lasts only three to five weeks before aridity reigns again. Summer weather patterns approach the region from the south and west, but they are uniformly warmer and drier than during other parts of the year. They bring little moisture with them, and the desiccating winds evaporate much of what was left over from the brief spring. Thunderstorms offer some relief as earth-warmed air cells rise randomly along mountain fronts. These cells form towering cumulus clouds, which fling intense bursts of rain against the earth. But the storms are extremely brief and localized and not the type of precipitation that will adequately quench the thirsty landscape. The dry, summer weather systems do not bring moisture, but they do give rise to another natural phenomenon that affects vast areas of the Northern Rockies: lightning.

On the southern end of the Madison Mountains in Montana, Hilgard Basin lies at the base of some of the highest peaks in the range. Lakes fill depressions in undulating glacial moraines, small stands of spruce and fir are scattered throughout flower-speckled meadows, and snowfields cling to the surrounding peaks. Echo Peak is an easy climb, and there are trout to be caught in the lakes that lie at its base. All in all, a good place to hang out for a couple of days.

The year was 1988. Earlier in the day Alice and I had sat on one of the nearby ridges and watched the mushrooming gray smoke of Yellowstone Park's great Fan fire, burning out of control to the east, a harbinger of events to come later in the summer. Now, as alpenglow was fading from the peaks, a much larger mushrooming cloud, still pink in the last rays of the sun, was building above the basin.

I look forward to summer thunderstorms in the mountains. They're spectacular, they're exciting, they're short lived, and they make for great photographs! This one would occur a little late for photography, but its light show would be worth the trade-off. We sat on some boulders in the meadow until the first gusts of wind began bending the trees, and then, along with our two dogs, crowded into our dome tent.

Rain spattered lightly on the fly at first, but soon, driven by the wind, its intensity increased. By darkness, peering out of the door, we could see the surrounding trees silhouetted by intermittent flashes of light. The storm was moving over the basin, and all four components—wind, rain, lightning, and thunder—surrounded us in a riot of sound and light! Thunderstorm winds came in gusts, rolling across the landscape like bowling balls. With each gust, the tent's aluminum poles buckled, then snapped back to their domed shape. The inside of the tent flashed brilliantly, easily enough light to read by for a few seconds. At each blast of thunder, I flinched involuntarily but then immediately wondered if the next one

would be louder. Counting the seconds between searing light and deafening sound will give you an idea of how close the strike is, but when your ears start ringing, the number of seconds becomes a moot point. However, such storms move relatively rapidly, and in the space of a half-hour or so may be just a faint rumble fading in the distance. The air was heavy, and the smell of brimstone permeated the meadow. Stars appeared above the trailing wisps of clouds, and the normal night sounds returned.

From May through September, in an average year, lightning strikes the ground approximately 190,000 times in the portion of the Northern Rockies under U.S. Forest Service fire protection. Of those strikes, about 1,200 become fires that are likely to burn a total of 10,000 to 15,000 acres. (Humans may cause an additional 300 or so fires, which will burn 20,000 to 25,000 acres.) The duration of the fires alters the impact of the ignition figures, because many of these fires are extinguished by rain from the storm that brought the lightning. The average size of a lightning-caused fire is about eleven acres. This, too, is a misleading figure because many of these fires are quickly put out by smokejumpers and other firefighting crews. Undoubtedly, many more acres would be burned if it weren't for initial fire-suppression efforts.

The other salient fact concerning precipitation in the Northern Rockies, after its sparseness, is its distribution. Most moisture falls in the winter, and most of it in the mountains. This uneven apportionment in both space and time leads to either deluge or drought at lower elevations. From October to March, snowstorms rage throughout the high peaks. Snowpacks build to great depths, storing water in the high basins and forests. In spring, the water is released. Spring snowmelt swells streams and rivers to many times their summer size, as water races out of the high country, beginning its journey to the oceans. In a relatively few weeks, peak flows pass through the adjoining valleys. This time often coincides with the shift in dominant weather patterns that brings the spring rains. Water is abundant for 10 percent of the year, but when the mountain snowpack is depleted, streamflow drops sharply. Summer weather patterns become established, and from mid-June to October water is again in short supply. The remaining 40 percent of the year, (the same 40 percent that contains the growing season) must depend on random, localized thunderstorms for moisture.

Depending on location, winter snows account for anywhere from 60 to 80 percent of the moisture. Snowpacks in the high country can reach some truly impressive levels, with depths often exceeding fifteen feet. Although accumulations of these magnitudes are impressive if you have to shovel it, or are fortunate enough to be able to ski in it, a foot of snow yields only about an inch of water. So even if the great snowpacks of the high basins were spread out over the valley bottoms, the landscape would still be flirting with desert status.

Make no mistake, there's lots of water in the snowpack of the mountains of the Northern Rockies. And if the amount and the distribution are not capable of creating and sustaining a Garden of Eden in the surrounding valleys, they are capable of creating and sustaining the river systems that make up the headwaters of the continent!

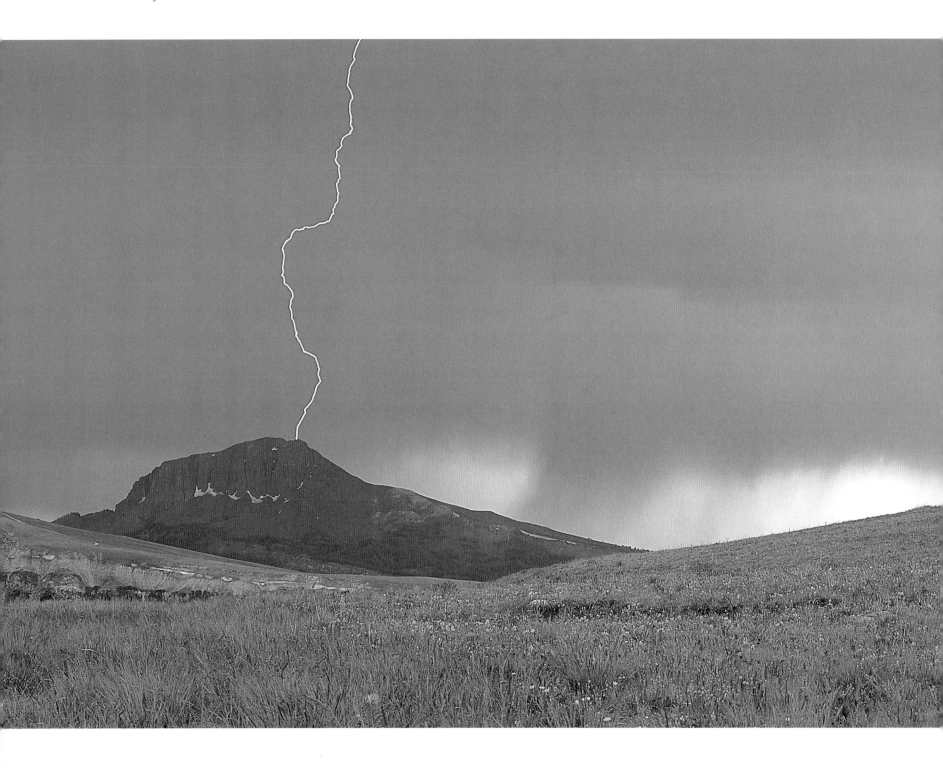

By mid-April, the lengthening days and rising temperatures cause subtle changes in the high-elevation snowpack. As heat builds in the snowpack, snow crystals, deposited as pointy stars, begin to transform into round spheres. The resultant water vapor forms water molecules, which begin to work their way down through the snowpack. The ground soaks up the water like a sponge, but the shallow mountain soils are soon filled to capacity, and sheets of water flow downhill between the earth's surface and the snowpack. Irregularities in topography concentrate the flow into rivulets, as the water moves downslope. Soon the hundreds of individual rivulets create a single channel, and the resulting stream becomes a vibrant, living organism that dominates the valley.

Spring snowmelt begins slowly beneath ice and snow that has accumulated over the winter.

Opposite:
Lightning strikes Black Butte in Montana's Gravelly Mountains.

Each spring, around the middle of May, I visit Lamar Canyon in Yellowstone National Park. It is then, with snowmelt rushing out of the high country, that the Lamar River is a roaring, thrashing, berserk being. Tossing foam fills the canyon from wall to wall, the water itself exploding into tiny droplets that hang in the air for fractions of seconds, as tons of water endlessly crash onto room-sized boulders. The sound engulfs you, much like the sound of a train speeding through the station. The river bed drops the equivalent of an eight-story building in a half mile. Rocks the size of cannon balls are torn from the river's bottom and bounced downstream, the sound of each collision punctuating the roar of the river like a rifle shot. Looking upstream from the river bank, you have the impression that the earth has been tilted and all its water is pouring down upon you. It is an unsettling feeling.

In hydrology we refer to "stream power." This is a measurement of the amount of energy contained by a river as it flows downstream. To calculate stream power, you sit at a desk and put numbers in a computer. To appreciate stream power, you stand on the banks of the river in Lamar Canyon in the middle of May.

For about five weeks, from early May to middle June, mountain streams run at full tilt, and the snowpack that took six months to build reduces to virtually nothing.

In the late 1700s, when the first tentative explorations began nibbling at the edges of the vast western wilderness, geographic theory espoused that there must be, somewhere in the interior of the vast continent, a "Height of Land" that would feed all the great rivers. This was depicted, along with the Northwest Passage, on the crude maps of that time. Like the Northwest Passage, many of the initial geographic theories proved to be wild speculation, but something akin to this Height of Land actually exists: the Yellowstone region.

Here on a high plateau in the center of the Northern Rockies rise the major tributaries of each of the three rivers of the West. South of Yellowstone National Park, the Continental Divide actually becomes a triple divide, sending waters west, east, and south. Snowflakes falling out of the same storm could eventually end up in the Pacific Ocean, the Gulf of Mexico, and the Gulf of California. The Snake River begins in the mountains just south of Yellowstone Lake, flows south through Jackson Hole, and then west across the lava desert of southern Idaho, to join with the Columbia River in eastern Washington. On the opposite side of the ridge that sends water to the Snake, melting snow flows north through the Yellowstone River, eventually to meet the Missouri River in eastern Montana. Finally, the Green River, containing water intended for the Gulf of California, flows out of the Wind River Mountains to its rendezvous with the Colorado River in central Utah. Although it is not the single mountain as appears on the early, speculative maps, the "Height of Land" that is the Yellowstone region distributes water to a third of the continent!

West of the Divide, rivers send their waters to the Pacific through the chain of reservoirs that once was the Columbia River. The Clark Fork River drains most of western Montana. Its major tributaries—the Flathead, Blackfoot, and Bitterroot rivers—collect snowmelt from all of western Montana and send it west through Lake Pend'Orielle and the Spokane River. Farther south, the Salmon, Selway, Clearwater, and Payette river systems all slice steep canyons into the Idaho Batholith before joining the Snake River, which in turn joins the Columbia. Because of their location in the well-watered portion of the region, these west-side rivers are large and powerful, maintaining substantial flows throughout the year. The geology that makes up the watersheds west of the Divide—sand-producing granites of the Idaho Batholith or the extremely hard Precambrian mudstones—does not easily weather to the fine particles that turn rivers brown. Consequently, the waters are generally clear. Most streams are steep, with many large boulders and cascades throughout their courses. Many have significant stretches of whitewater rapids. In short, these are rivers worthy of the name—at least those portions that haven't been dammed.

On the dry side of the Divide, the rivers look and act quite differently. The birthplace of the Missouri River is Three Forks, Montana, where the Jefferson, Madison, and Gallatin rivers come together. From there, this major tributary of the Mississippi flows north and east, collecting the Teton, Marias, Milk, Yellowstone, and Bighorn rivers, before leaving the region for the Great Plains. Although their watersheds are similar in size to those of their west-slope counterparts, these rivers contain much less water, and the streamflows fluctuate greatly throughout the year. Once they leave the mountains, most of the east-side rivers become quite flat. They are characterized by great looping meanders as they traverse wide valley bottoms. These valleys are filled with fine sediments eroded from the high peaks during Mesozoic time, and so provide a river channel that is more susceptible to erosion. Consequently, especially during periods of peak flow, the rivers on the east side are muddy and brown.

But no matter which side of the Divide they are on, no matter their size, flow, or sediment load, these rivers are the region's most important resource. The history of the Northern Rockies, its economy, and its habitation have all been wedded to them since Lewis and Clark rowed,

dragged, and floated their flimsy craft from St. Louis to the Pacific. It is ironic, then, that of all the physical resources of the region, rivers have been treated the worst by humans.

Rivers are unique systems because they bring together physical, chemical, and biological components into a single feature. Nothing else in the natural world does that. Each of these components works in concert with the others, forming an equilibrium that defines the river.

Although rivers do many things, their main function is to wear away the surface of the earth and transport the pieces to another location—a task they have been doing on many landscapes since Precambrian times. It is the factors that contribute to the physical portion of a river's definition—climate, rock, slope—that enable a river to do this. Climate supplies water to the river and determines when that water will be released as streamflow. The rock that makes up the watershed controls the amount and type of sediment the river will carry. Over time, a balance between these two is reached, resulting in a river that moves a certain tonnage of sediment with a given amount of water. This balance varies somewhat, in response to changes in the amount of precipitation from year to year, but it stays reasonably constant over the long term.

The chemical system is directly dependent on the physical system. Different types of rock contain different minerals, and as bedrock weathers, the minerals in the resulting soil reflect the chemical makeup of the parent rock. After every rainstorm or snowmelt, the water that reaches the river by percolating through the soil gathers these minerals and incorporates them into its own chemistry. Each river, therefore, has its own chemical fingerprint determined by the minerals contained in its geological makeup. This fingerprint ultimately defines the productivity of the river, for the mix of chemical elements dictates the life a river can sustain. For example, water that drains the Precambrian mudstones of Glacier National Park is virtually sterile, while the water from the limestone of Montana's Madison Range is extremely life supporting.

The biologic system is dependent on both the chemical and physical systems. The size of the channel, the depth and frequency of pools and riffles, and the size of the rocks in the bed all define what kinds of fish and insects can survive in any stream. The chemistry of the water dictates which mineral elements are available to produce the plants and aquatic insects on which larger animals feed.

The Salmon River disappears downstream behind steeply angled canyon walls. It is as if the river stops, for from the vantage point of a bobbing raft, there is no discernible way through the mountains ahead. But after two days on the river, you know this is not so. A similar view has repeated itself many times, as at each apparent dead end the river has curved either right or left, revealing another stretch of water disappearing into another series of V-shaped ridges. The river flows on.

The eighty or so miles of the wild and scenic river portion of the Salmon that our group was floating has an unusual trait for a river of this size: it has no floodplain. The

river fills the entire canyon. Angling down from either side are somber, grey slabs of schist and gneiss, extremely hard rocks from the Precambrian basement of the earth. For 2.5 million years the Salmon has carved this canyon, where today you have to look up to find the horizon. Many of the surrounding walls are bony ribs of rock, where the slope is too steep and the soil too shallow to create footholds for trees. This year, even though we are floating in the spring, we are at minimum water levels, for a record low snowpack has dictated this will be a year without a peak flow. About twenty feet above our heads, a line of vegetation marks the level where the raft would normally be.

Naturally, there are rapids! At just about any place along the river, whitewater is either fresh in your memory or uppermost in your thoughts. Most of the rapids are small, but size is of little consequence if you're bouncing off rocks in midstream. So concentration becomes the order of the day. Position the raft. Slide down the tongue of smooth water leading into the rapid. Ride the standing waves. Point the nose at midstream rocks and pull away from them. Each rapid is different, requiring a combination of specific techniques done with split-second timing. Like anything else that requires a great deal of skill, doing it right makes it seem easy. And besides, running rapids is just plain fun.

Rapids generally look as though they've been part of the river forever, but at a tributary named Bear Creek we ran across an example of just how fast they can form. The channel of Bear Creek is about the size of a normal hallway, yet a large storm in the mountains north of the river during the previous winter had sent thousands of tons of mud and debris down it, which dumped into the Salmon River. The river's main channel was almost dammed, with most of the water being pushed against the far bank. In less than an hour, the width of the mighty Salmon had been reduced by half. In an infinitesimal speck of time, hardly measurable in human terms much less geologic ones, a single event had left a result that would be evident for thousands of years.

The event had happened months before, but as we approached from upstream, the freshness of the mud could easily convince us that it had come roaring down only yesterday. We beached the rafts to scout the rapid that had resulted from this massive avalanche of mud and rock. Bear Creek was now a trickle that could be vaulted, but what it had done to the river was something else. Forcing the same amount of water through half as much space created a frothing, bouncing, exploding stretch of whitewater. Fortunately, there was a route down the right side that avoided a huge, raft-sucking hole in the center of the river.

We made the run without incident, staring defiantly into the churning hole as we passed by. And we gained a new awareness of the forces that shape not only the river but also the planet itself.

To define any river, one must include the interaction of the physical, vegetative, chemical, and biologic components. Idaho's Salmon River is not just a name on a map. It must be defined first by the eastward-moving air masses that rise off the Oregon desert and deposit their water on the slopes of the Idaho Batholith. The fact that the lower elevations receive little precipitation, and the higher elevations receive mostly snow determines the mix of Douglas fir, lodgepole pine, sagebrush, and grasses that cloak the slopes of the watershed. The vegetation, in turn, regulates the amount of eroded material that moves downslope to the stream channel. Much of the Salmon is confined by steep canyon walls, so that is part of the definition. The shape of the channel itself, its steepness, the size of the material on its bed, and the type of vegetation along its banks must all play a part. The granite, itself a product of the heat released by the subducting Farallon Plate, brings to the definition water that is high in calcium, magnesium, and phosphorous. These elements, in conjunction with the arrangement of riffles and pools in the channel, allow mayflies, stoneflies, and other insects to live on the river. Finally, the definition is completed by the salmon themselves, which rely on minute trace elements in the chemical fingerprints of individual tributaries to guide them from the Pacific Ocean to the exact stream in which they spawned.

Every river in the West has a similar, but altogether different definition. Each one is flexible to a point, allowing the various components some latitude to absorb changes while still maintaining the equilibrium among them all. But flexibility has its limits. The system of checks and balances can only be stretched so far. If one of the components is altered beyond its ability to accept change, the tenuous balance is upset. The alteration can be massive, such as the failure of a dam, causing large-scale erosion for many miles. Or it can be as subtle as the slow drainage of toxic water from a mine. Either way, once the balance is tipped, although the name on the map remains the same, the definition of the river will change.

In the West, the definitions of many of our rivers have changed over the past one hundred and fifty years. And we have caused these changes ourselves. Logging, grazing, mining, irrigation, damming, highway construction, and a host of other activities, coupled with sewage effluent and a suite of industrial wastes, have altered each or all of the components, so that it is a very rare case where one of today's rivers will meet its original definition. In many cases, we have redefined rivers in total ignorance of the effects of our actions. In some cases, the effects were known but assumed to be inconsequential. And in some cases the effects were known to be highly damaging, yet special-interest groups with enough political clout were able to rewrite the definition anyway.

Whether or not these changes in the definition of western rivers have been a benefit or a detriment to the West is a point of much discussion. In northern Idaho and western Montana, timber harvesting has altered stream channels to the point where their current value as fisheries

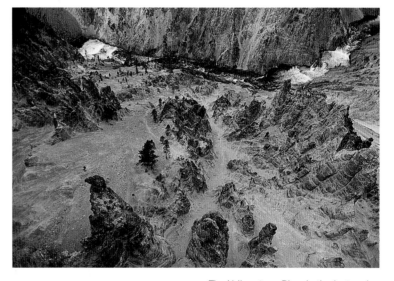

The Yellowstone River is the last major undammed river in the West. Attempts to dam the river have, so far, been defeated by dedicated citizens, but it is a continuous battle. One loss negates all previous victories.

is a pale imitation of their former value. But the jobs derived from the harvest of that timber have maintained the local economies since the early 1960s. In eastern Montana and Wyoming, a combination of livestock grazing and withdrawal of water for irrigation has altered many riparian areas so that they can no longer perform their functions of natural water storage and flood control. On the other hand, grazing has allowed the maintenance of a ranching lifestyle that has become synonymous with the American West. These are real issues that are being faced daily in today's West, and their resolution necessarily includes not only technical considerations but social and political ones as well. That most of the rivers in the West have been redefined by humans is a fact. The new definitions have often produced rivers that no longer function in a natural sense and are but pale imitations of their previous levels of biodiversity. The new definitions have allowed some people and corporations to become rich at the river's expense. The cost of this to future generations is yet to be seen.

VEGETATION: NATURAL COMMUNITY VS. ECONOMIC COMMODITY

Opposite:
Wildflower show in Alaska Basin, Grand Teton National Park. Indian paintbrush, aster, lupine, and groundsel are all part of the pageant.

Alice and I are fortunate to have spent time in the alpine environments of many of the mountain ranges of the Northern Rockies. Humping a forty-pound pack a distance of eight or ten miles and a couple of thousand feet in elevation has its drawbacks, but once camp is established the rewards always more than balance the costs. Then the experience becomes idyllic, and long summer days can be spent leisurely wandering among the peaks and snowfields. We have made dozens of these trips, and each one has produced permanent images, both in our minds and on film. Alpine wildflowers are one of the premier attractions of summer in the high country, and the mountains of the Northern Rockies can usually be counted on to display a profusion of colors. One trip in particular stands out for its botanic extravaganza. The place was Alaska Basin, on the west side of the Tetons; the time, early August.

Glacier-carved basins always have a great deal of exposed rock, as thousands of feet of moving ice have a way of scraping things down to the bone. However, over the centuries since the retreat of the glaciers, soil has formed in many of the depressions left by retreating ice. Often there is enough soil to grow an assortment of plant life. This particular year, the granite in Alaska Basin presented its usual tans and grays. But scattered among the rock faces, and across the floor of the basin, were explosions of color: reds, pinks, yellows, golds, purples, whites. The density of species and multiplicity of hues seemed endless. Meanders of violet fleabanes snaked through the deep red splotches of Indian paintbrush. Sparks of golden buttercups twinkled against backgrounds of purple lupine. Parrys primrose splashed dark pink along streamcourses. Although it is not uncommon to find a single slope or species that puts on an exhibition, this display was a pageant!

We had never seen a flower show like it, and haven't since. Only a specific combination of moisture and temperature will produce the truly spectacular displays, and to experience them requires being lucky enough to plan your trip at the right time. But these brilliant arrays occur somewhere in the mountains every year. That in itself is reason to keep going back.

Vegetation, the shaggy covering of the bones of the earth, is often the part of the natural world to which we most readily relate. Many of the sights, smells, and sounds that we associate with wild country result from vegetation and its effect on our subconscious. The whisper of aspen leaves as they shimmer in a light wind; the aroma of sage after an infrequent summer rain; the autumn colors in the forest underbrush after the first frosts—all play on our senses in a more abstract way than any other ecosystem component. By appreciating the abundance, health, and type of vegetation, we get a feeling for the productivity of a country.

In less aesthetic terms, vegetation is the most visible result of the interaction between geology and climate. As these two factors combine to distribute precipitation, the capability of the land is evidenced by the amount and type of plants that it produces.

It comes as no surprise that the distribution of vegetation throughout the Northern Rockies, like vegetation elsewhere on the planet, closely follows that of precipitation. Areas with greater precipitation produce denser and more varied vegetative communities, while in arid areas the vegetation is sparse and of less variety. Although precipitation remains the major determinant of plant success, it interacts with other factors to determine which plants occur in a given location.

The myriad factors that influence where particular plants will grow range from the physical (amount of precipitation, steepness of slope) to the biological (competition from other species, palatability to animals). To make things more complex, these factors interact on a number of scales, from hundreds of square miles to less than an acre. The sum total of these interactions across a landscape creates a variety of possible moisture conditions. Scientists term each combination of factors a site. Sites occur randomly, with each producing a moisture regime that favors particular types of plants. For example, if the combination of factors causes a site to be very dry in an area that has a short growing season, the resulting vegetation may consist predominantly of sagebrush, such as in the broad valleys of central Wyoming. On the other hand, a few inches' increase in precipitation coupled with a few degrees' rise in temperature would produce the forested valleys of the Idaho Panhandle. On a smaller scale, a depression on an otherwise smooth hillside may concentrate enough moisture to support a stand of quaking aspen in an expanse of sagebrush.

Scientists refer to the direction that a section of ground faces as its aspect. In mountainous country, where land surfaces often have steep slopes, aspect has a great deal of influence on the amount of sunlight a site receives. In the Northern Rockies, the sun is generally to the south, and slopes that face the sun (south and west) will be hotter and drier than those that face away from the sun (north and east). Moisture is much more scarce on south and west slopes, resulting in their supporting different vegetative communities than the moister north and east slopes. In

parts of the region that receive greater amounts of rainfall, an aspect change may mean nothing more than a change in the tree species on the site, while in the more arid portion of the region, a change in aspect may mean the difference between trees and grass, or between plants and bare soil.

Elevation and temperature are other physical factors affecting the distribution of plants. Elevation brings about an increase in precipitation, along with a concomitant drop in temperature. With the reduction in temperature comes a corresponding shortening of the growing season. Consequently, plants may be getting enough precipitation to flourish but might have to adjust to a shorter time in which to use it. On many hillsides in southwestern Montana and central Wyoming, you can see the obvious influence of rainfall and elevation on the type and distribution of plants. Upslope from the valley floor, there is usually an abrupt transition from grass to conifers, while higher up, the conifers give way to the stunted shrubs and colorful wildflowers of the alpine zone. On both sides of the lower boundary, the growing season is adequate for conifers, but below it there is only enough precipitation to support grasses. On both sides of the upper boundary, there is enough precipitation to support conifers, but above it, low temperatures limit the growing season. Consequently, conifers exist only in the middle elevations, where there is a compromise between the extremes.

These conifers are at their upper-elevation limit. Conditions above this level are too harsh for trees, and alpine plants predominate.

Soil properties—the size, shape, and arrangement of the individual particles—also figure in the distribution of available moisture. Soil is the medium that supports all vegetation and owes its existence to erosion. The properties of a given soil are determined by those of the rock from which it came. The granite batholiths of central Idaho, the glaciated Precambrian sediments of Glacier Park, the volcanic rocks of the Yellowstone Plateau, and the Cenozoic valley fills of southwestern Montana all generate soils with different properties. The differences are based on the mineral composition of the bedrock and the size of the soil particles. The minerals contained in a soil, to a large extent, determine the nutrients available for plants. Soils derived from limestone, for example, contain high levels of calcium, while those weathered from granite are mostly silica. The size of the particles determines the amount of water a soil can hold and the time it stays close to the surface where the plants can get at it. Soils weathered from granite produce sand-sized particles that hold water only for short periods of time, while the soils of mudstones produce silt and clay-sized particles that hold water much longer.

Like plants everywhere, those that grow in the Northern Rockies offer a lesson in adaptive survival, a fact that is assured by the dominance of aridity. A shift of a few feet in elevation, or a few degrees of aspect, might greatly affect the amount of water available for plant growth. This rapid shift of available moisture insures that there will be a wide variety of sites that can

be inhabited by an equally wide variety of species. From the immense cedars along the Lochsa River in Idaho, to fragile shooting stars in a meadow high in Wyoming's Absaroka Mountains, to the ubiquitous sagebrush of the high plains, the vegetation of the Northern Rockies reflects the region's diversity of habitats and capabilities.

The interaction of additional variables creates more chance for a change in vegetation. For example, the shape of a particular slope can either concentrate or disperse water depending on whether it is concave or convex. Or local topography can funnel storms so that the downwind sides of ridges become dump zones for precipitation. And subsurface soil conditions commonly change within short distances, thereby altering the availability of water near the ground's surface. The combination of physical variables is endless.

Yet, once a particular combination of plants is established, disturbances may cause it to change. In the Northern Rockies, these disturbances include fire, windthrow (trees blown over by wind), insect infestations, and disease. Disturbances can be large-scale, such as the Yellowstone fires of 1988, the mountain pine beetle infestation of the entire Flathead region in northwestern Montana during the late 1970s, or the 15,000-acre windthrow in Wyoming's Teton Wilderness in 1987. Conversely, the same disturbances can occur on much smaller acreages: wind may fell individual trees, pockets of disease might kill a dozen trees, or small fires may be naturally extinguished after burning a number of acres. Each occurrence disrupts the existing forest canopy and provides a niche for regeneration of the surrounding plant species.

The shrill blast from the smoke alarm jarred us when it filled the mobile home. But then we just glanced at each other and shook our heads in amazement. It was early evening, on Labor Day in 1988, and we were in the middle of the town of West Yellowstone. Smoke from the wildfires that were blazing in the park had finally gotten thick enough to set off smoke detectors inside houses.

Alice and I were staying with our friend Connie while we photographed the fires. For a few days the town had been poised for evacuation. And Connie's most prized possessions— skis, fly rods, and backpacking gear—stood by the door, ready for quick loading. In a time of crisis, it's easy to set priorities.

Although the threat of fire within the town had subsided, the perimeter defense of irrigation sprinklers continued soaking everything within range. Later that night, we drove out of town and watched the entire horizon ablaze with leaping flames from the North Fork fire. Even though the fire was miles away, it was awesome.

The fires of 1988 in the Greater Yellowstone ecosystem were the hottest news story of the summer. Not only were they a monumental natural event, they were a media circus as well. On the one hand, the stories pointed up the nation's intense interest in the fate of our first national park. On the other hand, they underscored the vast gulf between interest and

understanding. Some regarded the fire as a tragedy, others saw it as a functioning natural process of forest rejuvenation.

Conditions equivalent to 1988 occur in intervals of hundreds of years. A series of dry years, followed by one of the driest winters on record; large expanses of very old stands of lodgepole pine; a recent bark beetle epidemic that further weakened trees; and, once the fires started, a series of dry cold fronts that brought steady winds—all combined to produce a situation ripe for big fires. This combination of conditions has rejuvenated Yellowstone in the past. It will do so again. In 1988, it just happened to be on the schedule.

No amount of fire suppression effort could have "controlled" these fires in a wildland setting. In the case of Yellowstone in 1988, "control" was a political goal, and the time, money, and energy spent trying to accomplish that feat was largely wasted. Successful defense of the surrounding towns and interior buildings was a worthwhile priority and was accomplished through effective firefighting tactics and some good luck. Politicians, from county commissioners to presidential candidates, generally looked foolish as they wrung their hands over the "loss" of our national treasure. Business leaders followed suit, bemoaning that no tourist would ever again visit Yellowstone. (In the three years that followed, each year broke the visitation records of the previous.) Tourists, too, fell into the trap of the disaster scenario. Influenced by years of Smoky Bear commercials, most visitors felt they were seeing the end of the wilderness.

In fact, the 1988 fires were a boon to the ecology of Yellowstone. Nutrients were recycled, older forests were replaced with new ones, sagebrush was burned off and replaced by grass, aspen stands were born again, and diversity—the cornerstone of any ecosystem—was enhanced. True, some animals were killed by the fire, and others would starve in the coming winter. But nature is less concerned with individuals than with maintaining the function of the whole. If anything, the fires of 1988 provided a new benchmark for the size of wildland areas we need in a near-natural condition, if they are going to recover after large alterations of vegetation. Many areas similar to Yellowstone exist throughout the Northern Rockies, waiting for their turn.

A group of us were standing in the smoke along the Madison River when an obviously newly arrived tourist drove up and rolled down his window. "How much of the park has been destroyed?" he asked. "Well," I tried my best not to seem pointed, "none of it."

West of the Continental Divide and north of the Salmon River, the Northern Rockies are heavily timbered. The warm and moist Pacific frontal systems combine with the region's relatively low elevation to produce a diverse forest of mixed evergreens. In the more northerly latitudes,

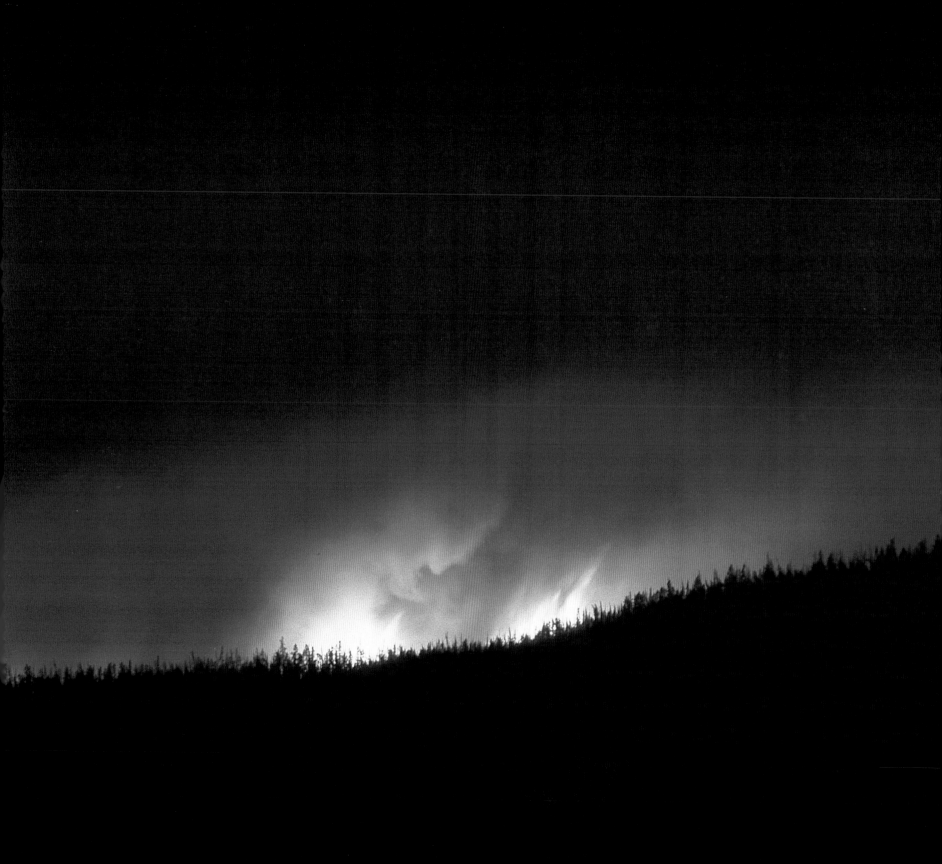

such as northern Idaho and northwest Montana, Douglas fir dominates the mixture at the drier, lower elevations. As precipitation increases with elevation, grand fir and subalpine fir take over the sites. Throughout the elevation range, western larch, a conifer that sheds its needles in the winter, grows well in areas disturbed by fire. The hallmark of these forests is their diversity— the number of species found growing in relatively close proximity.

In these northern forests, the underbrush species reflect the more subtle shifts in available moisture. On dry sites at low elevations, grasses such as Idaho fescue may form continuous groundcover, while in the wetter areas, a mix of shrub species, such as alder, snowberry, Oregon grape, and menzesia may appear in different combinations. Huckleberries are a common shrub throughout these forests, their succulent berries attracting all manner of mammals, many of them two-legged, during the late summer. In the spring and early summer, the sunflower-colored heartleaf arnica, the lavenders of lupine, and the flashy reds of Indian paintbrush all splash color on the forest floor. But it is in the fall when the northern forests are the most impressive. Misty light, diffused by low clouds, creates a mysterious quality beneath the trees. Visibility is often limited to hundreds of yards. The burnished gold of western larch stands out in shining contrast to the dark greens of the other conifers, providing a beacon in the mist. The browns and reds of the underbrush add more color. Dampness permeates the forests, and the moist smell of decay hangs heavily in the air. The mood is somber, but the experience is worth the effort.

Farther south, in the valleys of central Idaho and in Montana's Bitterroot Valley, exists one of the most impressive forests of the Northern Rockies. The open, parklike stands of ponderosa pine and its associated understory grasses provide counterpoint to the dense, complex forests of the north. The trees, often up to two feet in diameter, are widely separated, providing a sense of spaciousness uncommon in mature forests. Light and air fill the stand. Walking among the trees evokes the feeling of a well-manicured city park. These open stands, so distinctive to many early settlers, are actually the result of intentional burning by Native Americans. By introducing ground fires at short intervals, shrub species were kept out and grasses that were palatable to wildlife were perpetuated. Today, fire suppression has allowed shrubs once again to dominate the understory, and the more "natural" ponderosa pine stands are increasingly rare.

The color and aroma of ponderosa pine forever define it. The rusty orange bark, arranged in thin, curving plates, is so distinctive that it becomes the dominant visual image of the tree, while the pungent odor provides an equally strong benchmark for the sense of smell. Ponderosa pine inhabits the warmest and driest sites that will support trees in the region. The sandy soil that weathers from the granites of the Idaho Batholith, coupled with the low precipitation of the valley bottoms, provides a moisture regime that allows "P-pine" to outcompete its associated species.

East of the Continental Divide, it is better to think of lack of moisture rather than its presence as the dominant variable in the distribution of plants. This is readily apparent when crossing the Divide at Maria's Pass on U.S. Highway 2 in Montana, Lost Trail Pass on Montana Highway 43, leaving Yellowstone National Park on U.S. Highway 16, or crossing Wyoming's Togwatee Pass on U.S. Highway 287. The western slopes of these passes are generally covered with

Opposite:
The North Fork fire approaching West Yellowstone, Labor Day, 1988

Douglas fir, ponderosa pine, or lodgepole pine, depending on latitude and elevation. Crossing the Divide, the tree species change to those tolerant of the next driest conditions on the scale. Within a few descending miles, the vegetation is almost exclusively sagebrush. Classified as the "shrub-steppe" complex by ecologists, sagebrush is the dominant valley-bottom vegetation between the crest of the Rockies and the Great Plains.

For most people, sagebrush is a defining feature of the West. Hardly a western novel or story fails to address the romance of the sagebrush hills, and the plant is associated with everything from Zane Grey novels to right-wing political revolts. But although sage has always been plentiful in the West, in the past it was not as dominant as it is today. Much of its current range was once covered by equally vast stands of native grasses, such as bluebunch wheatgrass and Idaho fescue. However, the introduction of domestic livestock in the 1870s and the heavy use of the rangeland until the 1930s forced the grasses out and encouraged the more grazing-tolerant sage. The absence of wildfire, which tends to eliminate sagebrush and regenerate grasses, has perpetuated this trend as suppression became public policy. Today, much of the West has not recovered, and oceans of sagebrush have replaced the more diversified habitats that once existed. While the layman's fondness for sagebrush may have a certain validity, gradual dominance of the West suggests some valuable lessons. For sagebrush, perhaps more than any other plant in the region, represents the constraints of aridity and reveals the price paid for ignoring them.

The counterpart to sagebrush among tree species east of the Continental Divide is lodgepole pine. It is the dominant tree of the mid-elevations and can be found in virtually all habitats, from those that border sagebrush to those that border alpine wildflowers. Although it grows with Douglas fir and ponderosa pine on dry sites at low elevations, lodgepole occurs most often in pure stands. This widespread tree would not be nearly as plentiful if it were not for one factor—a factor that was seared into the nation's consciousness through wildfire during the summer of 1988 and again in 1994. Lodgepole pine relies on periodic fires to create the set of conditions that allow it to dominate sites that would otherwise support different tree species.

Lodgepole pine is uniquely adapted to exist in concert with fire because of a characteristic of some of its cones called serotiny (serotinous and non-serotinous occur on the same tree). Conifer cones carry the seeds that create new trees, with most opening while they are still on the tree and releasing their seeds. The wind then carries them to a suitable place for germination. Some lodgepole cones react like this but others remain closed, only opening when conditions for seed survival are optimum. The trigger mechanism for opening those serotinous cones is intense heat, conveniently provided by wildfire. Insulated inside the cones, the seeds are protected from being burned. Yet the fire's heat causes the cone to open and deposit the seed on the bare soil left by the fire. The resulting stands are made up almost exclusively of lodgepole pine, and because the conditions for fire are likely to occur again before other species take over the site, the continued dominance of lodgepole is assured.

Historically, fire occurs in all forest types, but its effects depend on the individual site and the types of trees present. In wetter areas the conditions that lead to large wildfires occur only at great intervals. Consequently, forests remain stable, and the orderly succession of vegetation

The valley of the Beaverhead River is representative of conditions in much of the Rocky Mountain West. Low rainfall and short growing seasons combine to make agriculture marginal.

occurs. Most of the fires that do occur in these forests are relatively small and serve the purpose of creating islands of diversity made up of younger trees. However, after a particularly dry year, or a series of dry years, conditions in these forests can lead to fires every bit as severe as those in drier habitats. In 1910, large fires swept through millions of acres in northern Idaho and western Montana, in forests that are normally among the wettest in the region. An incredible three million acres were burned in the span of two days. These conflagrations caused a great deal of damage to local towns, killed 86 people, and led to the emphasis placed on fire prevention and suppression that has been a hallmark of U.S. Forest Service policy.

Over the years, this emphasis has been a double-edged sword. For just as wildfire interrupts the succession of tree species, fire suppression interrupts the cycle of wildfire that has produced forests in the Northern Rockies for thousands of years. Of the 1,000 to 1,500 lightning-caused fires that occur every year, many are extinguished by fire-suppression efforts. Each extinguished fire also removes the chance for many acres of forest to be renewed. For decades, the elimina-

tion of wildfires has been the target of much effort and expenditure, and overall, the fire suppression target has been met more often than not. But other processes continue. And in preventing fire we may have inadvertently created a condition in the Northern Rockies that will produce forests, and also wildfires, of a much different character.

The removal of wildfire from forests allows the trees to attain maturity and often die a natural death. Although younger trees replace those that have died, the fallen trees eventually create a fuel build-up of immense proportions on the forest floor. The climate of the Northern Rockies will surely produce conditions that are favorable to wildfires, and the number of lightning strikes assures there will be ample opportunity for igni-tion. Just as surely, there will be fires that will escape even the most diligent suppression efforts. And when they do escape, they will be much larger and more severe than the fires that would have burned in the same forests prior to the large accumulation of fuels. The Yellowstone fires pointed out the futility of suppression efforts in the face of extremely large blazes. In 1994 that point was dramatically underscored, as fires in Montana, Colorado, and Washington defied control efforts for many weeks. However, the thousands of acres burned in recent years are but a fraction of those with critical fuel build-ups that are still unburned. Current conditions in the forests of the Northern Rockies indicate that the firefighters will get other chances to practice their techniques.

One additional plant community occurs throughout the Northern Rockies. Its importance is disproportionate to its size. Although small in area, it is crucial to the future of the West.

Streamside areas support vegetative communities that are vastly different from those on adjacent hillsides. Streamside *riparian* areas are characterized by high water tables that encourage vegetation that is not only more dense than that of neighboring uplands but also more diverse.

Heartleaf arnica blooms in profusion after the 1988 fires in Yellowstone National Park.

Tree and shrub species that need large amounts of water, such as cottonwood, willow, alder, and aspen, are those most often found along streams. The relationship between the trees, the stream channel itself, and the valley bottom creates a habitat of great importance.

Riparian areas exist along the entire length of any stream. Their width is determined by the valley bottom, for they will extend outward from the stream until the steeper hillsides are reached. As with lodgepole pine and fire, there is a symbiotic relationship between the river channel and the vegetation along it. Rivers saturate the soil allowing riparian plant species to thrive, while at the same time the roots of those plants provide stability to the streambank, maintaining its shape and preventing excessive erosion. This relationship allows the riparian area to function as an underground storage reservoir and to provide a floodplain that reduces erosion.

West of the Continental Divide, spruce, cedar, and hemlock can be found in dense stands along streams. Western red cedar, with its large trunk and lacy boughs, is the most impressive and tends to dominate valley bottoms. The trees' stately columns and dense crowns tend to shut out all but random, illuminating shafts of sunlight and keep the forest floor relatively free of underbrush and cool on even the hottest days. The cathedral-like nature of these stands often rivals that of the great old-growth forests of the Pacific Northwest. Many of the rivers and streams in western Montana and northern Idaho have their popular local cedar groves.

East of the Divide, the riparian vegetation is not as grand, but the difference between it and the adjoining uplands is a good deal more obvious. A transition from dry, sagebrush hillside to lush wetlands occurs within a few feet, and the analogy to an oasis in the desert is apt. Here, riparian areas consist of a wide variety of willow species. They are often an impenetrable tangle of brushy vegetation, commonly more than ten feet in height, through which it is impossible to navigate in a straight line. But from a vegetation standpoint, they are magnificent islands of diversity. The variety of riparian species seems endless when compared to the upland habitats, and the ready availability of water makes these places a welcome and popular place to spend time.

Unfortunately, their popularity has made riparian areas the most abused systems in the Northern Rockies. Stream bottoms are the most desirable locations for many of the land uses that have been the economic staples of the West. They grow the best timber and produce the most succulent forage. Gold has been a lure, wherever it has been found, and mostly it has been found by placer mining in the gravels of streambeds in a process that has rearranged not only the vegetation but the entire valley bottom. Townsites and roads are often located along river and stream courses, and many recreational developments take advantage of the only water in an otherwise dry landscape. Riparian areas have thus been grazed, mined, cut, paved, diked, leveed, subdivided, and otherwise altered until few of them bear much resemblance to their composition before modern man arrived.

On the other hand, because of the presence of water, riparian areas are among the most resilient of the western ecosystems. And, of all the vegetative types, riparian vegetation is probably the best indicator of the general health of the landscape. If the land-use practices in the present-day West are to begin to conform to the capabilities of the landscape, a change will be first evident along rivers and streams.

One of my favorite places to spend time wandering and photographing is the bottomlands of the Snake River, as it flows through Grand Teton National Park. In today's West, very few riparian areas function the way they did in presettlement times, so it is unique to be able to experience one that still does.

The high ridges, alpine meadows, and wide valleys in which we spend so much time, especially east of the Continental Divide, are open expanses where horizons seem unreachable. The riparian areas along the Snake are much more intimate, much less overwhelming. The horizons here are marked by old river terraces, a half-mile away at the most. Vegetation dominates the surroundings, shouting of the diversity that is the hallmark of functioning riparian areas. Thick-trunked cottonwoods create a canopy one hundred feet overhead, their deeply furrowed bark testifying to the decades required to reach that height. Dense stands of willow line the banks of the river, often making human access to the shoreline impossible. Small pockets of darkly cloaked spruce provide areas of deep shade. In the open spaces, tall, tan grasses create miniature prairies.

Old stream channels, some filled with still water, meander through the bottom, revealing that the river was not always in its current location. Gravels carried by water from glaciers that melted 10,000 years ago have been deposited in a wide band across the entire bottom, as the river cut downward from the current valley floor. With a few moments' thought, the symbiotic relationships among river, floodplain, water table, and vegetation is easily perceived.

A day in these bottomlands can provide an incredible amount of wildlife viewing. Moose feed on underwater plants in the shallow ponds, water cascading off their raised antlers like mini-Niagaras. Bald eagles patrol the river early in the morning, periodically diving on unsuspecting trout. A great blue heron stands transfixed in the tall grass at a pond's edge. River otters chase each other across a midstream gravel bar. A hairy woodpecker's staccato rapping punctures the stillness. The place is alive.

However, a dark cloud threatens the riparian area along the Snake. A mobile river created this ecologic masterpiece, and an equally mobile river must maintain it. But the Jackson Lake Dam now prevents peak flows from shifting the river channel and creating new gravel bars where willows and cottonwoods can begin to grow. If the river stays in the same channel, spruce will eventually replace cottonwood throughout the bottom, and the vegetative diversity, as well as the habitats that go with it, will be lost.

But for now, the riparian area of the Snake River is one of the magical places in the Intermountain West.

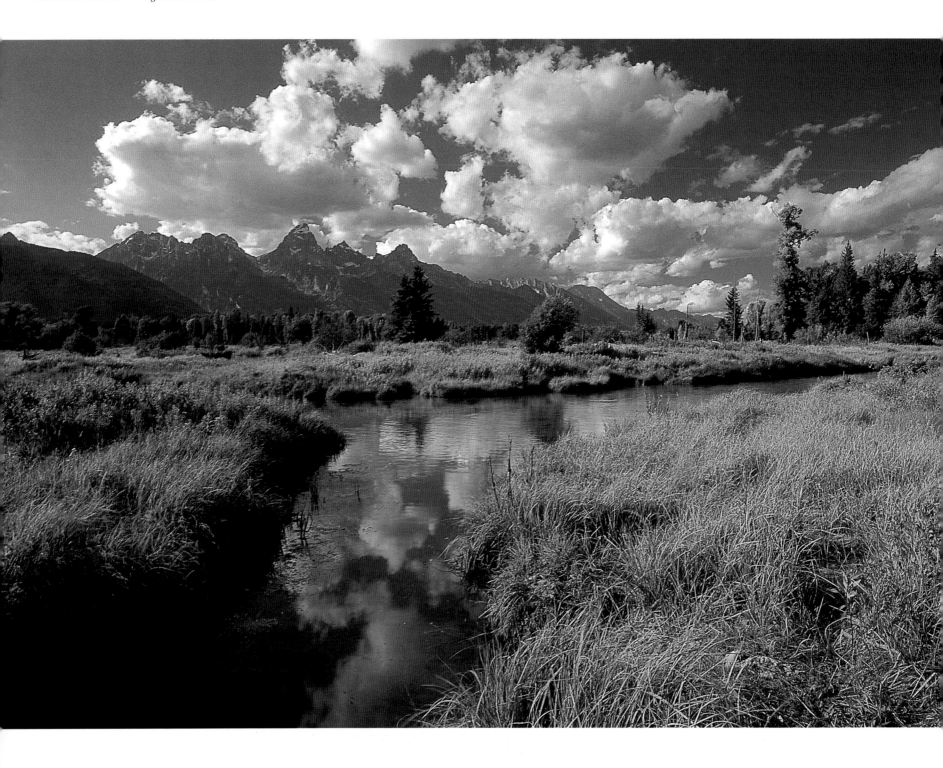

As in the case of water, man's influence has changed the definition of most of the plant communities in the West. There can be little argument that the mixture of species and total biomass on many sites has been considerably altered since presettlement days, and that during the alteration process, timber and forage have somehow been labeled as a "renewable" resource. In a gross sense this is an accurate label, for in all but the most severe cases of site disturbance, when plants are harvested, they will grow back. However, although we have certainly managed to feed livestock every year and have seen harvested forests begin to regenerate, the renewal has seldom re-created what was originally there.

Trees and forage are closely intertwined with the economy of the Northern Rockies. The timber and livestock industries have survived (barely) since the late 1800s by "renewing" the region's timber and forage for profit. Consequently, vegetation has become an economic commodity. As such, timber and forage need only be renewed to perform a single role: that of contributing to profit. Any other benefits that might accrue from those plants, or roles that they might play, have been secondary to the dominant role of supporting an economy. It has been easy, therefore, to define the success of forest and grassland management in terms of its commodity role.

The other role of vegetation, that of serving a purpose within the natural community, has been given little value in management scenarios over the past hundred years. Although the two are not mutually exclusive, and can be symbiotic, maintaining the natural diversity and function of forests and grasslands while also using them as an economic commodity involves some degree of economic sacrifice. Fulfilling both roles subtracts from profit, and so maintaining the natural community has rarely been given serious consideration. The result has been logging and grazing practices that have, for the most part, "renewed" vegetation in the commodity sense but often eliminated community.

Throughout Wyoming, Idaho, and Montana, livestock grazing has changed the vegetation of many riparian areas. Instead of willows and sedges, crucial in maintaining stream bank integrity, these riparian areas now feature exotic species such as bluegrass and dandelion, which have sparse root systems and offer little protection against erosion. As a result, streams that were once narrow and deep are now wide and shallow. Although these riparian areas can still support livestock, their effectiveness in the areas of flood protection, and water table and fish habitat maintenance—benefits that are far more valuable to the community—has been severely compromised. Similarly, methods of logging in western Montana and northern Idaho often compact sensitive soils and delay or prevent the return of the natural community once the commodity is harvested. There are many vegetative communities in the Northern Rockies in which poor logging and grazing practices have prevented vegetation from fulfilling its dual role of community and commodity.

In the introduction to *A Sand County Almanac,* Aldo Leopold speaks of the conundrum between land as commodity and community. A solution to this conundrum is crucial to the future of the West. Without successful resolution, this single issue is capable of causing turmoil and strife in the region in the foreseeable future. As with water, the current choice for land

Opposite:
A riparian area in Grand Teton National Park. These important streamside locations reduce flooding, maintain water tables, and provide habitat for numerous plant and animal species.

hinges on a judgment based on value rather than science. Many people have profited and many economies have been perpetuated with vegetation as a commodity. However, in the process, vegetation's role in the larger community has often suffered. Central to a resolution is this question: In the arid West, where much of the region edges close to desert status, is it possible to continue to renew vegetation as a commodity while still allowing it to perform its service within the natural community?

INHABITANTS: THE LITMUS TEST

On a backpacking trip in the Canadian Rockies, Alice, our friend Karl, and I had not chosen an ideal location for a campsite. On one side, a steep hill rose for a couple of thousand feet, and on the other, a lake took up the remainder of the valley. Occupying the hundred or so feet between the lake and hillside was our camp, immediately adjacent to the trail. But it was late and we were tired. Alice and I set up our tent, and Karl rolled out his sleeping bag a few yards away.

I awoke in the grayness of predawn. As I got out of the tent, Karl was stirring, so I headed for the tree where we had hung our food. After all, this was bear country, and we were careful campers. Returning with breakfast, I could see Karl walking toward me, his eyes about the size of saucers and his thumb jerking spasmodically over his shoulder. I glanced behind him. A grizzly was approaching about eighty feet away.

I wouldn't say we panicked, but the situation definitely commanded our attention. I crossed to the tent and told Alice to follow me. We headed, hopefully not fast enough to interest the bear, for the nearest climbable trees. Alice was barefoot and balked at climbing. But she hadn't seen the bear and probably doubted Karl's and my identification capabilities. From here on it got funny, with the three of us in small lodgepole pines, Alice hopping from one branch to the other to ease the foot pain.

Had we bothered to look over our shoulders (if we don't look at him, he may not chase us?) as we fled camp, we would have seen the bear continuing down the trail, paying us no mind.

I had seen the bear for perhaps three seconds, but I have relived those seconds for many hours.

There is beauty in the limitless arrangements of rocks, water, and vegetation, but a landscape is given life by the creatures that inhabit it. Even in the grandeur of the mountains and the violence of their weathers, the landscape seems essentially passive. But add a touch of life—the cry of a circling hawk, the slap of a beaver's tail, the turn of an elk's head—and landscape becomes habitat.

Opposite:
Western red cedar is a dominant tree in riparian areas west of the Continental Divide.

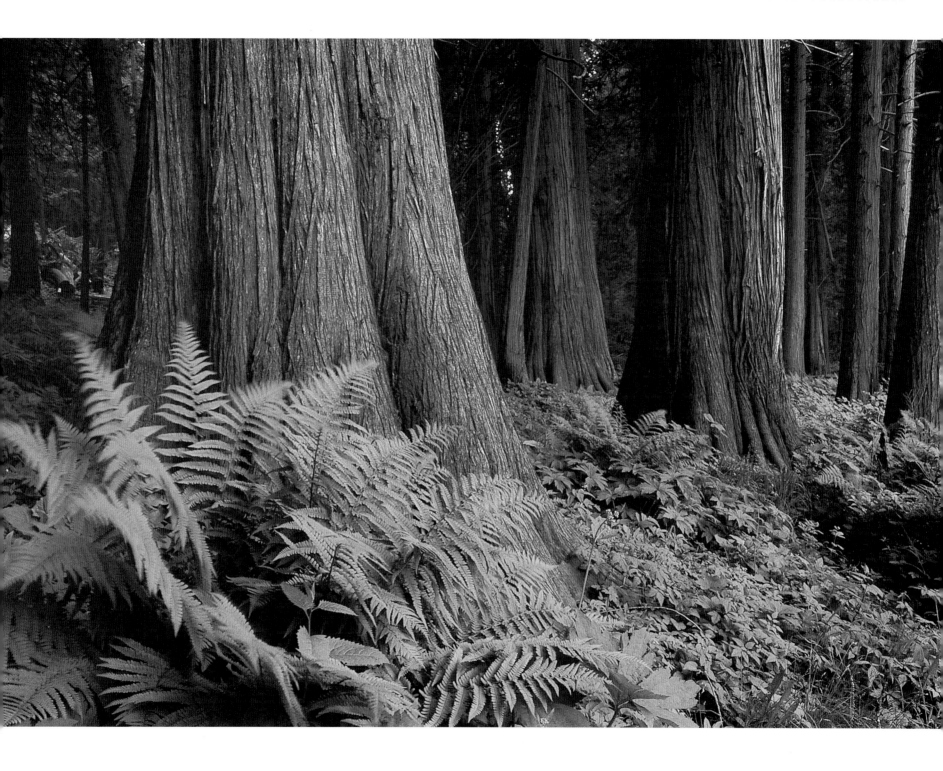

Basically, an animal's habitat defines where it can survive. Geologic forces produce a section of planet that has a certain topography and elevation, at a specific place on the globe. Topography and elevation help determine the type and amount of precipitation the area receives and how it is distributed. This precipitation scenario in turn regulates the type, abundance, and distribution of plants. The interaction of all these physical and biologic variables determines the specific mixture of foods and shelters for animals. Very few animals can alter their habitat, so success depends entirely on the ability to adapt.

Habitats come in many sizes. They can be very small, including only specialized locales, or they can be broad, encompassing many types of plants and elevation zones. Pikas, for instance, spend their entire lives on talus slopes. These isolated collections of rocks at or near timberline provide both food and shelter within a small area, with a narrow range of climatic conditions. Coyotes, on the other hand, can make do just about anywhere. Their habitat includes forests, prairies, marshes, and deserts. Both pikas and coyotes adapt to their habitats—the pika by performing regimented tasks each season to offset extreme climatic conditions, and the coyote by varying its behavior, depending on season and locality, to take advantage of changing food sources.

Of all the components of habitat, vegetation is by far the most important to wildlife. Changes in climate will cause animals to initiate further adaptation, but a change in plant life

Trumpeter swans, Yellowstone
National Park

requires quicker responses. As if to underscore this importance, habitats are often described in terms of groups of plants. In the Northern Rockies, there are four such habitat groupings, or biomes: sagebrush/grassland, coniferous forest, tundra, and wetland/riparian. However, across the spectrum of biomes, one rule holds sway: the biomes with the greatest diversity of plants will support the widest variety of animals. One end of the spectrum is the tundra, found above treeline on the West's mountain ranges. With its low, stunted trees and perennial plants that are necessarily small-featured to avoid the frigid, drying winds, the tundra has few year-round residents. On the other end, the coniferous forest boasts a wide variety of trees, brush, and other plants that harbor a corresponding diversity of animals. These plants grow to different heights, creating diversity above the ground, and are found in various combinations, offering diversity across the landscape. However, whether a particular habitat is located in the wetlands or the tundra, vegetation provides those elements most necessary for survival: food and shelter.

Essentially, food transfers energy from one life form to another. The vital minerals, vitamins, sugars, proteins, and carbohydrates that provide nourishment exist in the tissues of all plants and animals. As some feed on others, this energy is transferred. The ability of plants to obtain minerals from the soil, as well as to convert sunlight into usable energy through photosynthesis, makes them a vast storehouse of energy. All vegetation performs this crucial conversion and

storage of energy, and the wide variety of plants allows energy to be offered in a host of forms. Animals that feed on plants are called herbivores, and each herbivore obtains its nourishment from specific plant types. Elk graze on nonwoody plants such as grass and forbs in high meadows; pronghorn graze on the grasses in prairies and sagebrush communities; beaver gnaw the nutritious bark of willows and aspen; sage grouse peck at the leafy portions of sagebrush; and mountain goats nibble lichens from timberline rocks.

In the Northern Rockies, the change of seasons requires many plants to enter dormancy during the winter months, thereby preventing any single species of plant from providing nutritious forage throughout the year. Animals must adjust to this reduced availability. They do this by shifting to whichever plants are obtainable. Moose, for example, spend the summer feeding on aquatic vegetation in scattered ponds and swamps throughout the mountains. When these areas freeze over, they switch to twigs and the buds of willows in the riparian communities. For many herbivores, such as elk, the onset of winter means migrating to different locations, where they eke out a slim living on decaying, sometimes rotting, grasses. Fortunately, elk can rely on nutrient and fat reserves from summer to help nourish them through the winter.

Taking the concept of energy transfer one step further, plant energy converted into the flesh of herbivores becomes the source of energy for carnivores. Carnivores are necessarily predatory and generally range wider than their prey. They are also more opportunistic feeders. But just as herbivores feed on specific plants, so, too, do predators depend on specific prey. And because the prey animals are generally herbivores, the predators are also dependent on plant communities. For instance, the pocket gopher is a major food source of the great gray owl. Because gophers feed on the succulent forbs and grasses in mountain meadows, owls are most commonly found along meadow margins. In the dense forests of the Northern Rockies, a lynx will kill a snowshoe hare about every other day. These hares are the cat's major food, but because, unlike the rabbits and other hares, the snowshoe rarely ventures into open meadows, the lynx remains a phantom of the deep woods.

Vegetation also provides shelter and security. This is especially true in winter. In this most severe of seasons, vegetation mitigates the extreme climatic conditions, be it temperature or snow depth, by providing shelter during storms or freezes. The tree canopy overhead, especially in the case of conifers, prevents the earth's heat from being lost into the atmosphere, thereby providing warmer air temperatures beneath its protection. This softening of temperature extremes also prevents the snowpack from developing a hard crust, making it easier for large animals such as elk and deer to reach forage. Perhaps the most important winter benefit of vegetative canopies is the protection they offer from freezing winds, which can drain body heat. These benefits occur in all kinds of habitat groupings. For example, the sage canopy is as important to sage grouse as the lodgepole pine canopy is to elk. In riparian areas, the insulation provided by deep snow and overhanging vegetation prevents streams from freezing, thereby maintaining fish habitat. In summer, vegetative cover has the opposite effect, providing cool places to escape midday heat.

The bison was once the most prevalent large herbivore in the West. Almost hunted into extinction, its comeback has been a wildlife management success story.

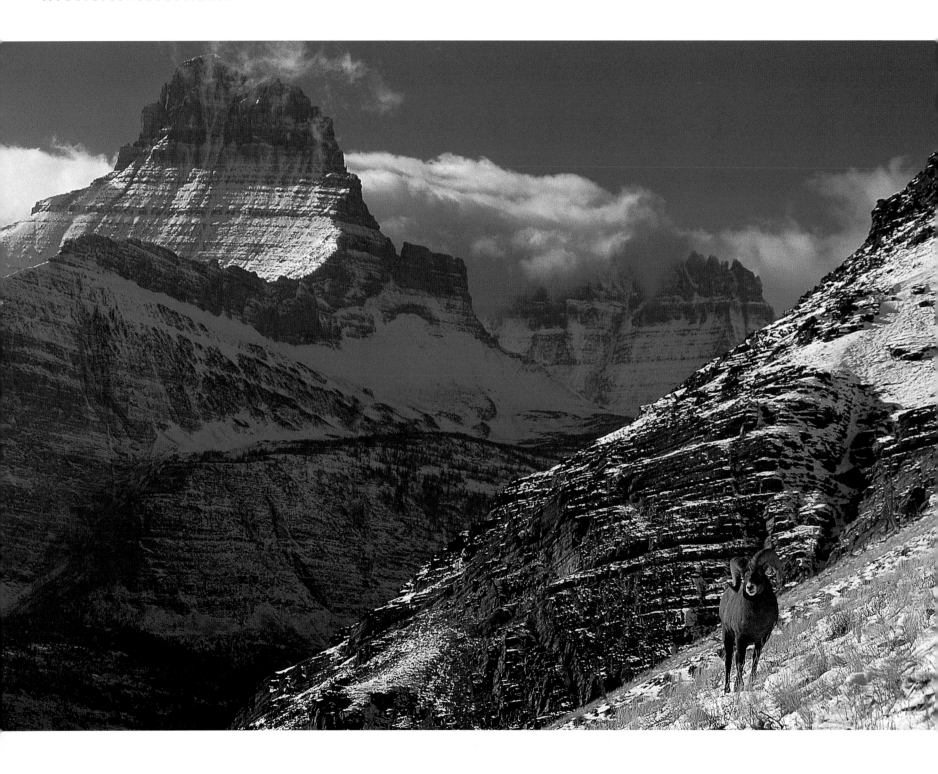

Vegetation also provides a place to hide. In fact, the security strategies used by a number of animals are determined by the vegetation in the vicinity. In the grasslands, for example, sagebrush and other shrubs allow small mammals to hide from sharp-eyed raptors circling above. In the forest, squirrels in the treetops are secure from all predators, save the pine marten. Some birds, such as the Williamson's sapsucker, make their homes in tree cavities. East of the Continental Divide, riparian areas offer both water and cover for species such as the whitetail deer. During summer months on the tundra, ptarmigan mimic the coloration of low shrubs such as willow, allowing them to hide in plain sight.

Many different animal species can inhabit a given biome without direct competition among them for food and shelter. The behaviors that each species develops, allowing it to use its habitat in a specific way, is said to be that species' *niche*. For example, two similar species of wading birds, the black-necked stilt and the American avocet, can coexist in the same marsh because their different feeding styles allow them to catch different prey and thereby, fill distinct niches. The concept of a niche goes beyond habitat, encompassing the role the species fulfills in the ecosystem. Hawks and owls are both raptors that hunt small rodents, but hawks hunt during the day and most owls hunt at night. Together they have a similar role, but they fulfill that role in different niches.

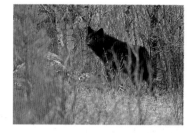

Energy transfer in action. The death of an elk provides food for predators—in this case a wolf.

Opposite:
Bighorn ram and Mount Wilbur in Glacier National Park. The interaction of climate and topography has created a habitat that is both steep enough and cold enough for the bighorn sheep.

Between timberline and mountain top exists the harshest of all biomes. Low temperatures, high winds, and short growing seasons combine to make the TUNDRA the most difficult portion of the Northern Rockies for animals to survive.

Mountain goat photographs do not come easy; they are earned. Goats are not nearly as gregarious as bighorn sheep, and their haunts are higher and more remote. The times they are both photogenic and accessible coincide in the fall, when their winter coats start to grow. All of this was readily apparent throughout the forty minutes that brought us to the middle of a steep, ice-rimmed talus slope in Glacier National Park. The solitary goat ahead was in an excellent position, looking out over an endless void, with a peak called Bishop's Cap rising in the background. If we could only get close. Foot by slippery foot we crept along until we were within range, holding our collective breath, hoping he would stay. Fingers flew in controlled frenzy as we went through the familiar drill: set the tripods down, find him in the viewfinder, check exposure, focus, compose . . . shoot! Two frames and he was gone. Another morning of goat photography. . . .

The mountain goat is clearly at home, its winter-long hair whipped by the snow-speckled wind, as it stands solidly on a cliff that falls into infinity. All animals are well adapted, but few demonstrate success in such dramatic fashion as does the mountain goat.

Adaptation for the goat starts from the ground up. Its cleft hooves would be the envy of anyone who has ever laced on a pair of climbing shoes and hooked into a rope at the base of a vertical wall. First, the pad extends slightly below the hard outer covering of the hoof, so that maximum contact with the surface is made at all times. The surface of the pad is textured to provide additional traction, and the pad is pliable enough to conform to minute projections on rocks. The ability of the toes to separate, creating a footprint that is almost square, increases the surface area beneath each hoof, as well as the chance that part of its foot will step onto something solid. Furthermore, the spreading toes can act as brakes when going downslope and as a pincer when climbing. Eight independently working toes help the goat navigate the high cliffs. It is no surprise that many people's first reaction to seeing a goat above them is to wonder how it got there!

Viewed from the front, a mountain goat has a much narrower body than its profile suggests. This enables it to keep most of its weight over its feet and greatly increases its balance. The goat's highly developed shoulder muscles provide the power to pull itself up steep inclines, rather than depending on bounding or leaping. Watching the seeming nonchalance and economy of movement with which goats negotiate their rocky habitat, I am reminded of an expert rock climber on the face of a difficult wall.

The intense cold of the mountain winters is mitigated by the goat's thick coat, which consists of hollow, eight-inch guard hairs covering an underlayer of fluffy wool.

Ironically, the conditions to which goats are best adapted often are their downfall. Gravity and avalanches claim more goats than any other factors. But considering where they live, it is no surprise that their most successful "predator" is their own habitat.

Like the goat, the ptarmigan spends the entire year in the tundra. Its ability to change color with the seasons allows it to use its habitat as camouflage any time of the year. In winter the bird's plumage is pure white, so in snow its black eyes and bill are often the only things that will give it away. In summer, the mottled brown feathers allow it to blend in with the low brush and lichen-splashed rocks. Ptarmigan are not strong flyers, so concealment is often their best defense.

In winter, ptarmigan burrow into snowdrifts, where the insulating snow allows them to wait out storms. Once under the snow, they will tunnel a short distance, then stick their heads out to take a look around.

Winter food consists of the buds of willow and other shrubs along riparian areas near timberline. Often ptarmigan spend long periods in one willow patch, and then just walk to an adjacent patch. Their feet are covered with feathers, which act like snowshoes to facilitate walking in fresh snow. The feathers that cover a ptarmigan's feet also provide insulation and reduce body heat loss.

$$\approx \quad \approx \quad \approx$$

Below the harshness of the tundra, the CONIFEROUS FORESTS provide a range of relatively hospitable habitats. A wide variety of bird and mammal species occupies an equally wide variety of niches in this, the most diverse of the biomes of the Northern Rockies.

The WHAP! WHAP! of helicopter rotors drove us into cover behind scattered clumps of sagebrush. We lay on our stomachs in the snow and mud, heads cocked back to see uphill. The sound grew louder quickly. Suddenly, the helicopter appeared, swinging wildly. The full blast of the rotor noise washed over us. Next thing, we saw eight cow elk racing toward us, necks stretched low and hooves pounding.

About sixty of us were helping the Montana Department of Fish, Wildlife, and Parks capture and radio-collar elk on the Beaverhead National Forest. In a technique known as "elk drive netting," helicopters had split small bands of elk from the winter herd and chased them into hidden nets, where we wrestled them down, tied, and blindfolded them. We determined the age and sex of each elk and attached a radio collar before letting the animal go. We fondly refer to this as "catch and release elk hunting."

We lay behind the sagebrush until the elk hit the first net. Pandemonium broke out as the elk struggled to regain their feet and became hopelessly entangled. We tacklers rushed uphill. Soon, bodies were flying and elk falling. It took about five of us to take an elk down, disentangle it, and keep it still while the biologists performed the tests and fitted the radios. We collared as many as sixty in a day, and over the past few years hundreds have been radio-collared and tracked. The biologists no doubt get a great deal of valuable data. And for us grunts, elk drive netting is a welcome change from winter's office work.

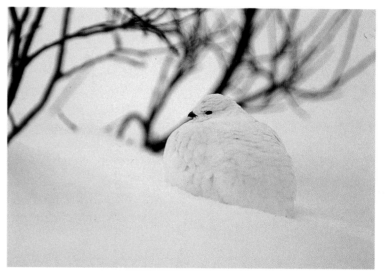

White on white—the ptarmigan hides in plain sight.

It has been written many times that the mating bugle of the bull elk is one of the most evocative, stirring, and thrilling wild sounds in North America. Anyone who has stood alone at dawn on the edge of a meadow, watching a regal bull stretch his neck and send those eerie high-pitched notes and squealing grunts into the crisp morning air will agree without a second thought. This bugle is never commonplace. No matter how many times you hear it, it always seems new. And when it awakens you in the middle of the night, you don't mind.

A subspecies of red deer, elk originally inhabited many of the subarctic steppes of the northern hemisphere and ranged into eastern North America. About 10,000 years ago, rising

sea levels, coupled with the last glacial retreat, flooded the isthmus between present-day Asia and North America. As a result elk were separated into two populations, which are today nearly indistinguishable. As great Ice Age herbivores such as woolly mammoths died out, elk expanded southward, filling the niche left by the larger grazers.

Today, elk are the dominant herbivore of the coniferous forest from the Wind Rivers Mountains to the Idaho Panhandle. They are gregarious, with the cows, calves, and yearlings staying together in herds throughout the year. The herd is their first line of defense against predators, which were once wolves but now consist mainly of coyotes and bears. Mature bulls travel in small bachelor bands for most of the year, joining the cows in early fall for the mating season.

The peak of this rut is the most active and dramatic time of the year for elk. The shorter days trigger hormonal reactions within the bulls, causing them to advertise themselves to cows as prospective mates. By bugling, displaying their large antlers, and urinating to distribute their scent, they broadcast their amorous intentions throughout the mountains. A successful self-promotion campaign will bring a dominant bull a sizeable harem, with which he must mate and constantly defend against other bulls. No wonder the bulls rest for the other eleven months.

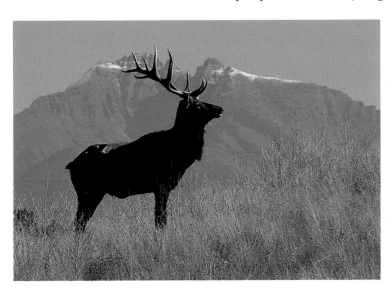

The most regal of Northern Rockies wildlife, elk symbolize the region for many people.

Females have a more subtle, but nonetheless important role in the process. Cows choose the dominant bull to breed with them to ensure that their offspring will have the pick of the gene pool, and hence the greatest chance of survival.

Perhaps more than any other species, elk symbolize wildlife for people living in the Northern Rockies. Elk hunting is the dominant recreational pursuit of many residents of the region, and the opening days of hunting season are the high holy days in states like Montana, Wyoming, and Idaho. Because of this, elk have developed an ironic symbiosis with man. The revenue received from hunting licenses grants the elk virtually the undivided attention of the state game agencies. The agencies, often in conjunction with private organizations, have purchased large tracts of winter range, which insures that both the elk and the revenues will be perpetuated.

The coniferous forests of the Northern Rockies provide a prey base for many predators, and no predator is more efficient than the great gray owl. Sitting inconspicuously in snags, fifteen to twenty feet above the ground, an owl seems to be resting. In reality, with the slow rotation of its head the great gray is scanning the forest floor for voles, mice, shrews, and especially pocket gophers. But the eyes might as well be closed for all they are being used. The owl's scanning mechanism is a finely tuned sense of hearing. The feathers in the owl's face funnel sounds to its ears, much as a parabolic microphone on the sideline picks up the sounds at a sporting event. Each of the owl's ears is asymmetrically placed, enabling it to triangulate on the source of the sound and fix its exact location.

The owl visibly tenses when it locates its prey. It takes a final bearing, cocks its wings, and drops silently to the ground. Even when it lands, the owl still has not seen its prey but is homing on the sound from the rodent's hole. The owl reaches a talon into the hole and, as often as not, withdraws a pocket gopher.

Great grays nest in the broken tops of dead trees, such as the Douglas fir. They annually raise broods of three to four chicks, a chore that keeps the male hunting almost continuously during the spring and early summer. Estimates suggest that a family of growing owlets will have consumed as many as a thousand prey animals by the time they fledge. The male does most of the hunting, with the efficiency of his sensitive sound locating system making it possible to keep the entire brood supplied.

≈ ≈ ≈

The low level of precipitation in the Northern Rockies ensures that the GRASSLAND/SAGEBRUSH biome plays an important role in the region's ecology. Indeed, east of the Continental Divide, it is the single largest biome between the Wind River Mountains and Canada. Although not as diverse as the coniferous forest biome, it still supports a variety of species.

Taxonomically unique, the pronghorn is the only species in its family to survive the climate change following the last Ice Age. Its closest relatives are antelope and goats, but antelope have spiral horns and goats have unbranched horns, so the pronghorn, with smooth, branched horns, fits neither category. Yet these are subtle, scientific distinctions. What really sets the pronghorn apart is the way it moves.

Speed and grace. Grace and speed. The two words are universally linked to the pronghorn. Ask anyone who has watched a pronghorn race across sagebrush flats, and those are likely the terms that will be used. The blurred leg extension of a running pronghorn makes you think it is covering the distance airborne. No hiding in the sagebrush as an escape mechanism here. Pronghorns just kick in the afterburners.

The pronghorn is built both for speed and endurance—lungs on legs. Its legs are slim and long, its body sleek. Its heart, lungs, and windpipe are exceptionally large for an animal of its size, allowing for a tremendous intake of oxygen for extended periods. The result is speeds of up to fifty miles per hour during short bursts, thirty miles per hour on cruise control. Nothing on legs can catch it. Very few things even try.

The sound of the courtship ritual of the sage grouse can best be duplicated by rubbing two pieces of ripstop nylon together, then dropping a stone into a well. In the predawn hour of April, on obscure, nondescript sections of sage-covered ground, this constantly overlapping sound arises from dozens of male grouse establishing their turf. As first light scrapes across the tops of the sage, the males whirl around in short, direction-reversing patterns, much like targets in an arcade. By puffing out its breast and inflating a pair of large, yellow air sacs (which resonate the mating sound), the male hopes to attract a passing female into his territory.

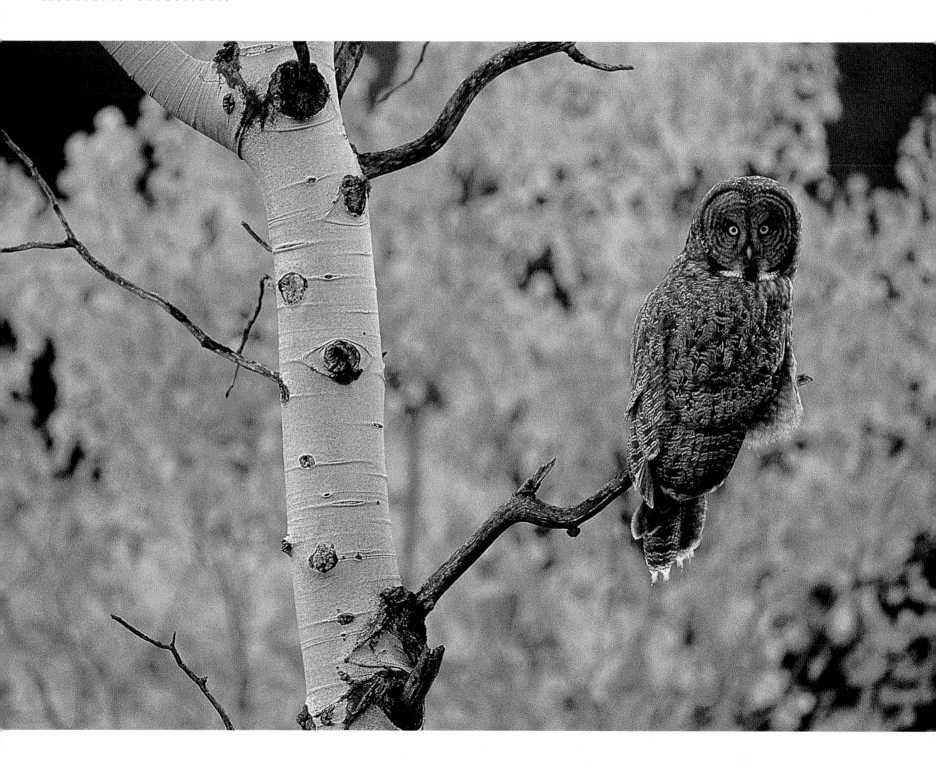

Females seem to slink about randomly, often pursued by a line of interested males. Quite often males will meet each other at their respective territorial borders. The result is much posturing, feinting, and occasional wing-flapping combat. Sporadically, silence may cover the whole proceedings, as the shadow of a golden eagle crosses the area, but such pauses are short lived. The whole scene is rather chaotic, but as with most species, the job gets done.

The strutting ground, known as a *lek,* seems to be no different from any of the other thousands of acres of sagebrush that surround it. Yet, before light has brightened the edge of the sky, grouse descend on the lek from all directions. The displaying starts immediately and continues until just after sunrise. Then, as if by some silent, prearranged signal, the birds scatter to the compass points.

Few animal species are as dependent on a single plant species as the sage grouse. Their distribution almost exactly mimics that of mountain big sage, the one species of sagebrush that can be counted on to exceed the depth of winter snows.

Now that I've been photographing sage grouse for a while I've gotten smarter. I put up a tent for a blind and spend the night on the lek. (Alice, even smarter than me, doesn't do this at all.) The first time I tried it, I got up at 3:00 am, drove forty miles, found the lek in the dark, and crouched under a net for cover. And froze! I was sure I had the right spot, but when light came, I discovered the birds were behind me. Turning around is easier when you aren't under a net with a tripod. The trick for me was to turn without flushing the birds. I finally made it and, as it turned out, the resulting photos of strutting birds silhouetted against the orange sunrise, are far more interesting than any other sage grouse shots we've got. It's always better to be lucky than good.

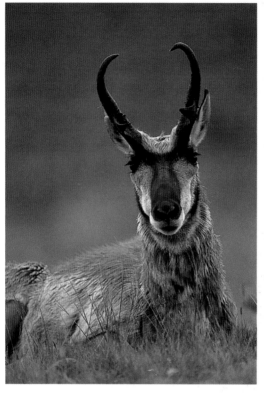

The pronghorn antelope, actually a relative of the goat, is the fastest land animal in North America.

*Opposite:
A gray ghost. The great gray owl is an efficient hunter along the margins of forests and meadows. A pair can capture up to a thousand prey animals to feed a single brood of chicks.*

Riparian areas and wetlands exist throughout the Northern Rockies. They are the smallest of the biomes, but because they contain and control water, their importance is disproportionate to their size. They are a unique blend of physical and biologic components—soil, water, and vegetation—that must function in concert if habitat is going to be maintained.

The beaver, perhaps more than any other animal in the region, is tied to the ecology of the Northern Rockies, for beaver have the ability to create their own habitat. Like the U.S. Army Corps of Engineers and the Bureau of Reclamation, the beaver finds flowing water an anathema (unlike the agencies, though, the beaver's efforts are in concert with their surroundings). By damming streams and creating ponds in which they can construct their lodges, beaver create secure habitat for themselves. As byproducts of this operation, the water table in the valley bottom is raised, allowing a broader swath of riparian vegetation to become established. This vegetation, most often willow, in turn provides a food source for the beaver.

North America's largest rodent, the beaver also has the continent's premier work ethic. Dams are often large, spanning valley bottoms for many hundreds of feet. Once the water is

stopped, the dam must be extended to the valley sides to prevent it from being bypassed by the stream. Upon completion of the dam, maintenance requires constant patrolling to repair leaks and shore up weak spots. Then there is the matter of food. Willow and aspen branches must be cut and stored in caches that can be visited in the winter. Only when the deep snows cover the valleys do beaver allow themselves a little slack.

After a few decades, beaver colonies must shift locations. Sediments fill in the dams, and food sources are depleted. Even though the colonies break apart, a legacy remains. The sediments grow lush grasses and sedges, the stream reestablishes a meandering pattern, and a mountain meadow provides new niches for different species.

The speckled body often seems little more than illusion, like movement in the corner of your eye. A flick of its tail, a shadow darting across the graveled bottom of a small stream, and the cutthroat disappears under an overhanging bank. Was it there to begin with?

The cutthroat, the Northern Rockies' only true native trout, worked its way up the Columbia River between glacial advances of the Pleistocene Era and occupied the waters of the Snake, Clark's Fork, and Kootenai systems. The species eventually split into Westslope (Kootenai-Clark's Fork rivers) and Yellowstone (Snake River) subspecies; however, pure populations of either are becoming increasingly rare because interbreeding with introduced rainbow and brook trout has diluted the cutthroat gene pool. Today, pure members of each subspecies are found only in the extreme tributary headwaters, where the introduced species have yet to penetrate.

Although originally from Pacific stock, both subspecies made it over the Continental Divide. Moving up tributaries from the large lakes at the margins of the continental ice sheets, such as Lake Missoula, cutthroat populated small lakes in cirque basins, as well as a few lakes that had outlets watering both sides of the Divide. Subsequent glaciation along the Divide often altered the drainage patterns, and lakes that fish entered from the Columbia system sometimes eventually drained into the Missouri, perhaps allowing the cutthroat to disperse east of the Divide.

The draining of the glacial lakes, and the lava flows that formed the present Snake River plain, effectively eliminated the possibility of any new species coming upriver to compete with the native cutthroat. However, man's introduction of rainbow, brook, and brown trout breached those barriers. Today, cutthroat are a "species of special concern" and receive some measure of protection in the isolated pockets where pure populations still exist.

~ ~ ~

The habitat of most species is restricted to a single biome. They establish their niches and live out their lives in relatively constant surroundings and fairly small territories. Many species inhabit areas called ECOTONES, the edges of vegetative groupings, and so establish a habitat in two biomes.

But there are two types of animals in the Northern Rockies whose habitat spans all biomes, from wetlands to the tundra. Both are successful in a variety of vegetative complexes.

Opposite:
With erratic movements resembling wind-up dolls, male sage grouse strut to defend their territories. They inflate large, yellow air sacs on their chests to attract mates.

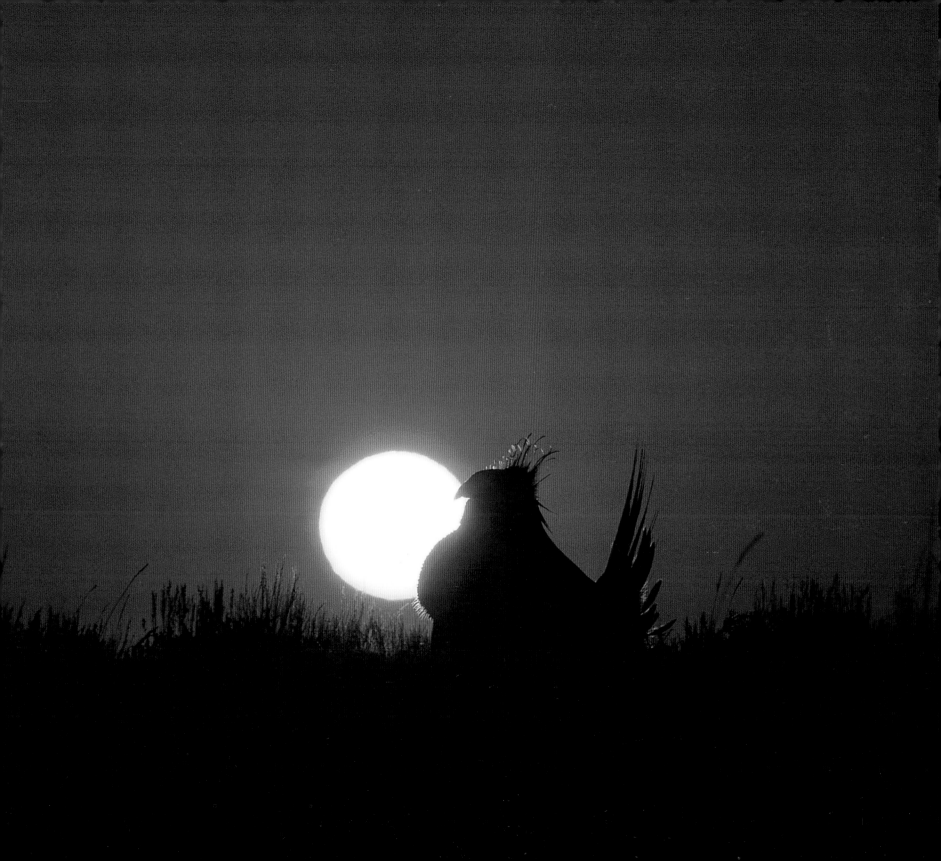

Both require alteration of man's perceptions and actions when he enters their territory. One is a voracious bloodseeker, the other a reclusive omnivore.

The mosquito is everywhere. There is no escape. High mountain lakes, low-elevation trout streams, sagebrush, and lodgepole pine are all hospitable habitats. No back-country expedition or afternoon outing can be undertaken without the proper precautions. Nets, sprays, lotions, smoke, and ultrasound have all been marshalled to blunt the stinger of this whining, buzzing pest. And to no avail. There have been many changes in the Northern Rockies since Lewis and Clark religiously made journal entries by smoky campfires, but their descriptions of "musquitors" still ring true.

There are places in the Northern Rockies that are unique in the lower forty-eight states. The uniqueness is not derived from the mountains, or rivers, or forests, but rather from the fact that when man enters these places, he is not the dominant creature. That distinction is reserved for Old Ephraim, *Ursus arctos horribillis,* the grizzly bear. With its humped shoulder, dished-in face, and silver-tipped fur, the grizzly is as distinctive as it is dominant. In the high basins of Glacier National Park, the open meadows of the Bob Marshall Wilderness, and the dark lodgepole pine forests of the Yellowstone Plateau, grizzlies are a palpable presence. They are there in the misty spring mornings along river bottoms, when carcasses of winterkill are likely to be picked up by the cresting waters. They are there on a narrow trail through head-high huckleberry bushes and six-foot visibility. They are there when you come upon the remains of a half-eaten elk, covered with pine needles. And they are there when you have to get up at night.

Of course, man, as a species, has dominated the grizzly over the years. Hunting, trapping, and poisoning, coupled with various forms of habitat destruction, has left the great bear hanging on the brink of extinction until recently. But on an individual basis, on the bear's home turf, there is little doubt whose set of rules apply. Being in grizzly country carries with it the tacit admission that there is something else there, something more primitive and more powerful, something that can overwhelm you. And that is as it should be.

The response to this presence need not be an unreasoning fear, although a little doesn't hurt, but rather a humility that instills respect. If we are ever going to realize that our role on this planet is one of coexistence rather than domination, we must first respect the other components of the whole, as well as the whole itself. From Massachusetts Bay westward, our first contact with the Great American Wilderness spawned fear and led to attempted dominance. Fear gave way to greed, as natural resources became synonymous with wealth, and dominance became exploitation. Today, greed has led to contempt, and exploitation to scarcity. But the earth is a finite system, with a fixed amount of capability and limits we must respect. The fear-greed-contempt scenario that has characterized man's relationship with nature in the past will not continue to support his presence. As a species, we must attain the humility that leads to respect. To do so, we need teachers and classrooms that will impart this basic theme for both the planet's and man's survival. Grizzly bears and their habitat instill humility and command respect. Often instantly! Sometimes harsh, sometimes subtle, their teaching methods are

nonetheless effective. Today, we can have cautious optimism for grizzly populations. In the Yellowstone area, particularly, numbers seem to be approaching sustainable levels, yet concern for adequate habitat still exists. The 1988 fires, which were generally an ecological boon to the park, burned a considerable amount of whitebark pine, an important late-summer food source for grizzlies in Yellowstone. Also the continued encroachment of development on the park's borders eliminate valuable bear habitat. So the corner has yet to be turned. The grizzly is still a litmus test for our commitment to wildness.

In the winter of 1995 that commitment was strengthened, as the gray wolf was returned to Yellowstone National Park. Hunted to extinction in the lower 48 by the 1930s, the wolf fell under the protection of the Endangered Species Act, which mandates, among other things, that species be reestablished in their former range where possible. An incredibly complicated political process finally gave the go-ahead for wolves to be trapped in Canada, then released in Yellowstone and in Idaho's Frank Church River of No Return Wilderness.

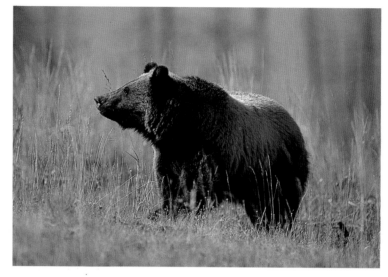

The grizzly is the proud symbol of western wilderness. After spending time in grizzly country, you'll need no other definition.

Early June snow whipped through the gray of predawn in Yellowstone National Park's Lamar Valley. Spring was late, and the elk herds had not yet moved out of the valley to summer in the high meadows. This morning the elk, normally spread out and intent on grazing, were bunched and milling nervously. Some groups ran in aimless patterns across the valley floor. The reason was not apparent to the naked eye, but when we trained our binoculars on the running elk, it quickly became evident. The dark shapes loping easily behind the elk would make any herd of ungulates nervous. Wolves had returned to Yellowstone!

Of course, we had hoped to someday glimpse the wolves, which had been released a few weeks previously, but we never figured it would be soon, or for such a length of time. For forty minutes they moved back and forth across the valley, testing bunches of elk and bison, howling to other pack members on the slopes of Specimen Ridge, and occasionally cavorting among themselves. On one occasion all six walked slowly towards us, in a line abreast, making me think of the Earps and Doc Holliday headed for the O.K. Corral. On another they passed under a cottonwood tree where two bald eagles perched. Who says the Endangered Species Act doesn't work?

We shot some pictures that, from an artistic standpoint, were pretty mediocre. But from an emotional standpoint they may be the best we've ever taken. The pack is back! And it's about time.

The entire wolf reintroduction process was filled with bitter controversy and highly charged emotion. Most stockgrowers wanted no part of a predator they had so laboriously exterminated a few short decades ago. Some hunters were equally vehement in their opposition, fearing that any elk a wolf ate was one less for them to hang on their walls. The environmental community was split between those who favored reintroduction and those advocated allowing wolves to filter down from Canada on their own, as some are indeed doing. Each faction had its own experts, its own carefully reasoned science.

All this was moot, though, the day the doors to the wolf holding pens were opened, and fourteen wolves padded out onto the crusty spring snow of the Lamar Valley. The Yellowstone Ecosystem once again had its most effective predator.

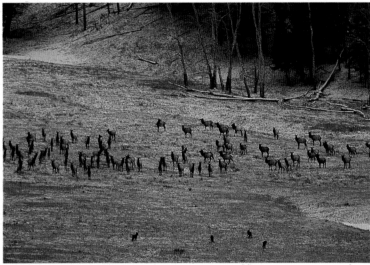

The pack is back. Four of the wolves reintroduced into Yellowstone in 1995 have the undivided attention of a herd of elk in the Lamar Valley.

Opposite:
Bull moose, Yellowstone
National Park

And it needs one. Elk and bison herds have increased in recent years. The park service is hard pressed to defend its policy of "natural regulation," as a series of warm, dry winters has not produced enough winterkill to thin the ungulate herds. Estimates vary as to how much effect wolves will have on elk and bison populations (some range as high as 30 percent), but they will no doubt play a part. It seems only reasonable that an ecosystem with all its parts will function better than one with major components missing.

But regardless of the outcome, the fact that reintroduction was accomplished at all is cause for optimism. As a society, we have moved to rectify a former mistake. In so doing we begin to operate under a different set of values, one that says we are part of this earth, but we do not control it.

Endangered species have always been considered the canary in the coal mine. It is a much-used analogy and an apt one. The thinning eggshells of ospreys and bald eagles were the exclamation point at the end of Rachel Carson's warning about pesticides in her landmark book, *Silent Spring*. We heeded that warning, and now the skies above waterways across the nation support the soaring silhouettes of both these magnificent birds. But what unknown human dangers have we also averted by changing our attitudes toward the mass applications of chemicals? The recovery of an endangered species may well be an additional benefit of the Endangered Species Act; the real profit will be measured in the time it buys us to figure out a better way to do things.

The wolf howls echoing across the vastness of Yellowstone are more than the call of the wild, they are a call to the future.

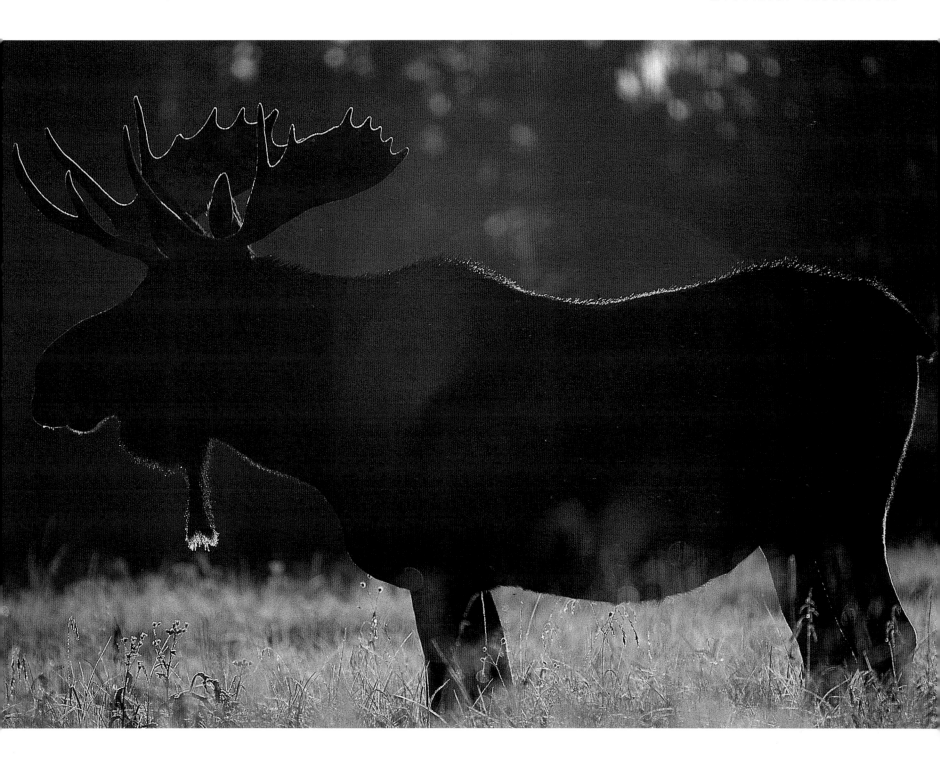

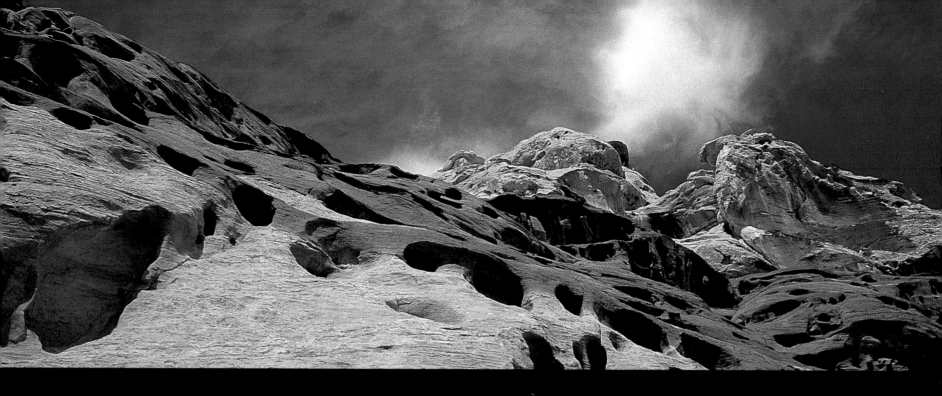

Mesas ~ The Colorado Plateau

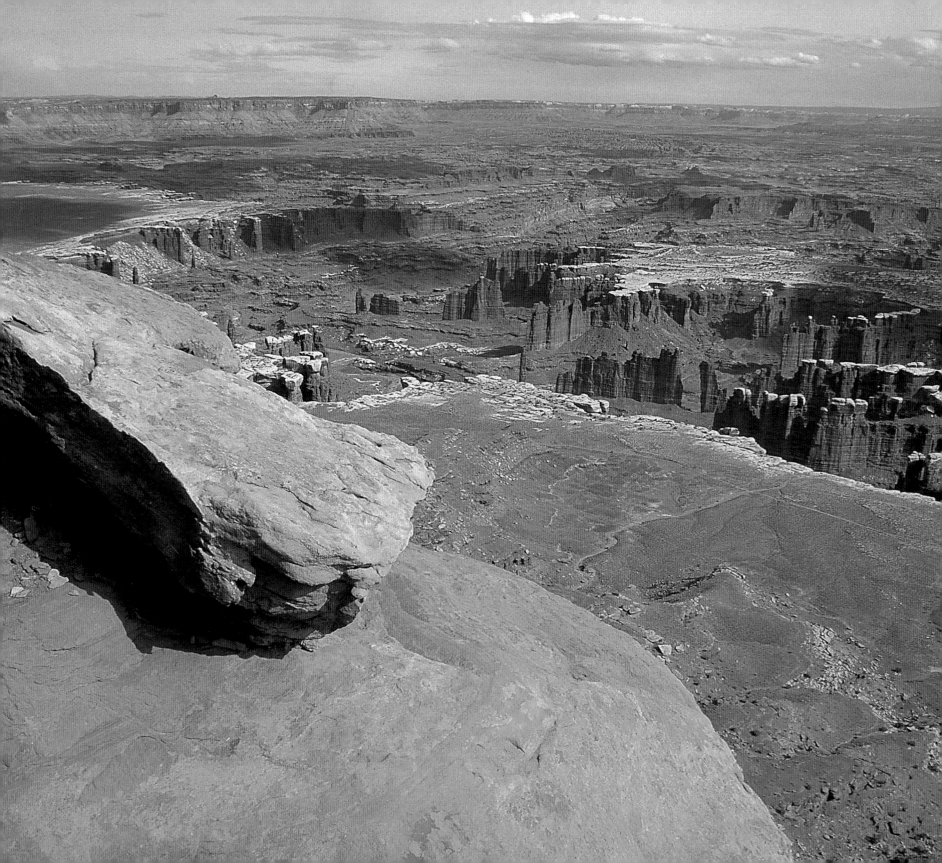

FOUNDATION: PALETTES OF STONE

In fifteen or so years of traveling and photographing the American West, we have seen many spectacular vistas and landscapes. By viewing other photographers' work, we have become familiar with many additional scenes. Indeed, photography of the American West is so prolific that few landscapes have not appeared in calendars or books. Given the subject, this is entirely justifiable, but the prevalence does sometimes make the spectacular seem less special. When we photograph a place for the first time, we often know what to expect, and even where to look for the "best" opportunities. The magic of discovery has become increasingly elusive.

Yet two exceptions stick out in my mind. Both were locations familiar from published photographs; yet, when I viewed them for the first time, I was stopped in my tracks and let out an amazed "Wow!" One was at Titcomb Basin in the Wind River Mountains; the other was at Delicate Arch on the Colorado Plateau.

Delicate Arch, in Arches National Park, Utah, has been photographed so often, its image almost seems ubiquitous now. Photographs of the arch appear everywhere, from calendars to postcards to book covers. The logo for the state of Utah, it is one of the most recognizable natural features in the West. But photographs can never do it justice. The main trail is about a mile and a half in length, long enough to let your mind wander while hiking. The arch pops up, without warning, from behind a fin of the Entrada Sandstone. Even after you blink, it remains in your vision. The sweep of the bowl in the foreground, the symmetry of the arch itself, and the stacked horizons leading to the La Sal Mountains in the distance epitomize the splendor of the Colorado Plateau. At sunset, the vision transcends spectacular and enters the realm of sublime. Don't miss it!

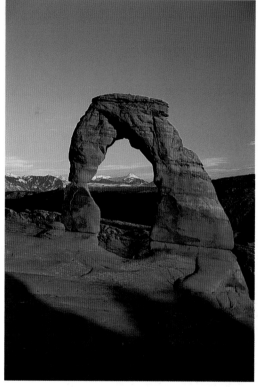

Although thousands of photographs and paintings of Delicate Arch have been published, nothing can prepare you for this most spectacular sight in the West.

Opposite:
Monument Basin in Canyonlands National Park. The heart of the Colorado Plateau, Canyonlands provides the true flavor of this wilderness of stone.

At any place on the globe a single element often dominates the visual experience. On the oceans, water commands your view. On the prairie, it is grass. Vegetation rules the jungles and forests. On the high peaks, it is ice and snow. In Denver and Phoenix, it is asphalt and glass. On the Colorado Plateau, it is rock.

Naked, unadorned rock is everywhere. It shows itself in mesas, spires, turrets, pinnacles, buttes, cliffs, arches, bridges, and other forms that defy naming. It dresses up in reds, browns, lavenders, grays, whites, greens, and pinks. Its appearance ranges from sharp and jagged to smooth and sensuous. It is the very skeleton of the earth.

Between the Great Basin on the west and the Rocky Mountains on the east, encompassing parts of Utah, Colorado, Arizona, and New Mexico, lies a region like no other on the planet.

ERA	AGE (IN MILLIONS OF YEARS)	IMPORTANT PROCESSES	WHEN ROCKS WERE FORMED	WHEN FEATURES WERE FORMED
CENOZOIC	Present	Vulcanism	San Francisco Peaks	San Francisco Peaks Grand Canyon
		Faulting		High Plateaus
		Regional uplift and canyon cutting		Grand Staircase Zion National Park Escalante Arches National Park Canyonlands National Park Bryce National Park
		Deposition in freshwater lakes	Bryce National Park	
		Magma intrusions	La Sal, Henry, and Abajo Mountains	
		Uplift, folding (Laramide Orogeny)	Capitol Reef National Park	
MESOZOIC	66	Deposition in shallow seas		
		Sand dunes	Arches National Park Zion National Park	
		Deposition in shallow seas		
		Pangaea breaks up	Canyonlands National Park Escalante	
PALEOZOIC	245	Pangaea forms	Canyonlands National Park Grand Canyon	
		Deposition in shallow seas		
PRECAMBRIAN	570	Deposition and erosion		
	2700	Metamorphism	Inner gorge of Grand Canyon	
	4500			

Geologic time scale for the Colorado Plateau

Nowhere else is the geologic chronology of the earth so exposed. While the rest of the West has gone through any number of geologic convolutions since the dim beginnings of the Precambrian Era, the Colorado Plateau has remained relatively intact. Upheavals of the earth's crust lapped at its edges, and volcanoes picked at its perimeter. Although these events affected the region to some degree, they had relatively little real impact. The story here is mainly one of deposition and erosion of sedimentary rock.

Even during Precambrian time, earth-forming processes were similar to those active today, and, like the Northern Rockies, the story of the Colorado Plateau begins with deposited sediment. For 3,000 million years, faulting created mountain ranges and erosion reduced them. Like Precambrian sediments farther north, pressure from above and heat from below transformed the older sediments into much harder schists, granites, and gneisses. Toward the end of the Precambrian, about 700 million years ago, a long period of erosion stripped away the softest of the existing rocks, leaving a nearly level surface of granite and schist. Today, these 3,100 million-year-old rocks are exposed in only a few places on the Colorado Plateau, as subsequent deposition of sediment for 570 million years has buried them under thousands of feet of sediment. Erosion has cut through that sediment pile only in the inner gorge of the Grand Canyon. Here, at an elevation of 2,400 feet, the exposed rocks are of similar age as those at 11,000 feet in the Teton, Beartooth, and Wind River mountains of the Northern Rockies.

Toward the end of Paleozoic time, about 250 million years ago, all the continents coalesced into one supercontinent, known as Pangaea. Drifting in from the northwest, North America was the last to join. Much of this gigantic land mass was located in the southern polar regions, and parts were covered by ice caps. Most of the remainder of the globe consisted of one huge ocean. North America was on the northern perimeter of Pangaea, and the equator passed through the future Colorado Plateau, making for steamy, tropical conditions. Pangaea only remained stationary until Mesozoic time, and then began to drift north.

The supercontinent was never one land mass, but rather a collection of continental plates loosely held together. As this conglomeration began its northward journey, two forces that would have a profound effect on the Colorado Plateau began to act on the region. First, as the plates jostled and bumped against each other, sections of their crusts would react by rising and descending. Raised areas would provide landscapes that were subject to erosion, while lowered areas provided depressions in which eroded material was deposited. Then, as Pangaea moved northward toward the equator, the climate warmed, melting the existing ice caps. Sea levels rose about 300 feet on shorelines around the world.

A continent the size of Pangaea could not remain intact for long, and the various continents began to break off and set sail for their present locations. North America broke away from Europe about 150 million years ago, and South America left Africa 25 million years after that. The plate supporting both North and South America moved to the west, eventually colliding with the Farallon Plate. In the intervening millennia, the earth's crust underwent many stresses, sea levels rose and fell, and coastlines changed. Throughout most of this time, western North America stayed within the tropics, and though the climate remained hot, it vacillated between

periods of dry and wet, mimicking changes that would be experienced on a trip around today's equator. This combination of shifting shorelines and alternating climates set the stage for the landscape that is today's Colorado Plateau.

But we're getting ahead in the story.

In six hours on the Grand Canyon's Bright Angel Trail, you can walk through nearly three billion years of rock history. From rim to river the descent is constant, and the geologic ages go by like pages in a book. From the buff tan of the Kaibab Limestone, which forms the rim, to the oasis of Indian Gardens at the base of the Redwall Limestone, to the twisted black mass of the Vishnu Schist in the inner gorge, almost half the entire geologic story of the earth passes before you.

The hike is not a "wilderness" experience. But it is an experience. After a three-day wait for an overnight permit at Phantom Ranch Campground, we shouldered our packs at dawn and started down. Four of us from Montana were on our way to Phoenix for a meeting, and took a couple of extra days to explore and hike the canyon. We were all experienced backpackers and thought we'd seen quite a bit along various trails over the years. But nothing like this. Between the rim and Indian Gardens, the trail is a moving mass of humanity. We felt as though we were reliving a forced march in the army. Looking at the scenery was out of the question, as you'd lose your place in line. The trail surface was like talcum powder. The temperature was ninety degrees. Among our hiking companions were: a guy carrying an infant in his arms; a woman in high heels; a jogger wearing shorts, tennis shoes, and a watch, and trying to run through the crowd; people carrying water in plastic garbage bags; people carrying no water; a platoon of marines; a guy who was so large that if he fell the mules couldn't pack him out; the obligatory suffering boy scout troop, and so on. We rested at Indian Gardens, sitting next to four guys who were dividing a watermelon (a watermelon!), and tried to put this into perspective. Bill hit it on the head: "This is like being at the mall."

Now, I'm not trying to be the elitist backpacker. I really enjoy seeing people using and appreciating the wilderness. Indeed, the more who enjoy it, the better chance it has of remaining wild. But most of these folks weren't prepared to be out of their car. (Except the marines, of course.) And this was just one day's example. I can only imagine the stories park rangers have after a full season.

At the beginning of the Paleozoic Era, more than 570 million years ago, the sequence of deposition that eventually built today's Colorado Plateau was launched. As the North American Plate was about to join Pangaea, the first of the shallow seas invaded the Plateau from the west

and remained for about 100 million years. For the next 120 million years, similar cycles of advancing and retreating seas were repeated across the landscape.

As Pangaea drifted north, toward the equator, its ice cap melted, increasing ocean depths worldwide. Concurrently, the region to the east of the Plateau began to rise, forming the Ancestral Rocky Mountains in what is now Colorado. This was the first edition of a series of spasms in the earth's crust known as the Uncompaghre Uplifts. Subsequent editions would occur seven times throughout the rest of geologic history and, as they eroded, they would add thousands of feet of sediment to the Plateau region. From the late Paleozoic to the late Mesozoic, a span of 150 million years, a cycle of advancing and retreating seas was repeated three times in the area that would become the Colorado Plateau. When the area was inundated, sediments washed down from uplands adjoining the Plateau and settled on the ocean floor. When the seas retreated, rivers carried sediment across a landscape of low relief. As the climate changed from humid to arid, sand blew into the region, forming great expanses of dunes, some up to 3,500 feet tall. The Navajo Sandstone, one of the most exposed rock formations on the Plateau today, is the result of this wind-deposited sand. When the climate once more became humid, rivers again flowed, and mudflats buried the coastal dunes, cementing the massive layer of Navajo Sandstone with minerals washed down from above.

Throughout this time, the landscape that would become today's Colorado Plateau bore very little resemblance to its present form. It was either underwater or a low-lying coastal region with very little relief. There were mountains to the east during the various editions of the Uncompaghre Uplift, but just as often the great mountain ranges were eroded to low hills. However, the foundation was being laid.

Early in the Mesozoic, more than 200 million years ago, a gap opened between the future continents of Africa and North America. This gap would become the Atlantic Ocean, and as it widened it set the North American Plate on a collision course with the Farallon Plate. As the plates ground together, compression caused the Sevier Mountains to rise west of the plateau region during late Mesozoic time, narrowing the present state of Utah by about sixty miles. Erosion began attacking these mountains, and for the first time, high country lay to the west of the future plateau and shallow seas invaded the region from the east. The result, though, was much the same. As the Sevier Mountains were reduced by erosion, the sedimentary layers that would become the Colorado Plateau thickened.

The last sea to inundate the plateau occurred towards the end of the Mesozoic, more than 130 million years ago, and this was the greatest of them all. The northward-moving remnants of southern Pangaea were losing their ice cap as they approached more temperate latitudes, and sea level rose 1,500 feet. The sea advanced from the southeast, and eventually extended well into Canada, where it connected with an arm of the Arctic Ocean. It remained in place, its shoreline intermittently rising and falling for 50 million years. The sediments making up its floor deeply buried all previous sediments. As this last of the great seas retreated at the very end of the Mesozoic Era, the slow grinding together of the North American and Pacific plates led to an era of mountain building throughout the North American West: the Laramide Orogeny.

To the north, the Beartooth and Wind River mountains rose along giant faults. To the west, the coast ranges were formed and the existing Sierra Nevada pushed even higher. To the east, the recurring Uncompaghre Uplift spawned the current version of the Rocky Mountains.

As the crow flies, less than a hundred miles separate the top of the Paunsaugunt Plateau in Utah from the bottom of the Grand Canyon in Arizona to the south. Here, the surface of the earth drops 8,600 feet and exposes rock that represents about half of geologic time. Much of that rock is sedimentary, originating in a series of ancient seas that ebbed and flowed across the landscape and in rivers and streams. As minute particles of sand and mud were washed into the oceans from surrounding mountains, they began to build up. If the oceans happened to be warm and shallow, the skeletons of tiny sea creatures formed thick deposits of calcium carbonate as the marine creatures died. When oceans retreated, rivers and streams criss-crossed the land, shedding mud and sand. Ever so slowly, a great pile of layered sediments formed, which hardened into sandstone, mudstone, and limestone, as pressure from the uppermost layers pushed down on the lower strata. The Grand Staircase, a series of cliffs that stairsteps northward from the North Rim of Grand Canyon National Park to Bryce Canyon National Park, exposes this stack of ancient sediments. The Vermilion Cliffs, White Cliffs, Grey Cliffs, and Pink Cliffs form bands of color in a stone rainbow—chapters in a book that took 250 million years to write.

Sedimentary rocks are generally deposited by water at the bottoms of seas and lakes. Unless altered by movements of the earth's crust, they remain in horizontal layers, such as these along the San Juan River in southeastern Utah.

During the late Mesozoic and early Paleozoic eras, as rising mountain ranges surrounded the region that was to become the Colorado Plateau, it too, was uplifted. But the vast amounts of energy released by the colliding plates, energy that built many of the great vistas of today's West, could not accomplish the same feats with the massive sedimentary pile. Instead of mountain ranges, faulting on the Plateau produced *monoclines* (layered folds), *anticlines* (upwarps) and *synclines* (downwarps) within the layers of sedimentary rock. In many ways these formations are just as dramatic as the larger mountains ranges that surround the region. Deep-seated shifts from beneath the Plateau rearranged portions of the static, flat-lying strata so that today you can look at rock that has been in place for 50 million years and visualize a landscape in motion. The heaving, upward arching sweep of the San Rafael Swell, west of Green River, Utah, and the waves of banded sandstone lapping up against the western edge of the Monument Upwarp, near Mexican Hat, Utah, speak eloquently of an active earth. Perhaps the most spectacular example of this motion is the Waterpocket Fold in Capitol Reef National Park. Stretching across central Utah for one hundred miles, the rocks flexed upward in a tight fold only a few miles wide. From the east, the layers dramatically rise from the flat valley floor, until they seem to break like a giant wave. Viewing it from below, on the graveled switchbacks of the Burr Trail, it takes only a little imagination to see it happen before your eyes.

Although salt water seas had vanished forever from the region by the start of the Cenozoic Era, around 65 million years ago, ephemeral freshwater lakes, some very large, filled depressions in the now-rolling highlands. Sediments deposited in these lakes make up some of the region's most colorful rocks, notably the fantastically eroded hoodoos of Bryce Canyon National Park and Cedar Breaks National Monument.

Volcanoes had erupted around the periphery of the Colorado Plateau for millions of years, mixing their ash and occasional lava flows with the sedimentary rock. About 50 million years ago, vulcanism began to make a more lasting impression. The colliding giants, the North American and Farallon plates, had trapped a few smaller plates between them. One plate moved under the other, and a process much like the formation of the Idaho Batholith ensued. Magma began rising toward the surface through fractures in the sedimentary pile, but did not break the surface in either batholiths or volcanoes. Instead, it remained in large pockets among the layers of sandstone. Above these magma intrusions, the surface layers arched upwards forming what are known on the Plateau as laccoliths.

The general trend of uplift that began in the early Cenozoic continued, eventually lifting the massive sediment pile over a mile in elevation in a process that continues today. Although faulting rearranged some of the crust in response to local stresses, the entire region rose pretty much intact, maintaining the chronological sequence of the rock layers. The Uncompahgre Uplift made its last two spurts, leaving the current ranges of the Colorado Rocky Mountains as a mountain barrier to the east of the now-in-place Colorado Plateau.

After millions of years of deposition and erosion, the stage had been set for the final geologic event that would allow the Colorado Plateau of today to emerge from tens of thousands of feet of sedimentary rock. The twin mountain-building forces—faulting and vulcanism—had assaulted the great sedimentary pile, but compared to their contribution to the landscape of the Northern Rockies, they made relatively little impression on the sedimentary layer cake. Instead, the forces of erosion would create most of the landscape we see today.

An increase of more than 5,000 feet of elevation brought with it a corresponding increase in precipitation. The beginnings of a river system had begun to form as the plateau region began rising, and now, fueled by the added runoff brought about the increasing elevation, a powerful perennial river began to meander across the gentle topography. Rivulets of water, formed by local undulations of the sandstone, began to cut grooves into the soft rock, as water flowed between depressions in the surface. The grooves became canyons, and the streams became rivers. Gradually the topography of the Plateau funneled the rivers into one: the Colorado River.

The shape of a river is determined by the balance between its slope and the sediment load it must carry. However, no matter what the combination of slope and sediment, a river will find the easiest way to carry its load across the landscape. On relatively flat terrain, such as the surface of the newly uplifted Colorado Plateau, the most efficient river is one that flows in great looping bends called meanders, covering a long distance to go a relatively short way. If the surface of the ground remains at the same elevation, and the river's sediment load is large, the river will periodically drop that load. On the Colorado Plateau, however, the land's surface

kept rising as the river was downcutting, trapping the river within a deep channel of solid stone. The Colorado River had no choice but to stay in that channel and carry its sediment load all the way to the Gulf of California.

And what a sediment load it was! The Colorado Plateau has been rising en masse since the Cenozoic Era, while the river downcuts at an equal pace. To date almost a mile of sediments has been stripped from the land's surface by river action. The younger sedimentary formations, those which formed at the bottom of the Cenozoic lakes, are today visible only on the higher reaches of the Plateau in places such as Bryce Canyon National Park. The floor of the last great

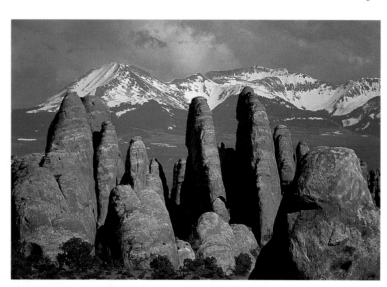

The laccolithic La Sal Mountains of east central Utah are volcanoes that never reached the surface. They are visible today because erosion has stripped away the overlying sandstone.

Opposite:
Granite Rapid in the Grand Canyon. In a geologic eyeblink, the Colorado cut through millions of years of sediments.

Mesozoic sea is gone from much of the Plateau's surface, with 100 million years of deposition being removed by less than 10 million years of erosion. Today, the same sediments that formed the last sea floor on the Colorado Plateau are at the bottom of the sediment pile beneath the Gulf of California.

Erosion also began uncovering the blisters on the earth's surface, beneath which lay the synclines, monoclines, and anticlines of the Laramide Orogeny. Also uncovered, as erosion worked its way through the sediment pile, were the subsurface magma intrusions of the early Cenozoic. The solidified magma was more resistant to erosion than the soft sandstone, and today the intrusions have been uncovered as the craggy La Sal, Henry, and Abajo mountains, as well as Navajo Mountain on the Utah–Arizona border.

Today, the heart of the Colorado Plateau exposes the rocks that were formed in the middle of geologic time. The 180 million years spanning the late Paleozoic (330 million years ago) to late Mesozoic (150 million years ago) has provided the mortar for much of central Utah. Subsequent erosion has produced the wonders of Arches, Canyonlands, Capitol Reef, and Zion national parks, as well as the spectacular canyons of the Escalante River.

About 15 million years ago a series of powerful faults uplifted portions of the western edge of the region, creating southern Utah's Paunsaugunt, Markagunt, and Aquarius plateaus. Still rising today, these highlands separate the Colorado Plateau from the Basin and Range Province to the west. As faulting progressed, fractures in the earth's crust allowed molten basalt to flow to the surface, burying the sedimentary formations. Much harder than the underlying sedimentary rocks, the basalt cap provided protection from subsequent erosion, allowing these plateaus to remain at a higher elevation.

As the Colorado River carved its way south into present-day Arizona, it did not make the sharp turn to the west and flow through the Grand Canyon, as it does today. For that course did not yet exist. As with the Yellowstone country of the Northern Rockies, nature was saving the best for last.

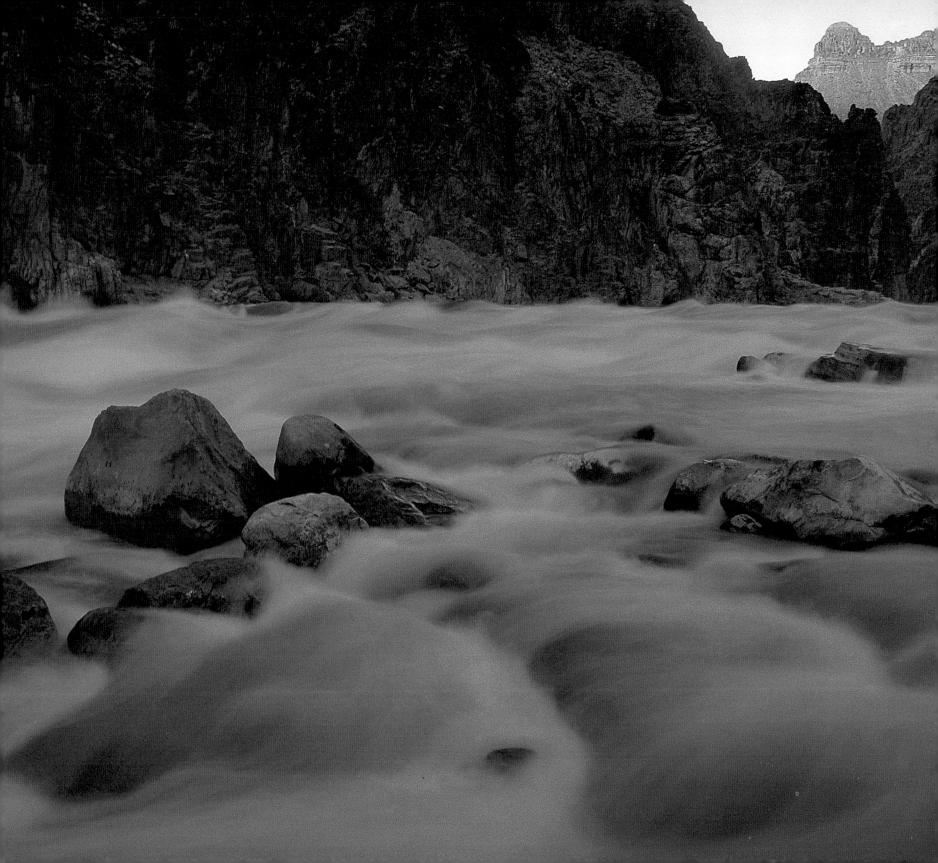

There is still some doubt as to the sequence of events that led to the Grand Canyon, but the most widely accepted theory holds that the original version of the Colorado River flowed south along the east face of the Kaibab Upwarp. This massive bulge prevented any westward turn of the river. However, another river system was flowing along the west flank of the upwarp, at a lower elevation than the Colorado. A tributary to that system began eating its way eastward across the Kaibab Upwarp, much as a gully extends up a hillside. Inevitably, the two systems met. The smaller tributary "captured" the entire flow of the Colorado, and the mighty river, draining much of the central Rocky Mountains, began flowing westward. It had a lot of elevation to lose, and a short distance in which to lose it. No time for meanders here—the Grand Canyon formed in a geologic eyeblink. The deposition of 320 million years was cut through in just a few million years, as the Colorado became a hydraulic buzz saw.

I had waited a long time to photograph the Grand Canyon. Now as I approached the South Rim in the perceived light of predawn, prior to what promised to be a cloudless sunrise, I was thinking of glowing red rock and slanting rays of light. Boy, was I disappointed!

The sun rose in a murky haze, diffused behind a blanket of brownish smog. Normally blinding, the sun could be stared at directly without squinting. Weak light filtered through the haze onto canyon walls. But instead of deep reds and oranges, the colors were pale and washed out. The stacked horizons of buttes and mesas within the canyon, normally sharp distinctions of tone and shadow, were fuzzy and blurred. I had heard about the air pollution problems at the Grand Canyon, but seeing it firsthand was a jolt.

I mechanically shot a few rolls of film, but the joy had vanished. Instead of shooting pictures, I wanted to shoot something more tangible: slimy politicians, greedy utility company officials, wimpy park service bureaucrats, anybody who might be responsible for this violation! All the people I've named are guilty. Yet, to some degree, the responsibility also belongs to the rest of us. The Grand Canyon lies, as much as is possible today, in the middle of nowhere, a three-hour drive through relatively empty high desert from any direction. Yet, the exhaust emissions from Los Angeles and Phoenix are filling it from rim to rim. The electricity that cools the Southwest and drives the pumps that waste its water is produced in the coal-fired generating plants at Page, Arizona, and Four Corners, New Mexico. The gaseous excrement from those plants mingles with the airborne particles from Phoenix to defile the views at the Grand Canyon. But, when we visit the Southwest, we generally drive, and when we're there it's nice to step into an air-conditioned building. And in so doing, we all pick up a little of the responsibility for the murky sunrises. How many of us realize that? Today's society needs to know the effects of its lifestyle and how far-reaching it is. Only then can society make a decision to change.

As a kid in the fifties, I remember flying into Los Angeles. I can still see hilltops and buildings sticking out of the dirty, opaque blanket, only then becoming known as smog. I remember being aware of how extensive it was, but I doubt I thought about where it would all end up. Now I know.

The Grand Canyon continued to form during the great Pleistocene Ice Age. Evidence that the colder, wetter climate allowed some glaciers to form on the highest elevations of the plateau has recently been uncovered at Brian Head, Zion National Park's Kolob Canyons, and Cedar Breaks National Monument—all in southern Utah. More importantly, glaciers also formed in the mountain ranges surrounding the Colorado Plateau—the same mountain ranges that contained the headwaters of the Colorado River. As the glaciers retreated, more water fueled the downcutting river, and the Grand Canyon grew at an even faster rate. It sliced through the easily erodible layers of the late Paleozoic and came into contact with the much harder Precambrian granites and schists. Here erosion slowed, but the rock that formed in the distant Precambrian past had once again been exposed.

It remained only for vulcanism to write the most current chapter in the story of the Colorado Plateau. The lava flows that capped the upthrusted plateaus along the western edge of the region 15 million years ago were accompanied by similar flows south of the Grand Canyon. However, it has only been in the last four million years that the forces of Vulcan have left their most distinctive mark on the landscape. North and west of Flagstaff, Arizona, the San Francisco volcanic field has created a number of distinctive volcanic peaks. The largest, most recent, and most spectacular of these is San Francisco Mountain. Once a classic, cone-shaped *stratovolcano* in the mold of Oregon's Mount Hood or the former Mount St. Helens, massive eruptions caused a collapse of its summit. Now, after smoothing by Pleistocene glaciers, it is a series of peaks, the largest of which, Mount Humphreys, at 12,633 feet is Arizona's highest point.

As recently as a million years ago, a series of lava flows cascaded to the Colorado River from the Grand Canyon's North Rim. Effectively damming the river, they created huge lakes that extended upstream for most of the length of today's canyon. The river eventually breached the dams, and erosion began to level the river's gradient. Today, the roar of Lava Falls, dropping thirty-seven feet in two hundred yards, offers spectacular evidence that this leveling process is still going on.

After sixteen days on the river everyone was a little cocky. We were veterans now, having survived the upstream tests of more than one hundred and fifty rapids. The rock garden at Hance, the stomach-dropping elevator ride at Hermit, and the seething maelstrom at Crystal had tempered and hardened us. But one test remained. Like the calculus final at semester's end, Lava Falls sits in the back of your mind from the day the permit arrives in the mail.

Scouting the rapid quickly dispels the scant solace derived from the obligatory touching, "for luck," of Vulcan's Throne (a huge chunk of lava sitting in the river some distance upstream). Most of the rapids on the river provide a line, a glassy tongue of water that is the key to unlocking the route. Lava is not so accommodating. It is a steep sheet of whitewater from bank to bank. The left side is a rock garden, the middle has a gaping ledge "hole" at the top, and the right side offers a large boulder at the bottom. Some choice.

Our route decided on, we head back to the boats. The approach is long, flat, and blind. It seems to take a week to get in position. The rising spray and ever-growing roar fill our world. Finally we reach the lip of the rapid. The ledge hole slides by on our left as we drop into a trough and rise over a large standing wave. We have to keep momentum or we'll stall and flip. Another wave crashes over us as we power through it. A lateral wave slams us from the side. We sink into another trough, faced by a foam-crested liquid haystack. Rising, we power through this one too—and are face-to-face with the black lava boulder. Left oar! Just in time, and we safely ride the cushion of water spilling off the rock. The boulder quickly disappears astern.

The roar of twenty thousand cubic feet of water falling thirty-seven feet still fills the canyon. But somehow it is now less threatening.

Like the earth's surface everywhere, the Colorado Plateau is a work in progress. Beginning about a thousand years ago, a series of eruptions in the San Francisco Volcanic Field formed more than 400 cinder cones. The most prominent of these, Sunset Crater Volcano, erupted for more than one hundred years, reaching a height of a thousand feet and spreading cinders over a 120-square-mile area. In 1992, an earthquake measuring 5.8 on the Richter scale occurred near Zion National Park in Utah, causing a landslide that moved 18 million cubic feet of material. In the spring of 1995, another landslide blocked the Virgin River and covered the road that accesses Zion Canyon. Across the Colorado Plateau, on a smaller scale, rock continues to fall, flash floods alter stream channels, frost widens cracks in sandstone cliffs, and the wind picks up sand grains wherever it finds them. What will the Plateaus look like tomorrow?

~ ~ ~

Ask any first-time visitor to the Colorado Plateau what their dominant impression is, and the answer is likely to be one word: COLOR. To someone from another part of the planet, where skies are overcast, rocks are gray, and vegetation is a muted green, the colors of the Plateau are likely to be overwhelming. Only the fall spectacle of the hardwood forests is its equal. The sky arching across the horizons is a brilliant cobalt blue. But blue skies can be found elsewhere in the West. The color spectacle here is rock.

Chamber of Commerce brochures announce that you are entering "Color Country," and "Red Rock Country" is a common appellation for the entire Plateau. Names on the map underscore those claims: Vermilion Cliffs, Pink Cliffs, Roan Cliffs, Black Mesa, White Rim, Lavender Canyon, Great White Throne, Redwall Limestone. There is even a Kodachrome Basin.

The various hues that make up this rock rainbow are the result of a process called oxidization. This simple chemical reaction between minerals in the rock and the atmosphere forms a thin stain on each particle of stone and, in so doing, has colored the entire region. The dominant mineral in a rock determines the color of the stain: manganese produces black and lavender stains; copper results in green ones; and carbon, black ones. But the most abundant mineral in the sandstones of the Colorado Plateau is iron, and the dominant colors it produces are red and yellow.

That the endless repetition of a seemingly mundane process could produce the stunning rock palettes of the Colorado Plateau can best be appreciated from any of the overlooks that are scattered around the region. Spend a day at Dead Horse Point State Park or Grandview Point in nearby Canyonlands National Park, the Burr Trail in Capitol Reef National Park, or at one of the rims of the Grand Canyon. Watch the interplay between light and rock, the symphony of color played on instruments of stone: the dark red of the Moenkopi Formation, the pinky-beige and buff of the Navajo Sandstone, the pink of the Claron Formation, the gray of the Mancos Shale, the striking red of the Entrada Sandstone. Each formation has its signature hue. But even within a formation, the color is never constant. It changes, depending on the angle and intensity of light. At midday, most are dull, washed out, and flat. But at sunrise and sunset, they seem to have an inner fire. It is then, when the sun's rays are low and the shadows long, that the colors that define the Colorado Plateau bring the entire landscape to life.

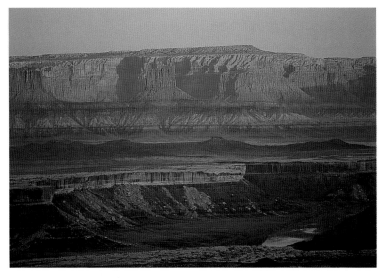

The rock rainbow of Canyonlands National Park

Arches, windows, turrets, mesas, hoodoos, goblins, spires, castles. The easily eroded plateau rocks produce an indescribable variety of form and shape. Like snowflakes, no two are the same. The endless variability of exposure, resistance to erosion, and physical properties of rock have allowed water and wind to transform the Colorado Plateau into an intricate rock garden covering thousands of square miles. If color elicits wonder, form stimulates imagination. The names of rock formations speak to the skill of the wind, rain, and frost: Angel Arch, the Parade of Elephants, Lizard Rock, the Totem Pole, Thor's Hammer, Druid Arch, the Golden Throne, Fairyland Castle.

Cliffs are the most dominant visual form on the Colorado Plateau. At the lowest elevations they entrap rivers, while at the highest they support the caprock of the plateaus. A form that repeats itself so often is obviously structurally sound. Most cliffs are vertical by necessity; overhanging rock would succumb to gravity, while laid-back slopes would disappear as a result of

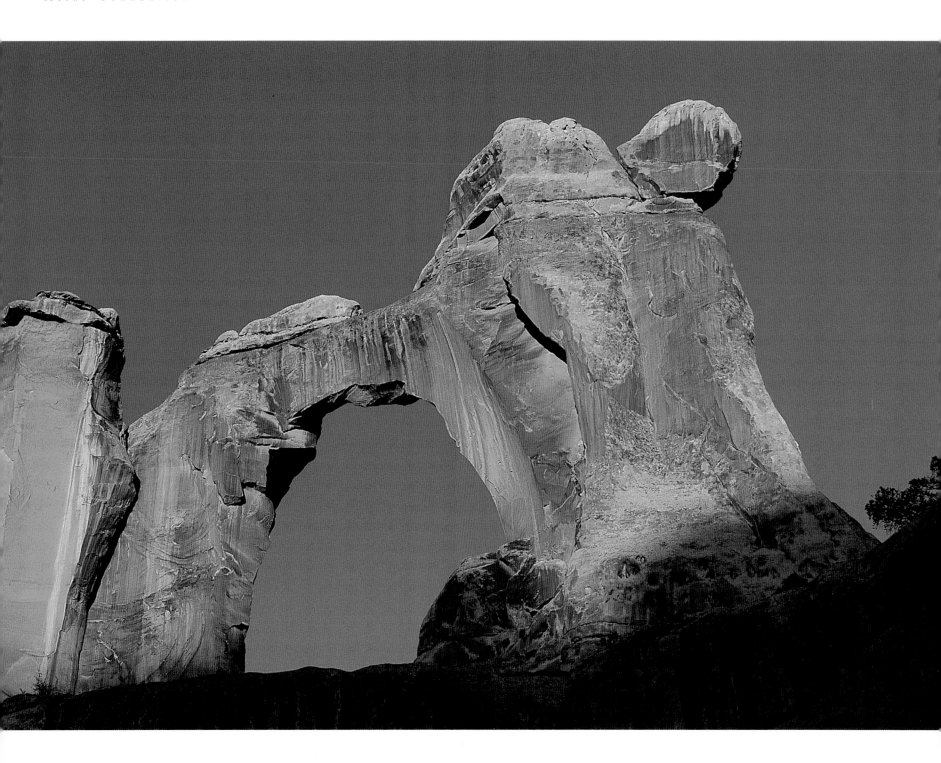

erosion. Cliffs are also harder than the materials beneath them, a factor that allows them to maintain their stable shape, while at the same time contributing to their eventual disappearance. As soft material at the base of a cliff is eroded by a combination of frost, water, and wind, the harder rock above is undercut, thereby losing its support. Vertical cracks, resulting from either faulting or erosion (or both), form in the rock behind the cliff face, providing areas of weakness. Gravity does the rest. Columns of rock are pulled off the face of the cliff to collect in huge rock piles below. Little by little the cliff retreats, and the valley becomes wider. The magnificent cliffs of Navajo Sandstone in Zion National Park are a result of this unique combination of faulting, erosion, and undercutting. On a larger scale, the Grand Staircase, which contains Zion in one of its middle steps, is a series of distinctive cliff bands, from the Brown Cliffs of the North Rim of the Grand Canyon, to the Pink Cliffs at the top of the Paunsaugunt Plateau. Rock type also plays a part in the shape of the cliff. Sandstone forms tall, vertical cliffs, while the mudstones, siltstones, and limestones form a shorter, stair-stepped cliff.

Massive cliffs, such as West Temple in Zion National Park, Utah, dominate much of the Colorado Plateau.

Opposite:
Angel Arch is an aptly named formation in Canyonlands National Park, Utah.

Thrusting upward from pedestalled bases, curving into the sky, natural arches lend an architectural flavor to the region. These stone spans are easily the most striking creation of the elements. Whether it's the thin slab of Landscape Arch, the massive columns of Druid Arch, or the interlocking rings of Double Arch, the random interactions that conspired to produce a particular formation at a specific location defies calculation.

The formation of an arch requires many steps, each dependent on the one preceding it. Initially, a body of rock, perhaps a cliff, is stressed to the point that a number of vertical cracks, or *joints,* form within it. The joints are widened through erosion by groundwater or frost, until the cracks become quite large. If the joints were closely spaced initially, as they widen, they leave a thin wall of rock, known as a fin, remaining between them. Frost begins to act on the fin, and if its weak points are near the center, frost erosion will eventually eat through from both sides, creating a hole. Wind now acts in conjunction with frost, and the hole is enlarged. When the hole becomes almost as big as the fin, an arch results.

Arches occur across the Plateau, but in Arches National Park, localized jointing of the Entrada Sandstone has created more than 2,000 known arches in a relatively small area. Elsewhere, the right combination of events has occurred in dozens of scattered locations. Most are remote, tucked away in a hidden canyon, appearing when least expected. How many exist that have not yet been discovered? How many are even now being formed?

Erosion creates many forms. Cliffs are blocky and solid, giving a feeling of permanence, of straight lines and square corners. Arches are curving and graceful, ethereal, impermanent even in this world of stone. Hoodoos, on the other hand, defy description. Other than being taller than they are wide, they have no specific shape. Their lines can either be curved or straight,

their faces smooth or knobby. Some become narrower as they get taller, only to flare into a bulbous helmet that mocks gravity. Others form solid pedestals, seemingly as resistant to erosion as the cliffs themselves.

Hoodoos are the result of differential erosion. Even though a given sedimentary rock formation was laid down over the same time period, by the same process, and is often made up of the same material, there are differences within that formation as to the strength of the minerals that cement individual grains of stone. Areas that are weakly cemented will be the first to erode, while those that are tightly cemented will resist erosion. Hoodoos represent the most tightly cemented portions of a formation—everything around them has been stripped away. Consequently, they now stand alone, often, such as in the Standing Rocks area of the Maze in Canyonlands National Park, separated by great distances from any other rock of the same formation. In other places, such as at Bryce Canyon, they are in tightly packed formations, like soldiers marching down from the canyon's rim. Eventually, they will crumble, and the once towering spires will become just another collection of boulders on the ground.

Nowhere else on the continent can we realize such an intimate relationship with the rock that is the skeleton of the earth than on the Colorado Plateau. Shorn of the cloaking vegetation and ice of other climes, the Colorado Plateau stands naked for our inspection and wonder. To some people who pass through the region, pausing briefly to stand at an overlook before speeding on, it may seem like an inhospitable, forbidding collection of rock and sand. But for those who have taken the time to wander among its walls, drink from its potholes and seeps, and float its arterial rivers, the plateau becomes not the bones of the earth, but its marrow. The heat given off by sun-warmed rock after twilight, the rush of cool air at the mouth of a slot canyon, the pulsating inner light of the rocks at sunset are all physical reactions, easily explained by the laws of physics. But they also speak to us on a different plane, one that requires intuition and instinct rather than knowledge. It is on that plane that we become one with the earth, part of it rather than a tenant on it. The rocks of the Colorado Plateau speak to us on that plane. They have much to say. But first we must learn to listen.

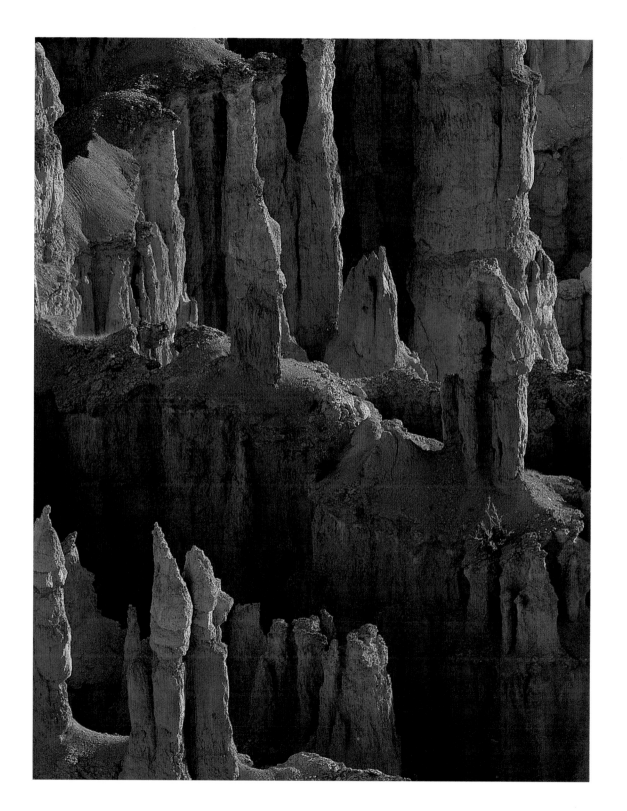

The hoodoos of Bryce Canyon in southwestern Utah. Located at the top of the Grand Staircase, these are some of the youngest and softest rock formations on the Colorado Plateau. Water, wind, and frost have combined to wear away the least resistant rock, leaving the slender hoodoos.

LIFEBLOOD: THE SCULPTOR

Backpacking in the desert is a pain. Like every other living thing there, you need water, but unlike every other living thing, you haven't had many thousands of years to develop mechanisms to locate or conserve it. So you carry it. Lots of it. You sacrifice items that you normally take, such as tents and clothes, so that you can carry more water. And you never carry enough. No matter how much you have, it's always in the back of your mind that you'll need more. Perversely, the prospect of running out makes you thirstier. Every sip is rationed, every guilt-ridden gulp regretted.

We were on the third day of a backpack trip in the Druid Arch area of the Needles District in Canyonlands National Park. The trip had been wonderful—three days among the sandstone castles, slot canyons, and narrow trails. But our empty water bottles were starting to outnumber the full ones, and the dryness in our throats was a constant companion. We camped that night in the center of Chesler Park, surrounded by the pinnacles and hoodoos of the Cedar Mesa Sandstone. Rationing our dwindling water supply through dinner, we talked of how many more days we could stay.

I climbed an unimposing muffin of sandstone to look for photo possibilities—and almost fell into a pothole filled with pure, clean, unevaporated water. It was like winning the lottery. No sipping now. We guzzled until we bloated, and even moved our sleeping bags on top of the rock so we could get up and drink at night. Though the desert is mostly harsh and uncompromising, it sometimes throws you a bone!

It would take little effort to convince drive-through summer visitors to the Colorado Plateau that they are traversing a desert. Warm temperatures, low rainfall, sparse vegetation, and clear skies would suggest that conclusion. Yet, just as the climate of the Northern Rockies leads one to believe there is more precipitation, the parched appearance and lack of vegetation of the Plateau creates the impression of less.

The Plateau is part of a series of deserts that extends from central Mexico into southeastern Oregon. The dryness of these deserts varies, depending on elevation and surrounding topography. The Colorado Plateau, thanks to the rising of the earth's surface for the last 25 million years, just happens to be a little higher than its neighbors. This enables it to gather marginally more precipitation than the Great Basin Desert to the west, and substantially more than the Mojave Desert to the southwest and the Sonoran and Chihuahuan deserts to the south. Therefore, only about a quarter of the Plateau's 130,000 square miles receives less than ten inches of annual precipitation, the thirsty threshold beneath which true deserts lie. Precipitation from the small towns that dot the Plateau bear this out. Monticello, Utah, at 6,800 feet, gets 14.4 inches per year; Escalante, Utah, and Cedar City, Utah, both at 5,800 feet, get 10.5 inches and

10.3 inches, respectively. These towns are not at the highest elevations, so some areas get considerably more. In the heart of southeastern Utah's canyons, however, Moab (4,000 feet) receives but 8 inches annually, and Hanksville (4,350 feet) only 5.2 inches. So officially, the Colorado Plateau is considered semidesert.

Unofficially, though, when you empty your last water bottle five miles from the trailhead, or when the noonday sun radiating from the Navajo Sandstone "slickrock" raises the temperature in your boots to about 120 degrees, or when a tarantula scurries out from behind the rock from which you just removed your hand, the difference between eight inches and twelve inches of annual precipitation becomes rather remote. The Colorado Plateau feels like desert. Period!

Just far enough north to get the westerly flow of winter weather systems off the Pacific, and just far enough west to be in the path of summer storms from the Gulf of Mexico, the Plateau's limited precipitation is both seasonal and sporadic. The rain shadow of the Sierra Nevada falls over the Great Basin and extends eastward to the edge of Canyon Country. But as the air masses rise to clear the Plateau's higher elevation, condensation wrings some moisture out of them. In the winter, when this east-flowing air interacts with arctic air coming down from Canada, precipitation often occurs as snow. Most of the weather stations on the Plateau record snow every month from October to May. From these storms, the hoodoos, spires, and mesas acquire an application of frosting, standing out like figures on a surrealistic wedding cake.

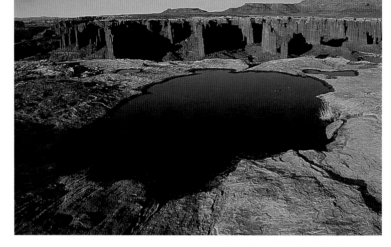

In Canyonlands National Park, a welcome find: the desert pothole.

I seem to have a knack for scheduling trips to the desert at the same time as one of the winter frontal systems moves in from the west. Instead of blue skies and red rocks, I experience a couple of days of low, dirty gray clouds and spitting rain.

One Thanksgiving, a couple of friends and I started out for a day hike into Upheaval Dome in the Island in the Sky District of Canyonlands National Park. The sky was streaked with different shades of gray, and the only reason we knew the temperature wasn't freezing was that the rain hadn't turned to snow. Nice day.

Upheaval Dome is a giant crater, the origins of which are still somewhat murky, with the most plausible explanation being that it was formed by rising salt layers displacing sedimentary rock above them. Another theory holds that it is a crater formed by a meteor that didn't completely burn up in the atmosphere. From the rim of the crater neither explanation is readily obvious. To me the area looked like a jumbled mass of broken, twisted rock that had been dumped in a hole. We headed in.

An intermittent rain fell as we worked our way down over sandstone ledges and along water-carved gullies. By midday we were in the bottom of the crater. Slabs of sandstone tilted all around us, as the normally flat layers stood on end. The entire "floor" of Upheaval Dome looks to be in frozen turmoil, and there is virtually no flat ground. We continued hiking up narrow, V-shaped gullies to the far end of the crater.

The rain increased its tempo and, with lunch gone, the long walk back the way we had come was not a pleasant prospect. We eyed the canyon rim, three hundred feet above us. If we climbed out, we would be perhaps a half-mile from the trailhead. If we backtracked, we'd be three miles from it. The climb looked possible, and we were soaked. Up we went.

About two-thirds of the way, we encountered a sandstone slab that angled away from us for about thirty feet. We would have to cross it because other routes were too steep. If it had been dry, the slab would have been a snap, but now, covered with a thin sheen of cold, running water, it was lethal. We hesitated, then finally started up, inching along on imaginary toeholds. Kerry, in front, fell. I can still see him sliding by me, feet in the air, arms splayed in a vain effort to slow down, until he thumped into the sand at the bottom of the slab. They don't call this stuff "slickrock" for nothing! Paul and I gingerly turned around and crept back. The light started fading, but the rain didn't. Shivering from lack of movement, we knew we'd have to start back down. We picked our way to the drainage at the bottom of the crater, which by now was starting to flow with a considerable amount of water. Hurrying, we sloshed downstream.

Now near dark, the water was rising, we were wet, and we didn't know where the trail was. We found a dry spot under an overhang and got as snug as possible, preparing for a long night. Gloomily, we shared the last of a squeeze tube of peanut butter.

To make a long story short, the rain stopped, and soon a full moon cast its ivory light across the sandstone. We decided to make a slow hike back through a surreal black-and-white landscape; anything seemed better than shivering under that ledge until morning. We finally reached the truck a little after midnight.

Among the many lessons we learned was that even in the desert, you can't always count on the sun.

In summer, the Plateau doesn't depend on outside weather systems to send it precipitation. Instead, it makes its own. Each morning the sun rises in a cloudless sky. As it arcs upward, the thousands of square miles of rock beneath its unrelenting glare begin to heat up. The rock radiates heat into the atmosphere, creating rising cells of warm air. When the cells rise high enough, they cool, and the resulting condensation forms puffy, cumulus clouds. The clouds

expand geometrically, filling the sky with mushrooming white towers. As these cloud towers gain enough altitude, strong winds shear off their tops, causing them, incongruously, to resemble anvils floating around the heavens. The wind turbulence within the clouds is extreme. As the condensed particles get heavy, downdrafts hurl them at the ground. The intensity of the resulting storm is awesome. Viewed from afar, a desert thunderstorm is merely entertaining. To be caught in one is all-absorbing! The late afternoon sky darkens as clouds close over the sun. Thunder rumbles distantly at first, but the volume grows and reverberates acoustically, as if someone had turned up the bass. Flashes of light explode for searing seconds. Lonely drops of rain spatter the slickrock at wide intervals. They are the precursor of the deluge that is already on the way down. It strikes suddenly and violently, tearing away particles of rock and splattering loose sand. Yet its fury lasts for only minutes, then slackens to a shower. The storm cell moves on. For a too-short interval the desert retains a humid, vegetative aroma, with traces of brimstone. Then sunlight fills the gap, shafts at first, spotting the wet, red sandstone. The sky again becomes cobalt blue. In an hour, there's no trace of the deluge.

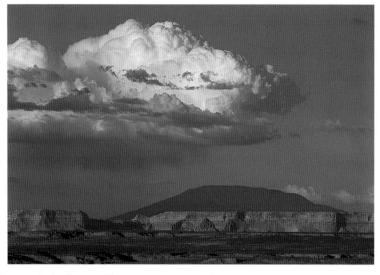

A mid-afternoon thunderhead shades Navajo Mountain on the Utah-Arizona border. Hot air rising off the rocks creates many storms during the summer months.

Unless you happen to be downstream! Hydrologists call the phenomenon "time of concentration": the interval it takes water from a storm to to reach the nearest steams. If intense storms fall on forests, the combination of vegetation and soil breaks up raindrop impact and absorbs most of the water. Streams may rise somewhat, but the time of concentration, if measurable, is generally several hours. Not so on the slickrock. The sparse vegetation and shallow soils cannot perform the same function as vegetation and soil perform in the forest. Sandstone absorbs water about as well as a parking lot, and the time of concentration is measured in minutes. Streams appear where previously there were only dry, sandy washes and gullies. Actually, *stream* is not a descriptive enough term. *Torrent* is much more apt. If the storm is intense enough, and falls in the right place, a seething, thrashing, devouring wall of water careens down dry streambeds. Erosion is massive because the sandy banks are virtually unprotected. If the water can sustain itself, it reaches the widely scattered rivers. If not, the front of the flood loses energy soaks into the ground, and leaves little trace of its passing.

The handmaiden of low precipitation is high evaporation. Hot temperatures, low humidity, and clear skies all combine to suck what moisture there is out of whatever is holding it. When vegetation dies, it almost immediately becomes dry and brittle, desiccated by the atmosphere alone. Evaporation is so great that it even affects falling water. Many clouds release rain, only to have it evaporate on the way down, in a phenomenon known as *virga*. On many afternoons these drifting veils of almost-rain can be seen floating above the slickrock, making a vain attempt to reach the ground.

Just as frost and wind generate a distinctive set of features on the Plateau's surface, so does water. Over the years water has been the dominant force in producing today's landscape. Each snowfall, each rainstorm, changes the land's appearance. Each gallon of moving water is responsible for the readjustment of a little more of the stone skin of the earth.

The most prevalent of the water-formed features are canyons, created by water cutting into rock. The amount of water and the hardness of the rock interact to determine the size and shape of a canyon. Smaller canyons, those formed in the headwaters of river systems, generally exist in only one rock formation. If that formation is hard, the canyon will be narrow and steep sided. If the sandstone is soft, the canyon will be V-shaped. As streams become rivers, the canyons are cut deeper, and intersect different rock formations. The step-sided shape of the Grand Canyon is caused by alternating layers of hard and soft rock. As the Colorado cuts deeper into the sediment pile, the formations it has bypassed become susceptible to cliff-forming processes. The vertical cliffs are the harder rocks and retreat away from the river as the softer rock layers erode beneath them. Tributary streams attempt to keep up with the rapidly downcutting Colorado River, creating mini-canyons leading away from the river. Gradually, the Grand Canyon widens as it deepens.

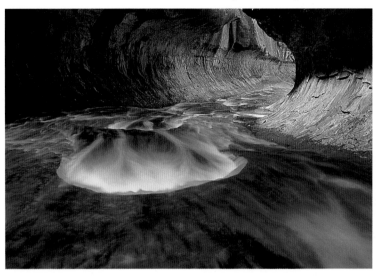

A water-carved canyon, Zion National Park

Perhaps no product of desert erosion is more interesting, or more enchanting, than slot canyons. When the first waters flowed across the almost flat expanses of slickrock, the hard sandstone forced them to cut vertically much faster than horizontally, leading to deep, narrow slits in the rock. Successive storms contributed to this pattern, and today there are many areas on the Plateau where the only evidence of flowing water is the narrow, deep, sand-bottomed canyons slashed across the rock. From inside one of these slits, it is easy to see the signature of running water. The walls are smooth and scalloped, tracings of surging waves being deflected from wall to wall. Periodically, overhead, sometimes thirty feet above the floor, are cottonwood logs wedged horizontally between the walls, dangling small twigs, and other bits of flotsam. It does not take much imagination to figure out how they got there.

The instantaneous coolness hits you first, like diving into a pool on a hot day. And it is even more refreshing. Chances are, the dive was made from a pool deck where you'd been lounging in the warm sun, a tall cool one not far from your hand. When you enter a slot canyon, it's after a long walk in the sand and heat, carrying tepid water in a plastic bottle. Believe me, the canyon is a lot more refreshing.

Darkness is the next impression. The blinding light bouncing off desert rock will have shrunk your pupils to pinpricks. Just like when you enter a tunnel ride at an amusement

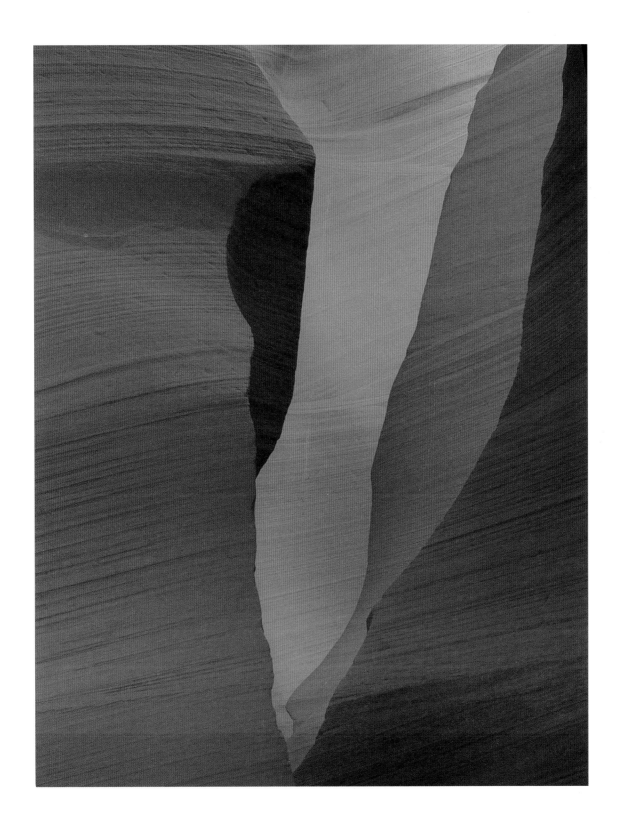

The kaleidoscope of light inside a
slot canyon in northern Arizona's
Antelope Canyon

park, your eyes need a few seconds to adjust to the deep shadows. But when they do, the narrow scope of your vision registers something magical.

The walls of slot canyons often appear to close overhead, shutting out the sky. Light enters these depths only as reflected shafts, bouncing among the smooth, angled planes on the walls. The intensity of light is softened by depth, and a vertical rainbow of warm colors cascades from above. When the sun is at its zenith, there is a never-ending kaleidoscope of reds, yellows, and oranges, as the descending light bounces off angled planes of rock.

Peekaboo. Spooky. Brimstone. Three slot canyons within a mile of each other in the twisted tributary canyons of Utah's Escalante River. Each is different, an individual product of random storms and the varying resistance of sandstone. Peekaboo is the most open. And after the initial climb in, you can walk through most of it, except for the part where you squeeze through a hole about the diameter of a garbage can. Spooky is narrow and short, with sandstone nubbins pimpling the walls. But Brimstone is the most intriguing. It's long, deep, and dark. Even at noon, only a faint, pale light filters down from above. Forward movement is sideways only, and only then with a gut-sucking, crablike motion. Weight Watcher dropouts need not enter. There are a couple of wide spots, but the slot finally disappears into solid rock.

Slots come in many sizes. Some require ropes for passage, and others require swimming. The challenges, and the experiences, are among the most interesting and rewarding in the desert.

On the Colorado Plateau water must flow across either rock or sand, as it makes its way toward distant rivers. As might be expected, soft sand creates stream channels that are the exact opposite of the slot canyons formed in harder sandstone. Arroyos are wide, flat-bottomed channels where the water spreads out and unleashes its energy on the banks rather than the bed of the stream. Arroyo beds are generally layers of gravel, while their banks are almost pure sand. Water, taking the path of least resistance, finds it easier to erode the sandy banks than the gravel beds, so the resulting channels are wide and shallow and known as washes. There are a number of places on the Plateau where water flowing in a broad arroyo encounters a band of sandstone. The flat, sandy channel is immediately transformed into a narrow slot canyon for the length of the harder rock, only to become an arroyo once again when the water encounters stream banks of sand.

But no matter the shape of the channel or the source of the water, all streams on the Colorado Plateau have only one destination.

The rivers of the Northern Rockies vary in size, direction, and personality. They are formed by the merger of countless snowmelt rivulets into frothing mountain streams. West of the Continental Divide they are large and flow steeply through vegetated V-shaped valleys to the Pacific Ocean. To the east they are smaller, meandering across the high, open plains on

their way to the Gulf of Mexico. On the Colorado Plateau, there is no such variety of rivers. They are all similar, and they all flow together to form the Colorado River.

Except for the Yukon River, the Colorado is easily the most mysterious and remote large river in the nation. Compared to the other great rivers—the Missouri-Mississippi, the Columbia, the Ohio, and the Allegheny—relatively few people have become acquainted with the Colorado. Along the almost 2,000 miles they flow on the Colorado Plateau, the Colorado River and its major tributaries—the Green, Grand, and San Juan rivers—are crossed by roads only five times. Only about twenty-five miles of road, Utah Route 128 east of Moab, parallels the Colorado's course. Few acres of floodplains gird their banks. The Colorado itself is generally inaccessible, often filling canyon bottoms from wall to wall. It is most often seen as a dirty brown ribbon, a couple of thousand feet below a canyon rim.

Although there is no great diversity in the rivers of the canyon country, the Colorado itself has a split personality. This is not a headwaters region, and even though the Colorado is the prototypical desert river, its origins are in the pristine snows of Wyoming's Wind River Mountains and Colorado's Rocky Mountain National Park. Each of the major tributaries spends its initial miles as a typical mountain river, frothing over smooth, hard boulders, sluicing gravel clean for spawning trout, and undercutting willow banks. It is when the tributary reaches the sedimentary rock on the 2,500-million-year-old monolith that is the Colorado Plateau, that it becomes transformed into something very different.

From the town of Green River, Utah, it is one hundred and seventeen miles downstream to the point where the Green and Colorado rivers join. For every one of those miles, the Green River drops about ten inches.

One May, we launched our canoes from the Green River City Park beneath the interstate bridge and headed for that fabled confluence, deep in the heart of Canyonlands National Park. The virtually flat slope of the river assured that, even though this was the week of peak flow on the Green, the float would be relaxing. And it was. For ten days we drifted with the current, camping where we pleased, and following no schedule but the river's. A few rainstorms spattered us, and upriver winds in the afternoons forced us to do some paddling, but generally we just sat back and watched the vertical stone walls drift by.

There were endless opportunities for explorations. We hiked side canyons, discovering overhanging alcoves and intricate grottoes. We climbed up to canyon rims for views of distant red cliffs. We poked into dead-end canyons, finding hidden petroglyphs. Many special images remain with me: the brown layer-cake of Dellenbaugh's Butte; Bowknot Bend, where the river flows away from you on your left, and then turns and flows toward you on the right; the massive cap of Turk's Head at sunset; a clearing thunderstorm in

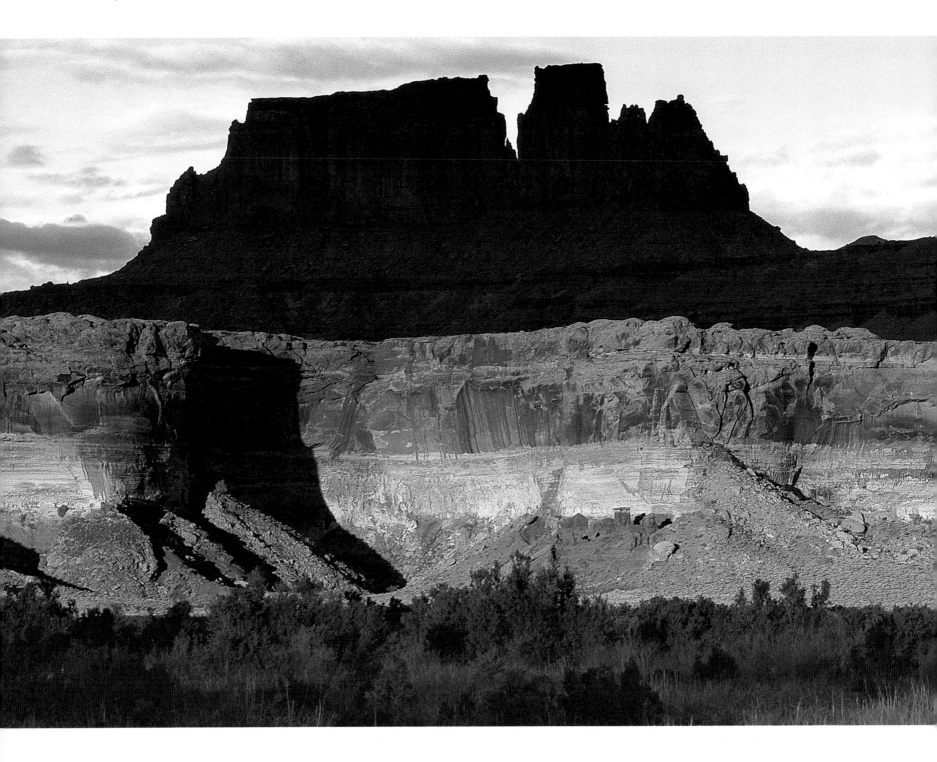

Anderson Bottom; the gargoyles of the Doll's House. At one camp, we moved a medium-sized slab of rock and found an ancient ear of maize.

At Spanish Bottom, below the confluence, we pulled out and waited for the jetboat that would come down the Colorado from Moab to pick us up. To continue downstream would mean running the rapids of Cataract Canyon, not a high-percentage activity in open canoes, especially with our level of expertise! In the preceding ten days, we had seen one other person, a kayaker who zipped past almost before he registered in our consciousness. Other than that, we had been completely alone in this wilderness of stone.

The Green is the major tributary of the Colorado River, but it originally flowed to the Gulf of Mexico via the Missouri River. A complex scenario of uplift and stream capture at the eastern end of the Uinta Mountains in Utah allowed it to create a canyon called Flaming Gorge, and then proceed south to its marriage with the Colorado in the heart of Canyonlands National Park. Hydrologically, the Green is the true headwaters of the Colorado, it being both longer and having a larger drainage area than the tributary that is often considered the headwaters, Colorado's Grand River. However, in 1921, local politicians felt that the Colorado River should rise in the state of the same name, so they simply had the federal government redesignate the Grand River as the Colorado. This would not be the last time that politicians ignored the hydrologic reality of the Colorado River.

The Colorado (Grand) River heads along the Continental Divide in Rocky Mountain National Park in Colorado. It flows southwestward, across the western slope of the Rockies, and starts to slice through the strata of the Plateau as it leaves the last version of the Uncompaghre Uplift. Its union with the Green is a placid one, with both great rivers joining in a giant Y deep within almost vertical canyon walls of Paleozoic sandstones. The Green River, after coursing through three hundred miles of sandstone canyons, is actually brown by the time it reaches the confluence. The Grand, much closer to its mountain headwaters, is actually green. Both rivers flow side by side, distinguishable by their colors, until the brown of the Green dominates the green of the Grand and becomes the red of the Colorado!

Downstream from the confluence, below an opening in the canyon known as Spanish Bottom, in the Maze Section of Canyonlands National Park, the river gets steeper as it tumbles through Cataract Canyon. In the ensuing twenty miles, forty-two individual rapids churn the placid river into a wild melee of waves and foam! After this tumultuous stretch the river once again returns to its quiescent self, as it winds through idyllic Glen Canyon: two hundred miles of flat water solitude, quiet alcoves, and rock temples. Eventually, the Colorado dies in Lake Powell: two hundred miles of water skiers, houseboats, and a bathtub ring on the Navajo Sandstone.

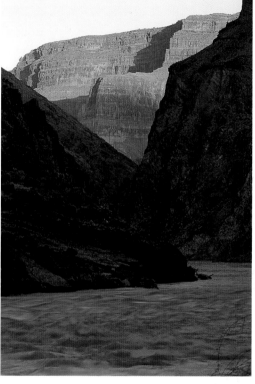

Sunrise, Inner Gorge of the Grand Canyon

Opposite:
A clearing thunderstorm in Anderson Bottom along the Green River allows shafts of sunlight to spotlight wet sandstone.

Like the other tributaries, the San Juan River is born in the snows along the Continental Divide. The San Juan Mountains are among the highest in the central Rockies, with many peaks cresting above 14,000 feet. The melting snows are delivered rapidly to the level of the Plateau, where the San Juan was trapped into steep-walled canyons by the land's rising surface. Before its junction with the Colorado, the San Juan flows through a set of spectacular meanders, the famous Goosenecks, in which the river almost turns back on itself three times in a distance of a mile and a half. Soon (geologically speaking), the San Juan will flow through giant natural bridges as the river breaks through the hairpin bends in the rock walls, shortening its course and flowing beneath the trademark spans of canyon country. The confluence of the San Juan and the Colorado now lies in darkness beneath the waters of Lake Powell.

There are also smaller tributaries to the Colorado, tributaries that rise within the boundaries of the Plateau and are true desert rivers for their entire length. The Paria, the Escalante, the Dirty Devil, and the Little Colorado might well be referred to as creeks in other climates, especially on the basis of their low, sometimes sporadic, summer flows. But here, they are rivers. As is the larger Colorado, they are encased within steep walls for most of their length, meandering back and forth in smooth, looping turns. Occasionally, such as on the lower Paria, they knife through the slickrock in large slot canyons. Throughout their length, they provide a welcome oasis system, supporting riparian vegetation even when their volume of water is at its lowest. These rivers and their tributary canyons drain some of the most remote, inaccessible, and wild areas in the West, and as such are precious treasures in a relatively unrelieved rockscape.

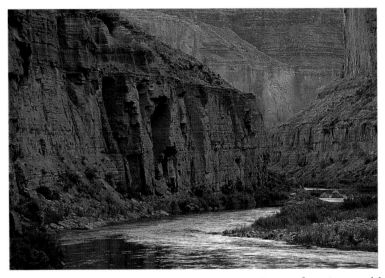

Marble Gorge in the Grand Canyon. Only half of the elevation loss through the canyon is in the rapids. The rest is taken up by long, relaxing sections of calm water.

The Colorado River leaves the plateau country via the Grand Canyon, truly the planet's greatest testament to erosion. We see so many movies showing whitewater rafting on the Colorado and its tributaries, there is the temptation to think that the river system is one foaming cauldron from headwaters to mouth. That's far from the truth. As the Green, Colorado, and San Juan rivers meander across the Plateau, their rate of descent is extremely gradual. Only in places such as the Grand Canyon, where the river was forced to drop a great deal as the land's surface rose, is the Colorado straight and steep. Throughout the rest of its length, it's mostly an easy-going river. For example, through its steeper sections, the inner gorge of the Grand Canyon drops 23 feet per mile. Conversely, in the 117 miles upstream from its confluence with the Colorado, the Green River drops 0.8 feet per mile.

While you float these desert rivers, the sound of sand scraping the bottom of the canoe is constant. But the canoe is not scraping the bottom of the river. It is scraping the sand carried along by the river. The Colorado, Green, and San Juan are not so much rivers as they are lubricated conveyor belts for sediment. Entrenched by the land's rising surface, the river has no choice but to continue along its course. And it carries the Colorado Plateau with it. Over the

last 10 million years, the river has transported billions upon billions of tons of sediment along its entire length. To best visualize the magnitude of the work this river has accomplished, stand on Island in the Sky in the center of Canyonlands National Park and look over the vast expanse of canyons spread out beneath you in all directions. You are 2,200 feet above the Colorado River. Now picture yourself at the same point, still able to see the mountains on the far horizons. But instead of the canyons and the thread of a river far below, try to envision the entire landscape as a plain level with your feet. The rock that makes up the difference between the imagined level plain and the existing canyons is only part of what the Colorado River has carried from the region.

Hydrologists have measured the sediment carried by the desert rivers for the last century. A glance at some of their astounding numbers underscores the extent of erosion on the Colorado Plateau. Below Flaming Gorge in Utah, the Green River is just beginning to enter the Colorado Plateau. In the 1950s, it transported 2.5 million tons of sediment per year at this

point. During the same period, farther downstream, 143 million tons per year passed Lee's Ferry on the Colorado River. And in the early 1930s, farther downstream yet, 180 million tons per year were exported from the Grand Canyon. In 1941, a single flood event on the San Juan River moved 12 million tons of sediment past Mexican Hat, Utah. In other words, the Colorado River today is what it always has been, a desert river that is responsible for wearing down sedimentary rock in one place and depositing it in another.

There is one difference today. The efficiency of the system has been somewhat compromised by the giant sediment traps that engineers have constructed along the Colorado. Although insignificant in geologic time, for they will rapidly fill, overtop, and eventually breach, Lake Mead, Lake Powell, and Flaming Gorge Reservoir are presently redistributing the load of the river.

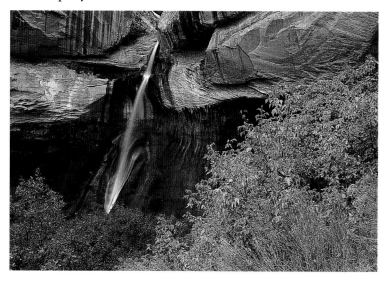

Lovely Calf Creek Falls in the Escalante River basin of central Utah. Dozens of waterfalls like this one have been drowned by Lake Powell.

In the future this may only mean a more challenging puzzle for geologists trying to figure out the deposition patterns in the Gulf of California, but today it means that much of the Colorado River ceases to exist.

The large dams that have been constructed on the Colorado River by the Bureau of Reclamation—Hoover Dam (1936), Flaming Gorge Dam (1958), and Glen Canyon Dam (1963)—have partially transformed a physical/biological system into a political/bureaucratic entity. Now the river must fulfill two roles. First, as a physical system, it must continue to wear away the Plateau and transport it elsewhere, while at the same time it must provide water and habitat to life along its margins. It has successfully eroded the Plateau and provided habitat for 10 million years. Second, as a political/bureaucratic entity it is also being called upon to produce irrigation water and electricity for those who have invested time, money, and career to see that it does so.

It has sporadically fulfilled this role for less than fifty years. Whether these two roles are capable of coexisting remains to be seen.

In the late 1920s, the Boulder Canyon dam project was conceived and implemented to provide irrigation water from the Colorado River to the newly developing agricultural industry in California's Imperial Valley, an area that receives less than three inches of precipitation annually. A gigantic, federally funded project, it was a boon to the farmers, and also to a federal government trying to spend its way out of the Depression. The result was Hoover Dam. Its legacy was a bizarre chain of events, often based on inaccurate data and even more inaccurate assumptions as to what the Colorado River could provide and what its role in the West should be.

A byproduct of the decision to construct Hoover Dam was the Colorado River Compact, an agreement dividing the river's flow between the lower basin states (California, Nevada, and Arizona) and the upper basin states (Utah, Colorado, and Wyoming). The Bureau of Reclamation estimated the annual flow at 17.5 million acre-feet. The agreement stipulated that Mexico would receive 1.5 million, and the upper and lower basins would split 15 million acre-feet. (The remaining million acre-feet were strong-armed by the lower basin when they threatened to leave the negotiations.) Additionally, because of the way the compact was written, the upper basin was required to deliver 7.5 million acre-feet to the lower basin annually. So, the lower basin, which produced a very small percentage of the water, was allocated more than half of it, and the amount was guaranteed. The one-sided Treaty of Versailles had ended World War I only four years previously, and one wonders if some of the Versailles negotiators did not work for the lower basin states as well.

Big miscalculation! The flow of the Colorado River was not 17.5 million acre-feet. A combination of crude measurement techniques and a wet cycle during the measurement period (1896–1921) caused the bureau to overestimate the flow of the river by 3.6 million acre-feet. Since both the lower basin states and Mexico had their amounts guaranteed, the shortfall would have to be suffered by the upper basin states.

In 1922, when the compact was signed, the upper basin had a low population and little need for water. But in the postwar years, populations expanded, uranium boomed in southern Utah, politicians were used to a big-spending federal government, and the crowd at the pork barrel began to grow. Since the upper basin was obligated to release 7.5 million acre-feet every year (and in dry years the river might not even flow that much), the citizens of Utah, Colorado, and Wyoming might be in the position of having to let the entire flow of the river—water from their snow and their mountains—flow unimpeded to California. This was not an enviable position for upper basin politicians. Clearly, they reasoned, if they were going to develop their own states and at the same time meet their compact obligations, they would need their own system of storage. And who better to build it than the federal government; after all, it was the Feds who built Hoover Dam for the lower basin states. The Bureau of Reclamation, whose Holy Grail is watering arid lands in the West, no matter what the cost, was all too eager to comply. And so the Colorado River Storage Project was born.

This project authorized more than forty dams in the upper basin. The showpiece projects were to be Echo Park Dam, in the center of Dinosaur National Monument, and Flaming Gorge Dam on the Green River. The Sierra Club and Wilderness Society took a strong stand against the locating of large dams in national parks and monuments and won a resounding victory, forcing the bureau to abandon the Echo Park site. As a compromise, the conservationists agreed to the bureau's alternate site at a remote, virtually unknown, location in southern Utah that few people had ever seen: Glen Canyon.

Glen Canyon was not the bureau's first choice because its engineers were concerned about the ability of the Navajo Sandstone to support a dam of that size. They feared that the high porosity of the ancient sand dunes would allow water to leak around the dam and soften the canyon walls. But after the Echo Park Dam was denied, concern for the Glen Canyon site evaporated like a shallow pothole. Political expediency has little patience with physical reality.

There are no fencesitters when it comes to Glen Canyon Dam. Like the wolf, it is an environmental litmus test. Since 1963, when the gates were closed and dammed water began to back up to form Lake Powell, the dam has been passionately reviled by environmentalists and religiously revered by developers. On the surface, the project has accomplished what it set out to do. It produces electricity and irrigation water that is utilized throughout the West, and Lake Powell is a destination recreation area. But under the veil of success, warts begin to show. The electricity produced is most often used only during peak periods, those few hours a day when Phoenix and Denver residents are most likely running their toasters, mixers, can openers, and air conditioners. The bulk of power for these and other metropolitan areas is provided from other sources, and conservation efforts could make the power generated by Glen Canyon Dam unnecessary. The Bureau of Reclamation sells the electricity and uses much of the money to subsidize agriculture in the low-precipitation and short-growing-season areas of the upper basin. Costs often run thousands of dollars to irrigate an acre of land that is worth, even with crops, only a few hundred dollars at best. Finally, many of the recreation developments on Lake Powell have gone to large, out-of-region developers. The local communities, which were to be the beneficiaries of the recreation boom, pick off the travelers going to and from the lake.

Springs such as this one in Zion National Park occur across the Colorado Plateau. The National Park Service has filed for water rights on this spring to keep its recharge area from being diverted for irrigation.

And there are the environmental costs, never considered in the initial decision to build the dam. The flows released from the dam have little resemblance to the Colorado River that created the Grand Canyon. In 1884, the spring peak of the Colorado was estimated to be 325,000 cubic feet per second. Flows of that magnitude tend to rearrange some river bottom; but although beaches were washed away as the waters rose, the sediment load of the river was high enough to rebuild the beaches as the water fell. Today, the Colorado emerges sediment-free

from the dam, and as canyon beaches are eroded there is no new sediment with which to rebuild them.

Instead of snowmelt, today's peak flows are dictated by energy demands and occur twice a day. They are nowhere near the natural peaks that formed the canyon. Additionally, the water is clear and cold, rather than muddy and reasonably warm. The channel catfish, humpbacked chub, Colorado squawfish, and razorback sucker, all desert fish that thrive in sediment-laden waters, have been replaced by rainbow trout, a species found in high mountain streams. And the shifting sediment and temperature regimes of the river have altered the riverine ecology throughout the entire Grand Canyon.

The situation in the Grand Canyon has prompted Congress to take action. In 1992, passage of the Grand Canyon Protection Act requires that Glen Canyon Dam be operated to "protect, mitigate adverse impacts to, and improve" natural and cultural resources within Grand Canyon National Park and Glen Canyon National Recreation Area. The Department of the Interior has prepared an Environmental Impact Statement that analyzes alternative ways of releasing water from Glen Canyon Dam, and develops a long-term environmental monitoring plan. As with any environmental law, a solution is not guaranteed. However, the legislation does signal society's recognition of values above and beyond the short-term benefits of cheap hydropower.

Lake Powell has a 27-million-acre-foot capacity, but even this figure is misleading. A million acre-feet is lost to bank storage, as water seeps into the reservoir walls. Each year, 450,000 acre-feet of water is lost to evaporation (12.6 million acre-feet since 1963), while an additional 70,000 acre-feet of capacity is lost as sediment fills up the reservoir (2 million acre-feet since 1963). Beneath the reservoir, the stretch of river that was once Glen Canyon is gone. The twisting labyrinth, soaring alcoves, lush springs, delicate waterfalls, and numerous cultural sites of "The Place No One Knew" have been experienced by a only handful, and are mourned by millions. There are many flat water reservoirs for water skiers and houseboats; in all the world, there was only one Glen Canyon.

On May 24, 1869, nine men launched four boats on the Green River in southern Wyoming. Led by a one-armed Civil War veteran and geologist, Major John Wesley Powell, their goal was to float, for the first time, the Green and Colorado rivers to the Grand Wash Cliffs, downstream of the Grand Canyon, a distance of close to seven hundred river miles. No mere joyride, Powell wanted to explore, map, and interpret the physical characteristics of this last, unexplored region of the country. On August 30th, six men and two boats emerged from the canyons. In three months on the river they lived constantly with adventure, faced starvation, overcame incredible odds, lost companions, and finally succeeded. Powell's information formed the core of knowledge concerning the canyon country.

But, impressive though it is, John Wesley Powell's greatest legacy is not his exploration of the canyons of the Colorado River. For Powell, more than any other man before him, knew the limitations of the American West, and what they meant to future settlement. Always the scientist and public servant, he became the second director of the U.S. Geological Survey. In his *Report on the Lands of the Arid Region,* he recognized the reality of the West: that lack of water

would control the region's destiny; that whoever controlled that water would control the region; and that, in the West, the traditional size of a family homestead, 640 acres, was far too small to support a family. If his recommendation to create state boundaries on watershed divides instead of the present grid system was followed, the interstate water battles that gave rise to Glen Canyon Dam, as well as future battles, might well have been avoided. If his recommendations for dryland farming had prevailed, the same might be said for the Dust Bowl of the 1930s.

But scientists and public servants often make poor politicians, and Powell was no exception. Western congressmen and senators, who had no interest in planning, and even less in limiting growth, consistently thwarted his efforts to fund surveys and publish reports. Although a blueprint for the arid West existed, it was seldom referred to.

The irony that the water behind Glen Canyon Dam is named for the greatest visionary in the American West is all too obvious. But perhaps it is fitting nonetheless. On one hand, the reservoir is an apt vignette of America's history in the West: development without thought; progress without definition; expectation without capability; profit without accountability. On the other, it reminds us that someone usually has the right answer. All we have to do is listen.

VEGETATION: STICKERS, SPEARS, AND THORNS

In Bryce Canyon National Park, I came across a pinyon pine that epitomized not only the hardiness of the species but also the impermanence of the landscape. On a low ridge of the Claron Formation, the soft, crumbly, pink rock that makes up the vast amphitheater that is Bryce, stood a solitary pinyon. It was small, maybe six feet in height, and seemed to have as many dead limbs as live ones. Its dark green needles flared into a bushy, globe-shaped crown. But it was not the crown that set this individual apart. Instead, it seemed to be supported by stilts. In reality, the earth had eroded away from the base of the tree, and more than a foot of roots was now exposed to the wind and sun. The roots flared almost horizontally from the trunk, and then, like knees, bent groundward. A tree with the tenacity to survive on minimal rainfall after its supporting land has washed away is a fitting symbol for the Plateau's vegetation.

No matter where you go on the Colorado Plateau, from the cool depths of canyons to the windswept tabletops of isolated mesas, vegetation is everywhere. Granted, this vegetation is not always obvious, and it is certainly not abundant, but it is always there. Some sort of vegetation is in sight virtually all the time, and in most places it is within a few dozen steps. The species are diverse, relatively numerous, and widespread. Given the physical conditions that exist on the Plateau, the existence of vegetation at all is pretty amazing.

The occurrence of vegetation here is governed by the same factors that control the occurrence of vegetation elsewhere: abundance and availability of water. In turn, as in all other regions, it requires a combination of physical factors—elevation, aspect, soil depth, and temperature—to distribute the water and create a variety of conditions for plants.

In terms of water distribution, elevation is the great equalizer. As in the mountains, precipitation increases with elevation, and in central Utah, a series of high plateaus immediately to the west of the canyons of the Green and Colorado benefit. The Paunsaugunt, Markagunt, Kaiparowits, and Aquarius plateaus rise as much as 6,000 feet above the surface of the surrounding slickrock and are in a perfect position to comb moisture from the winter storms moving east from the Great Basin.

This abundance of water enables these relatively small outposts to support groups of plants that could exist nowhere else in the region. Above 9,000 feet, on the very tops of the plateaus, the spruce-fir forest dominates. These species are most often associated with colder climates, and here they seem to be misplaced "islands" in an "ocean" of deserts. The graceful, upturning needles of white fir, their undersides silvery gray, give the tree both a delicate and solid appearance in the shadowy depths of the forest. The lighter green of the firs provides a slight counterpoint to the more somber spruce.

Winters at these elevations are as long and severe as any in the Northern Rockies, with snow depths easily reaching eight feet or more. A rule of thumb says that 1,000 feet of elevation is equivalent to about three hundred miles of latitude. Using that as a guide, the 3,500-foot rise in elevation between the Escalante River and the spruce-fir forests on the Markagunt Plateau would hypothetically place the conifers in central Montana, a latitude that suits them well.

One of the more interesting inhabitants of the spruce-fir community is the bristlecone pine, a species that may boast the world's oldest living individual. Twisted and bent, leaning away from the incessant wind on high, sterile ridges, these unique trees often look more dead than alive, which they are! The bristlecone's longevity is assured because a portion of the tree can die, enabling the nourishment that is produced to be used by the part that remains alive. In this way, the tree waits out the bad times, and resumes its growth during the good. This strategy, although seemingly crude, is effective. Bristlecones up to 1,600 years old have been found on the Markagunt Plateau in Cedar Breaks National Monument. (Farther west, some specimens have reached 4,000 years old.)

The elevation zone immediately below the spruce-fir association produces one of the most spectacular displays of vegetation anywhere. Quaking aspen may well be the signature tree of the Intermountain West. It is a component of many habitats throughout the region, generally as a somewhat minor species in isolated pockets. However, on the western slope of the Colorado Rockies and the high plateaus of Canyon Country it often dominates the tree stands. Initially established after wildfires because it relies on root sprouting rather than seed for reproduction, it usually fulfills an intermediate role in the cycle of the forest. Eventually, most of the places where aspen grows will be inhabited by conifers. The alpine fir seedlings that presently seem dwarfed by the taller aspen will one day shade out their now numerous neighbors and

Bristlecone pine, Cedar Breaks National Monument in southwestern Utah. The extreme longevity (up to 4,000 years) of this species is due to the fact that part of the tree dies so that nutrients can be used by the part that remains alive.

Opposite:
Gnarled pinyon pine clings to a ridge in Bryce Canyon National Park.

inherit the site. However, for the hundred and fifty or so years that the aspen dominate, they offer one of the most pleasant woodland experiences in the West.

On the high plateaus, the aspen is an arresting sight in all seasons. Even in winter, the silvery bark and bare limbs etched against the snow provide a delicate filigree in the landscape. In spring, the bright emerald of new leaves against a clean blue sky announces that another winter has been successfully survived. As the seasons progress into summer, leaves become a nuance darker, and the coolness beneath the shade of a pure aspen stand is a welcome respite from the heat rising off the desert below. In fall the aspen put on their most awesome display. Like the feathered robe of an Aztec king, brilliant gold drapes the plateaus. Whether backlit by early light, or bright against the blue sky of noon, autumn aspen rival the rock of the canyons below for color!

An aspen stand is a delight not only of color but also of motion. A unique flat stem bridges leaf and twig, making the leaf susceptible to even the slightest breeze. During any of the leafed seasons, there is always a shimmering in the canopy. In the fall, when strong winds blow, the leaves separate from the twigs and float to earth, like so many weightless doubloons.

Below the aspen forests, the vegetation begins to reflect the more arid conditions one expects of the Colorado Plateau. Ponderosa pine appears in many locations that straddle 7,000–8,000 feet in elevation. In the Northern Rockies, this species occupies only the drier and warmer sites. But on the Colorado Plateau, sites with moisture similar to "P-Pine" sites farther north are in the mid-range of the moisture spectrum. But like its northern cousins, the trademark scaly, orange bark, pungent odor, and open, airy stands also typify ponderosa pine on the plateau. Gambel oak is a prominent understory species associated with ponderosa pine. More shrubby than its eastern cousins, its leaves nonetheless provide the same vibrant coppery tones across the autumn landscape. Another understory species often associated with ponderosa pine, especially in the Bryce Canyon area, is red-barked manzanita. This shrub only grows as high as the snow depth to insure that it receives insulation during the winter months. As an added defense against water loss, the leaves of manzanita are oriented vertically and in a north–south direction to minimize evaporation and exposure to the sun. Even blindfolded, you can easily recognize manzanita because its characteristic sharp, pungent aroma fills your nostrils from quite a distance.

On a topographic map of the Colorado Plateau, the 7,000-foot elevation line shows up only sparingly. It encircles each of the major mountain ranges: the Henrys, the La Sals, and the Abajos; it traces the upper edge of the Kaiparowits Plateau and the rims of Zion Canyon; and it defines the oblong shapes of the Markagunt, Paunsaugunt, and Aquarius plateaus and the Coconino Plateau between the Grand Canyon and Flagstaff, Arizona. But these are widely spaced amoeba-like splotches. The rest of the area, easily more than half of the map, lies below the 7,000-foot line; here, the vegetative communities of the desert eke out their precarious existence.

Desert vegetation is not poetic or lyrical. There are not many odes to bitterbrush, or paeans to pricklypear. Very few authors wax eloquently on the shimmering leaves of buffaloberry or the stately boles of juniper. Desert vegetation is not inviting. Most of it has thorns, stickers,

or other unpleasant appendages. And even those species that don't have weapons are still capable of making their presence felt, as anyone who has come into contact with a juniper or pinyon snag can attest. But if desert vegetation doesn't inspire poets, it does command respect. It is functional, and it survives.

Most of the rock expanse of the Colorado Plateau receives six to twelve inches of rain annually—not enough, on average, to support the vegetation that is there. But it's where the vegetation occurs that tells the tale of survival. With water such a precious substance, any slight alteration of physical factors that either concentrates or disperses it can make a difference to an individual plant. And it is individual plants that we're talking about, for that is the dominant expression of many species. Seemingly minute alterations in aspect, shading, and slope can affect available sunlight, evaporation, temperature, and soil depth, all of which combine to spell success or failure for a single plant.

The rock is neither flat nor smooth. The undulations and breaks in its surface allow water to concentrate, enabling plants to gather enough water to survive. Depressions in the rock surface collect water and the sand grains that are carried with it. Soil builds and eventually becomes deep enough to allow seeds to germinate, provided all other physical factors have randomly combined to create a hospitable environment. These patches of soil can be anywhere from a few square feet to a few acres in size, and most of them support a variety of vegetation.

Even a few square feet is a large area by many standards. Often a horizontal, or even vertical, crack in the sandstone is enough to concentrate adequate water to support a tree. Indeed, cracks almost seem to be the preferred habitat for some specimens of pinyon pine or juniper, for it is not uncommon to find a tree six inches in diameter, with its root system aligned in a crack.

Given enough water, plants can grow just about anywhere.

On just about any hike on the Colorado Plateau, you will encounter both juniper and pinyon pine, for these two species dominate the vegetative community below 7,000 feet. By desert standards the trees are abundant and continuous, but are often registered as insignificant by human eyes, which are much more attuned to "real" forests in more humid locations. Indeed, the "P-J" association is often known as the "pygmy forest." Pygmy or not, this forest is as indicative of its environment as the deciduous forests of New England and the old-growth Douglas fir of the Pacific Northwest. Both pinyon and juniper thrive in areas with low precipitation and humidity, high evaporation rates, and intense sunlight—all qualities the Colorado Plateau can deliver in abundance. Although very different in appearance, the two almost seem to be vegetative synonyms—somewhat isolated, generally contorted specimens, often with as many dead branches as live ones, providing a splash of green in a beige environment.

Juniper is the most drought tolerant of the two, mainly because it can extend its root system up to fifty feet away from the main plant. It appears in harsh locations at the lower end of the elevation spectrum. Juniper is really nothing more than a low shrub, with few individuals ever attaining twenty feet in height. Although they grow in "pure" stands, pure is a relative

term, for the competition for water dictates that there be a lot of space between individuals. The bark of juniper is silvery-gray and stringy. It peels off in long strips and can be shredded into a fine excelsior-like material for insulation and tinder. The purplish berries can be brewed into a tea and are also used to flavor gin.

Pinyon pine fits most people's perception of a tree better than juniper does. In sheltered areas, pinyons may reach forty feet in height but when they grow in the open, as is most often the case, they tend to become shrubby, sprawling bushes. On the higher locations within its elevation range, pinyon dominates in its association with juniper and often produces a fairly uniform cover where soil is adequate. Like juniper, the bark of pinyon is rough, but scaly rather than fibrous. Its needles are short, stubby, and twisted. The nuts of pinyon pine provide a valuable food source for both birds and mammals, including humans. Protein-rich pinyon nuts were a mainstay for the Anasazi and other prehistoric southwestern cultures, who gathered them every fall for consumption and trade. Today, pinyon nuts continue to be a

A typical pinyon-juniper forest on the Colorado Plateau

Opposite:
Morning glories at sunrise near Horse Thief Canyon in Canyonlands National Park. The petals on these flowers will soon close to conserve water during the heat of the day.

fall treat, with one bumper crop usually coming about every seven years. The Navajo, whose reservation includes excellent pinyon country in northwestern New Mexico and northeastern Arizona, still rely on the nuts for added income.

Within the vast area covered by the pinyon-juniper association, a number of smaller vegetative communities exist that provide variety to the landscape. Blackbrush, a short, spiny shrub with tiny gray-green leaves, grows in pure stands where water tables are close to the surface, such as in shallow depressions in sandstone. Where the soil is deeper, the blackbrush is replaced by galleta, Indian rice grass, sand dropseed, and other bunch grasses. These native grass communities once occupied much larger areas, but domestic livestock have hit them hard in the last one hundred years. Today, the best examples of native grasses exist only in the more remote sections of the plateau, where livestock have not overgrazed the delicately balanced ecosystem.

Certain plants are closely tied to specific geologic formations. The chemical and physical qualities that are inherent to a given type of rock often inhibit or encourage specific plants. The shales of the Mancos and Chinle formations are made up of tiny clay particles that hold water tightly and give it up reluctantly, making extraction of water difficult for plants. Here, only saltbush and shadscale have achieved any measure of success. The fossil-rich Morrison Formation, found throughout the eastern portion of the Plateau, readily forms cracks and fissures, providing many sites for pinyons and junipers to become established. The sandy soils weathered from the Summerville Formation, immediately beneath the Morrison, seem to be conducive to grasslands, while those from the Entrada Sandstone, the arch-former in Arches National Park, support Mormon tea and sagebrush. Some plants, notably greasewood, seep-weed, saltbush, and pickleweed, have even developed a tolerance for salt and can exist on the

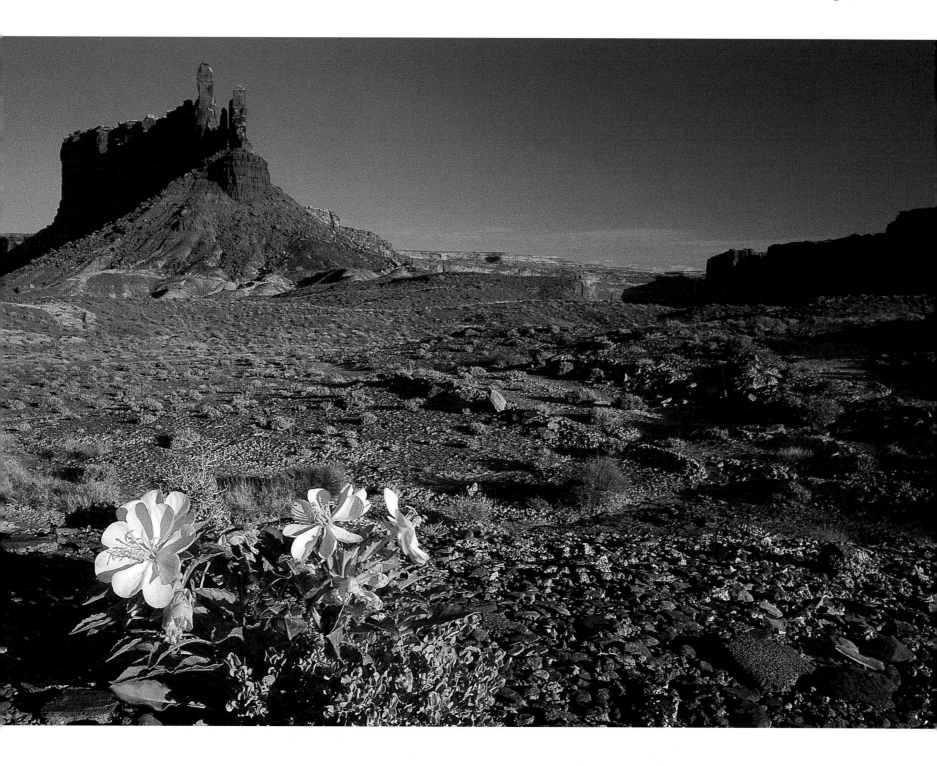

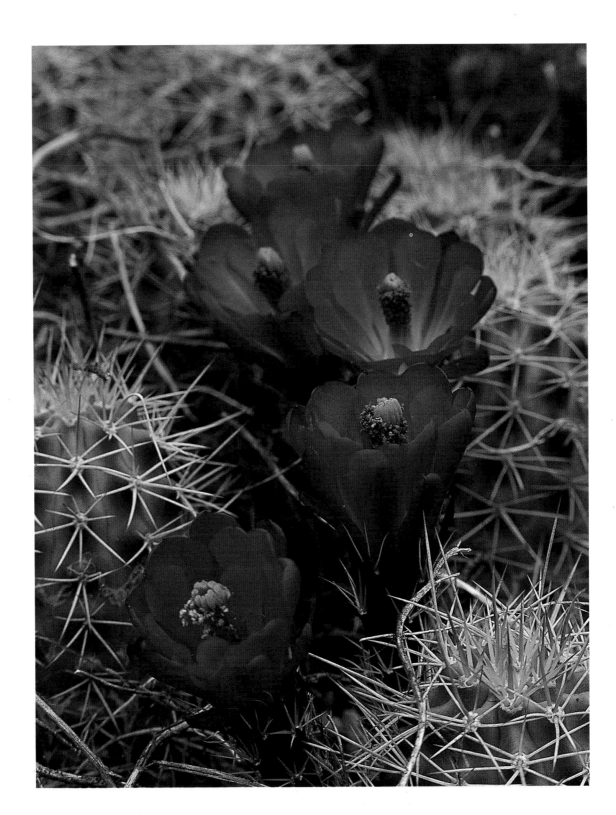

*Claret cup cactus blooms in Canyon-
lands National Park*

soils formed by the evaporation of seawater during the Paleozoic era. Certain formations, such as the Moenkopi and Chinle, are selenium-rich. Although selenium is toxic to many organisms, princes' plume and milkvetch have developed a tolerance.

Wildflowers too, make their presence known on the desert, although not as profusely as they do in the mountains. Here, hidden in shaded cracks and crevices, they provide bursts of color relief. Indian paintbrush and aster are two mountain species that are also common on the Plateau. Other plants of the Plateau have developed their own adaptive mechanisms. Evening primrose opens its petals only at night to conserve water, and cliffrose gets by with small, yellow blossoms that reduce evaporation. Some species, such as snakeweed and pricklepoppy, thrive in the overgrazed lands throughout the Southwest. As in any desert, cacti are common, largely because of their numerous adaptations to the country: sharp spines keep away grazers, a shallow, extensive root system draws water from long distances, spongy pads store water, and they have no leaves to transpire precious fluids. The brilliant red of claret cup cactus, the bright yellow of pricklypear, and the shocking pink of fishhook cactus add eye-catching highlights to the landscape.

For an area that consists mainly of weathered sedimentary rocks, much of which is sandstone, it seems odd there are not more dunes of loose sand. A delicate relationship between biological and physical factors fosters microbiotic soil, which is responsible for holding much of the sand in place. The top two or three inches of sand provide an environment that supports the formation of a group of specialized microscopic lichens, mosses, and fungi. Resembling nothing so much as a dark scab on the surface of the ground, this combination of primitive plants performs three valuable functions: it creates a veneer on the surface that absorbs water; it prevents erosion, especially by wind; and it extracts nitrogen from the air. In a land where plant occurrence is exceedingly random and variable, microbiotic soil amount to nothing less than a nursery for higher-order plants.

There is a portion of the Colorado Plateau where water is abundant, and where vegetation flourishes. The riparian areas along the perennial rivers and streams receive an amount of rainfall equal to that of the adjacent benches and valley bottoms, but the augmentation of that rainfall by water seeping into the riverbanks allows the growth of veritable oases. Cottonwoods are the dominant species in these riparian areas. Although shallow-rooted and subject to windthrow and bank erosion, cottonwoods often occur in groves and regularly attain girths of up to thirty inches in diameter. Like aspen in the highlands, cottonwoods provide splashes of color throughout the year and shelter for birds and other wildlife. In the shadows of late afternoon, their widely spreading crowns, often visible from far upstream, cottonwood trees signal to floaters a good place to camp.

Not so the tamarisk, or salt cedar. Introduced from the Mediterranean to control erosion, it, like other exotics, quickly took over the habitat of native plants, especially the cottonwood. Now it lines almost every river on the Plateau, creating impenetrable tangles. Immune to fire and any other control measure, it is another unfortunate example of ecological tinkering. Although tamarisk performs its erosion control function quite well, it has drawbacks. It seeps

salts into the soil, thereby excluding other vegetation from the surrounding area. But most of all, it is a water glutton, using and transpiring much more water than other riparian desert plants. And on the Colorado Plateau, it might have been better to accept erosion, which at best could only be delayed, in favor of saving water, which none of the inhabitants can afford to have wasted.

There is another water-rich habitat on the Colorado Plateau that can evoke feelings of having entered a different, magical world. No matter how hot the day, the temperature is cool and refreshing. No matter how parched the throat, there is enough water to slake any thirst. No matter how monochromatic the immediate landscape of sand and stone, vibrant color abounds. This is the world of the alcove spring, or "hanging garden." Water from thousands of years of thunderstorms and snowmelts seeps downward through tiny joints in the sedimentary rock. Eventually it reaches an impermeable rock layer and is forced to move horizontally outward, exiting the canyon wall as a spring. The seeping water weakens the formation, causing the rock to shear vertically away and form a domed alcove in the cliff. Some canyons, such as Death Hollow, a tributary to the Escalante River, have enough of these hidden springs to create a year-round stream. Maidenhair ferns and mosses cling to the wall where the water emerges, forming a verdant band around the alcove. Columbine, penstemon, monkeyflower, and other water-loving flowering plants, all add their individual hues to the delicate rainbow of color. Some springs, such as Weeping Rock and Emerald Pools Canyon in Zion National Park, are easily accessible, well-known attractions. But most are remote, and their locations not well advertised. Least of all, by me.

Well, maybe just one. Just before the Bright Angel Trail reaches the Colorado River in the depths of the Grand Canyon, a hundred-foot waterfall spills over vertical walls. Rather than free-falling, the lower half flows down the rock, fanning wider towards the bottom. The stream itself is incongruous enough in this furnace, but the plant community it supports really seems out of place. On each side of the waterfall, for perhaps fifty vertical feet, is a band of lush green plants, speckled with white columbines. Their long stems curve gracefully away from the rock face, allowing the blossoms to dance gently in the slipstream caused by falling water. Sparks of scarlet penstemons surround the pool at the base of the falls, twinkling brightly against green foliage. A room-size boulder hides the pool from view, making getting behind it seem like entering another world. The combination of colorful flowers, cool mist blowing off the falls, and the sound of falling water transports you from the bottom of the Grand Canyon to summer meadows among the high peaks. But no matter how idyllic, you can only tarry for so long. Reality awaits. It's ninety-five degrees and still two miles to Phantom Ranch.

Although there is little timber of commercial quantity or quality on the Plateau, the ubiquitous bovine has kept alive the debate between vegetation as a commodity or a community. Most of the Plateau, including some of the national parks, currently suffer the hooves and teeth of domestic livestock. Here, where precipitation is less than in the Northern Rockies and it takes a number of square miles to feed a single cow for a year, the effects of overgrazing have drastically changed native plant communities. Riparian areas in the sandy soils of the Plateau are more dependent on the stabilizing influence of vegetation, and many dry gullies exist today where perennial streams once flowed. Isolated mesas north of the Grand Canyon that have never been grazed testify to the productivity of the desert landscape. They exist as islands of grasslands in sagebrush seas.

The pinyon-juniper forest is the dominant vegetation on the Colorado Plateau, but all of the various species of plants in that forest are only satellite players in the great drama of rock and stone. However, in a small way, it might well be the vegetation that provides some of the Plateau's most telling and enduring images: the brilliant emerald of a sun-washed cottonwood superimposed on a curving, ark-shadowed wall of deep red; the flames of claret-cup cactus blossoms tucked under a ledge of pink Navajo Sandstone; the twisted skeleton of a juniper, silhouetted against the sunrise. These images speak of beauty, of adaptation, of perseverance, and are a fitting signature for the entire region.

INHABITANTS: LIVING ON THE MARGIN

A waterfall, columbine, and penstemon. What better place for a break after a long, hot hike?

Spring at Capitol Reef. From the promontory overlooking Chimney Rock, it seems as if most of the southern Colorado Plateau spreads out below us. To the east, the pale, rainbow-washed sandstone domes of Waterpocket Fold fill the middle distance to the Henry Mountains, while to the west, the Aquarius Plateau, the highest plateau in North America, bows upward in a long incline. It is from places like this that the geology of the region begins to make sense.

But the geology can be inspected at leisure. What attracts our immediate attention is the acrobatic display of a pair of ravens going on before us: power dives, Immelmanns, snap rolls, swooping turns! They start below us, climbing on the rising thermals, spiraling upward, rushing at each other, breaking off at the final instant before collision, then chasing tails in long dives; their repertoire of maneuvers is repeated again and again. It is their mating ritual, conducted each spring high above the spires and canyons of the Colorado Plateau. But watching them, you can't help but think that they're just showing off.

The clues are only faintly evident: unconnected j-shaped tracings on a sand dune, an inconspicuous hole at the base of a sagebrush, or the musky odor near cracks in a sandstone cliff. Possibly, what appears to be a random collection of silvery-gray sticks poised on a ledge may be all that gives them away. In any case, the creatures that inhabit the Colorado Plateau are never very obvious.

Following the sand dune tracings might lead you to a sidewinder, coiled just below the surface, only its head and hooded eyes above ground. If you are patient and watch the hole at the base of the sagebrush until dusk, a Great Basin pocket mouse will emerge and begin its nightly seed gathering. The musky odor indicates that a ringtail has been startled by your presence, for this common but little-seen member of the raccoon family spends its days in narrow cracks. And, during the spring, the haphazard collection of sticks will house a pair of nesting ravens. In short, the inhabitants of the Plateau may not be very obvious, but they are there.

The Colorado Plateau provides for wildlife in much the same way it does for vegetation: with an array of opportunities rigidly tied to elevation. There is a variety of habitats, each dependent on plant communities, which in turn are dependent on elevation. As one would expect, the peaks and plateaus that support the spruce-fir forest, and its often dominant aspen community, likewise support creatures that are frequently found much farther north. The physical similarities between the plateaus and the coniferous forest of the Northern Rockies ensure that their habitats, and the species that live in them, will be remarkably the same. Animals familiar to Montanans—blue grouse, black bear, marmot, marten, and pika—can all be found above the 7,000-foot contour line that encircles these forested islands in a desert sea.

Below 7,000 feet, however, success for animals depends on how well they cope with the dual challenge of intense daytime heat conspiring with severe lack of water. This limits the number of habitat niches, and hence the number of species that can adapt to them. Adaptive mechanisms are finely tuned and revolve around either finding adequate water or using available supplies wisely. Desert wildlife, perhaps more than wildlife in

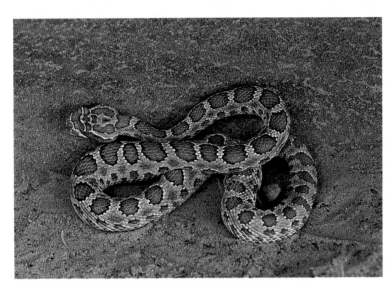

In all our hikes on the Colorado Plateau, we have seen only two rattlesnakes. This one was in Antelope Canyon near Page, Arizona.

other environments, is dependent on the maintenance of a delicate balance between adequate water and not enough. In order to cope with the stresses imposed by these unforgiving conditions, two strategies are available: animals either hide from desiccation or they resist it.

Most "avoiders" simply retreat into burrows during the heat of the day. Temperatures, even a few inches beneath the ground's surface, can be as much as fifty degrees cooler. By retreating when the sun is high and being active at night, many desert animals avoid the conditions that would otherwise dictate excessive use of water to cool their bodies through evaporation.

Drought avoiders sometime appear in the most unexpected places. On flat sandstone benches throughout the Colorado Plateau, separated from rivers and streams by vertical as well

as horizontal barriers, there exists an underwater community that teems with life. Depressions in rock surfaces form miniature watersheds known as potholes. These potholes, often several feet deep, collect runoff from areas as large as several acres. Until the water evaporates, they support a number of species in a miniature aquarium. And the sediment deposited in the potholes provides a medium for burrowing when the water inevitably evaporates.

The classic example of this avoidance mechanism is the spadefoot toad. It can spend two years buried to a depth of twenty inches in the bottom of a pothole waiting for the next rain. During this time, layers of shed skin cover the toad's body and help prevent water loss. Additionally, the toad's bladder will hold up to 30 percent of its body weight as dilute urine, which provides needed moisture. When rain percolates through the sand, the toads quickly dig themselves out and soak up water like sponges. Time is of the essence. In the next fifteen days, courting, mating, egg laying, hatching, and progression from tadpole to toad take place. By the time water in the potholes evaporates, a new crop of water-logged spadefoots is ready to dig in until the next rain. This is an example of evasion in its ultimate form. Other avoiders also inhabit potholes. Fairy shrimp cleverly enhance their survival chances by laying two types of eggs, one for summer conditions and one for winter. The mechanism obviously works, for these crustaceans have been around for at least 26 million years.

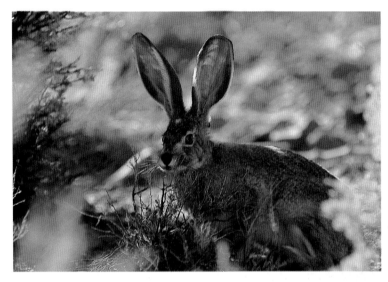

Black-tailed jackrabbit. The most abundant rabbit on the Colorado Plateau, the black-tail is actually a hare because its young are born with their eyes open and already furred.

At the top of the pothole food chain is the ultimate aquatic predator: the pothole beetle. It breathes air from a bubble trapped under its wing as it hunts underwater for tadpoles and other prey. But it is not an avoider, when the pothole water evaporates, it simply flies away.

However, drought "resistors" are the more common desert animals, for there are many adaptive mechanisms. In a region where standing water is virtually nonexistent, food itself can often supply necessary moisture. Cacti and other succulent plants are part of the diet of desert dwellers such as javelinas, or wild pigs. Moisture thus obtained sees them through until they can find standing water. Functional efficiency is a byproduct of adaptation. Many desert creatures, kangaroo rats and scorpions in particular, reabsorb water from their feces before depositing them, while others have extremely low respiration rates and oxygen requirements. The varieties of adaption are endless and enable a surprising number of species to fill what niches do exist in a seemingly harsh world.

Some animals combine both resistance and avoidance mechanisms. Arthropods (insects, scorpions, spiders, crustaceans, centipedes) have built-in advantages that give them a head start in the game of desert adaptation. The hard shells that cover their bodies, known as *exoskeletons,* reduce water loss; they have a low respiration rate; and they use tiny microenvironments such as cracks and crevices to escape the heat. At night, they consume tiny drops of condensation too small to be available to larger animals. They can also lose a large percentage of their body

weight from desiccation without suffering much damage. Scorpions epitomize this group of creatures. They are nocturnal hunters, and spend their days burrowed beneath the sand and their nights waiting in ambush for prey. They sense approaching morsels by the vibrations created in the sand and dispatch them with their tail stingers. Scorpions are hardy and can withstand up to a 30 percent loss of body weight before suffering serious consequences. Their nocturnal lifestyle, however, make them prey for owls and bats.

The rugged topography of the land itself often forces adaptation. Cliffs, canyons, and rivers all provide both vertical and horizontal barriers to travel. As the newly forming Grand Canyon began to cut across the Kaibab Upwarp, it divided populations living there at the time. As the canyon grew, it became impossible for the species to reunite. Without the interchange of genes, each population exhibits minor differences in features, which makes them distinct enough to be considered subspecies. To journey from one rim to the other, a rodent such as a squirrel or chipmunk would have to descend 5,000 feet through seven separate vegetative life zones (each with its own distinct food sources and predators), cross the Colorado River, and ascend through the same spectrum of life zones to the opposite rim. No wonder relatives haven't seen each other for a couple of thousand years! Today, each rim of the canyon has its own separate subspecies of gopher snake, chipmunk, porcupine, and meadow mouse.

But the most famous evolutionary cousins are the Aberts and Kaibab squirrels. These are the only large tree squirrels in the region and are distinguished by the tassels of hair at the tip of each ear. Separated from the main population of Aberts squirrels by the Grand Canyon, a subspecies evolved on the North Rim. This subspecies, the Kaibab squirrel, developed totally different coloration from the Aberts, although in all other respects they are similar. Aberts squirrels have dark gray backs and sides and white undersides. The Kaibab is dark all over, but has a white tail. Both species are almost wholly dependent on the ponderosa pine for their existence. They have been known to consume up to 75 percent of the cone crop in a single year. This pine dependency is a more serious problem for the Kaibab squirrel, for if insects or disease seriously reduce the ponderosa pines on the North Rim, there are no other alternative habitats to which it can temporarily shift.

The Grand Canyon provides another example of adaptive mechanisms by forcing a color change in the diamondback rattlesnake. Normally buff or tan, a subspecies has evolved that matches the orange or salmon of the surrounding rock of the Supai Formation.

In the early 1900s, an unusual episode involving wildlife population dynamics occurred on the Kaibab Plateau near the North Rim of the Grand Canyon. It became the classic study in predator-prey relationships for generations of biologists. The story begins, as do many stories in the West, with severe overgrazing by domestic livestock in the late 1800s. On the Kaibab Plateau, an area that supported about 4,000 mule deer, ranchers grazed 15,000 cattle. By 1900, much of the region's native grasses had disappeared and had been replaced with plant species that provided much less forage and groundcover. Subsequent erosion reduced productivity even more. In order to help starving deer, managers decided to eliminate predators and over the next few years killed close to eight hundred cougars, as well as hundreds of coyotes, bobcats, and

wolves. This helped the deer so much, that by 1926 there were 100,000 of them looking for food in an area that formerly supported only 4,000. Tens of thousands starved. To prevent wholesale die-off, massive hunts reduced the population to a manageable level. Today, with livestock grazing eliminated in Grand Canyon National Park and predator numbers restored, the population has come into balance with the vegetation, and so remains stable. In reality, the two-dimensional, predator-prey explanation is somewhat simplistic. The synergism among biological and physical ecosystem components (predator, prey, food, weather, terrain, stress, aggression) are far more complex. Nonetheless, the lessons of the Kaibab have been well learned by biologists. The interdependence of predators and prey is now universally recognized by the scientific community. It's not nice to fool Mother Nature.

Reptiles are the animals most people associate with the desert. In dozens of movies and stories, the hero comes face to face with an angry "buzzworm" at some inopportune moment. Snakes and lizards are common throughout the lower elevations of the Plateau, but they're not exactly lurking behind every bush and rock. We have encountered two rattlesnakes in many years of hiking in the canyon country.

Reptiles are cold-blooded, so they must rely on their behavior and environment to regulate body temperature. Throughout the day, reptiles will move between sun and shade depending on whether they need to gain or lose heat. In reptiles color is an important adaptive feature, as dark scales will absorb more solar radiation than light ones. Few reptiles rely on drinking to obtain water. Snakes and lizards get the required moisture from the flesh of their victims, and the endangered desert tortoise relies on succulent cactus. Like arthropods, some of the smaller reptiles can lose up to 50 percent of their body weight and still function.

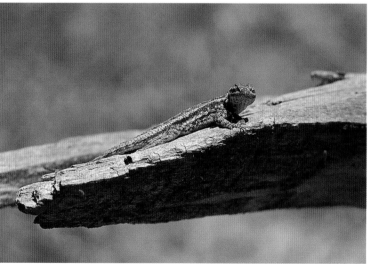

Sagebrush lizards are found throughout the arid West. Like all reptiles, they must regulate their temperature by external means.

If reptiles seem to be the natural creatures of the desert, birds appear to be the interlopers. Even though they're an integral part of the system, they seem somewhat out of place. Yet, of all the inhabitants of the Colorado Plateau, birds have the least trouble adapting to environmental conditions. Their mobility enables them to reach water with relative ease, to remain at altitudes where the air is cooler, or to migrate from the region altogether. Still, birds do employ adaptive mechanisms, the most common of which is to remain in the shade during the heat of the day. Others compress their feathers, so as to reduce insulating air pockets; in extreme heat most will resort to panting to remove heat from their body. However, despite the fact that their natural avoidance mechanisms are so effective, it is surprising that birds are among the least numerous of desert creatures. What birds lack in numbers, they more than make up for in fascinating behavior. Perhaps because so many of them seem incongruous in desert surroundings, they attract more attention than some of the more desertlike animals. Along riparian corridors, such as Labyrinth Canyon on the Green River, clouds of white-throated swifts remain airborne most of the day, foraging

for insects. Built for speed, they can reach up to 200 mph in a dive! In flight, their wings seem to flap alternately, giving them an erratic motion in the air. Watching a couple of hundred of them twisting, darting, and diving in a great feeding melee is an entrancing experience! Vultures, too, are common in deserts. These large, soaring birds ride rising thermals above the canyons searching for carrion on the rocks below. The vulture's adaptive mechanism is simple patience. It has learned that the desert is a good provider. But for those who have taken time to explore the twisting, narrow slots and grottoes of the Colorado Plateau, it is not vultures that best define this area; that distinction is reserved for the canyon wren. These small, brown-and-white birds are heard more often than seen, and it is their lilting song that stays with so many canyon visi-

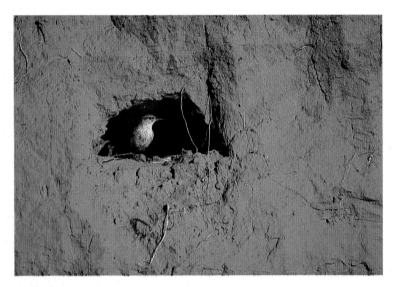

A canyon wren perches in its nest along the Green River.

Opposite:
A lone desert bighorn is inconspicuous among sandstone boulders in Canyonlands National Park.

tors. Canyon wrens live in a vertical world, nesting in cliffs bordering many of the drainages on the Colorado Plateau. Their frenetic bobbing and scurrying in search of insects keeps them in almost perpetual motion. But it is the canyon wren's song that sets it apart. The clarity of the song is like fine crystal. The dozen or so plunging notes, each lower in pitch than the preceding one, echo among canyon walls, then fade away, leaving the listener waiting for a repeat performance. It is never heard enough.

Mammals are the least seen inhabitants of the Colorado Plateau, mainly because humans are ill equipped to look for them at night. If we had the benefit of night vision, mammals would quickly become the most obvious desert dwellers. About half of the mammals on the Plateau are rodents; kangaroo rats, pocket mice, chipmunks, squirrels, and prairie dogs all belong to this group of highly productive, chisel-toothed mammals. They spend the day underground, where twenty-four-hour tempera-

tures rarely vary more than two degrees, and they emerge at night to forage for the seeds that comprise most of their diet.

Among these rodents, kangaroo rats are perhaps the most interesting. The adaptive mechanisms they have developed make them one of the most efficient dwellers of any habitat. They do not drink water, but instead extract moisture from the seeds they eat. This capability is dependent on a unique combination of adaptive mechanisms, including highly efficient kidneys, nasal passages that condense water before it is exhaled, and being nocturnal. Conservation of water, rather than its intake, becomes paramount. The seeds of desert plants, when stored in the relatively high humidity of underground burrows, can hold up to 20 percent of their weight as moisture. Once the kangaroo rat ingests the seed, its body lets little of that moisture escape. Its powerful hind legs enable the kangaroo rat to leap, erratically, distances of up to nine feet in an effort to escape the snakes, owls, foxes, badgers, and skunks for which it is prey. In the dim light of the desert night, predators with a keen sense of smell have an advantage. To combat this, kangaroo rats have bulges on the back and sides of the skull that house the sensitive ear apparatus that enables them to detect the low-frequency sounds emitted by stalking predators.

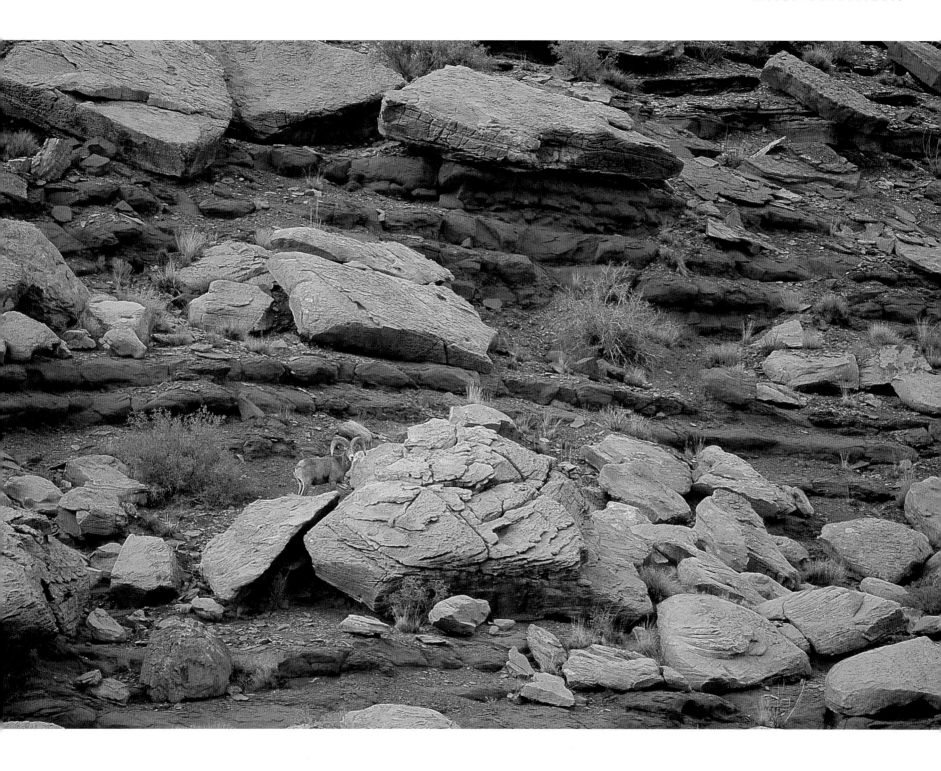

Larger mammals have an easier time adapting to desert environments. Consequently, coyotes, mule deer, cougars, and bighorn sheep resemble their counterparts in other habitats. Their large size alone prevents them from relying completely on water processed from food, but at the same time enables them to move longer distances to find continuous supplies of water. Body mass also controls the speed at which internal temperatures rise; the larger the body, the longer it takes body fluids to reach a dangerously high temperature. Therefore, large-bodied mammals have more time to forage at elevated air temperatures before they need to seek shade and begin the cooling process. Although large mammals are not plentiful in canyon country, by knowing the location of widely dispersed water sources, and at the same time regulating the timing of their activities, select populations have adapted nicely to the arid conditions. And it is at dawn or twilight that you must be at those same desert waterholes to catch a fleeting glimpse of desert mammals.

Today's desert bighorn sheep have descended from sheep that wandered farthest, after their ancestors made the eastward trek across the Bering Strait at the end of the Pleistocene Era. They inhabit isolated mountain ranges where native grasses haven't been depleted by domestic livestock, although successful reintroduction programs have established them in most of the national parks of the Southwest. Their evolution in an arid habitat has given them a somewhat different appearance from their northern cousins. Petroglyphs chipped into panels of desert varnish by prehistoric Native Americans depict sheep with very large horns for their body size. To people familiar with the Rocky Mountain bighorn, these petroglyphs seem grossly crude and distorted. However, they are right on the mark. The horns of the desert sheep are thinner and more flaring than those of the more northern species, giving them an extremely out-of-proportion look. They have the smallest bodies of the North American sheep, an adaptive characteristic helpful in maintaining the necessary internal heat balance. They can go days without drinking and are seldom found far from cliffs that provide security. Wary, almost reclusive, getting by on the thinnest of margins, they personify the inhabitants of the Colorado Plateau.

Canyon Country does not boast the "charismatic mega fauna" (Park Service terminology!) of the Northern Rockies. Although many species are the same as those found to the north, the abundance is nowhere near that which occurs in the northern habitats. Frying pan heat and suffocating aridity limit the niches for eking out a living. Like vegetation, wildlife provides worthwhile lessons in adapting to the region's capability rather than trying to change it.

Afterword ~ History, Economics, and the Future

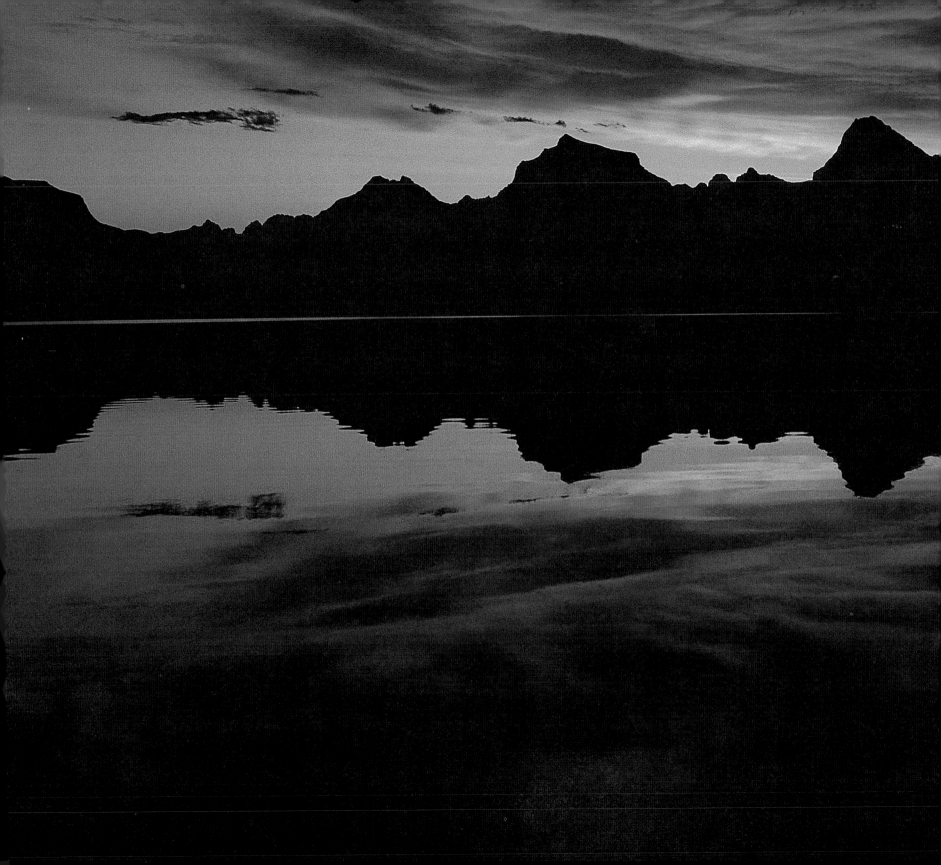

HISTORY, ECONOMICS, AND THE FUTURE

Hundreds of millions of years of continental collisions, of gradual uplift and erosion, of waxing and waning oceans, of volcanic eruptions—all continually modified by ever-changing climates—have produced the landscape of today's West. High, dry, and often cold, it is a landscape that supports vegetation only grudgingly, and animals only after generations of adaptations. Although today's West is but a point on the timeline to infinity, it is the point at which we live. If we are to do so successfully, and in a sustainable fashion, we must craft a society that fits the capabilities of the region.

As the twentieth century draws to a close, that process is under way. And it is painful. Economies that have supported the West in the past are hard pressed to remain viable, while new, often conflicting economies are elbowing their way forward to challenge the old guard. Established traditions are being questioned as new values emerge, both from within the region's borders and from the rest of the nation. Western communities, in the past both isolated and insulated by distance and space, are being forced to cope with change that seems to be occurring at an accelerated rate. All too often, change precipitates conflict as the volatile mix of economics, politics, tradition, and philosophy simmers near the flash point.

The opposing forces in the battle over western resources could be termed Wise Users Versus Tree Huggers. Although there is a wide spectrum of people within each faction, the two schools of thought might be generalized as follows: As a rule, Users are people who make their living directly from natural resources and believe that those resources exist for consumption and profit. Users are often, but not always, native to an area and have a strong sense of the rights of individuals to engage in the traditional land uses. Many Users have been supported by the West's natural resources since the late 1800s and feel they can maintain their traditional lifestyles through continued use of those resources. Some Users may believe that a form of natural resource regulation is necessary, but only in some future time and in some other place. Huggers, on the other hand, are guided by a less consumptive approach to natural resources. Many tend to take a spiritual view of nature, believing that the benefits derived from natural resources are more experience oriented, including such activities as solitude and recreation. This "kinder and gentler" approach leads the more hard-core Huggers to favor preservation over any sort of consumptive use. If extractive land uses must take place, then they should do so only within strict limits. Many Huggers depend on natural resources for their livelihood, but that dependence is based on the maintenance of the landscape in a relatively undisturbed state.

Users and Huggers have been battling over the American West since the 1860s, and both sides can claim their share of victories. The Users were dominant before the turn of the century,

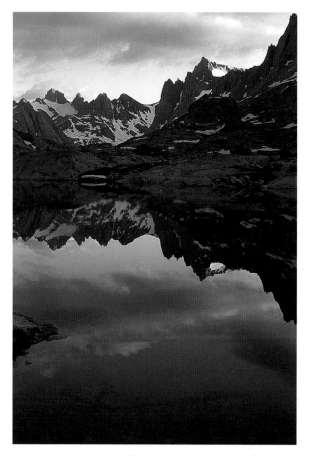

Titcomb Basin, Wind River Range, Wyoming

Opposite:
Sunrise, Lake McDonald, Glacier National Park

but the Huggers have made significant advances in recent decades. Hugger victories have occurred mainly in the legislative arena. Witness the Wilderness Act (1964), the National Environmental Policy Act (1969), and the National Forest Management Act (1976), all passed in response to User excesses. Huggers have gone on to employ this new legislation successfully in the courts. User victories, on the other hand, have come on the ground. Much of the West is open to resource extraction, and the traditional land uses continue today much as they have in the past. The Users have also been extremely successful in controlling western politics, and have been able to restrict budgets and funnel appropriations in such a way as to negate many of the Hugger legislative and legal advances. Although the Huggers are gaining momentum and, with their legislative victories may have more big guns to bring to bear in the future, the Users are definitely ahead on points. And that's too bad. For the Users' approach to living in the West is not one that has shown itself to be self-sustaining.

At this point it might be advantageous for the two sides to step back and take a longer view. Both sides could be aware of historical perspective and land capability, of demographics and future needs, and both might consider issues from a national as well as local perspective. Maybe, then, the inevitable change might be better understood. Maybe. . . .

There are a number of "truths" about the American West that determine the success or failure of all facets of life in the region today. They have shaped the West in the past and will control it in the future. They have been dominant. They have been inflexible. The Holy Trinity of the American West—Aridity, Public Land, Outside Control (one physical, one political, one economic) form the mold into which life in the West must inevitably fit.

The first and most important truth is aridity. Previous sections of this book deal with reasons for the lack of moisture in the major part of the Intermountain West. Aridity is the region's dominant physical feature. Precipitation in valley bottoms east of the Continental Divide in Montana and Wyoming, south of the Salmon River in Idaho, and across the entire Colorado Plateau, hover at the desert-defining, ten-inch level. Yet, since the days of the pioneers, Americans have repeatedly tried to sustain the Jeffersonian ideal of the yeoman farmer and his agrarian society in the Intermountain West. What small success that has been achieved has been tied to massive federal support and is almost totally dependent on expensive technology. This influx of money and bureaucracy has managed to soften the hard edge of aridity—but only locally, only marginally, and only temporarily.

The siren song of water storage is enticing to many Users, yet like the Loreli, beckoning sailors to destruction on the rocks, it leads its victims to eventual disaster. For agriculture in an arid environment requires solutions for three water-related problems: amount, location, and

Red fox kit in Beaverhead National Forest

timing. Adequate water must be delivered to crops during the growing season. A system of dams, canals, and ditches can only store and move water, not create it. The most important factor—the need for a long-term water supply—is not addressed by a system that merely redistributes the water that it annually receives. If the supply is not replenished, there is no water to store or distribute. By continually cajoling an all-too-willing government into investing in a system that solves only the storage and redistribution problems, Users have deluded themselves into thinking that aridity can be beaten. In reality, they have increased their dependence on the capricious whims of climate.

Eventually, the advantages gained by bringing water to crops begin to be outweighed by the long-term economic and environmental costs. Throughout the long run of history, every society dependent on irrigation has failed. The causes are varied: irrigation in arid environments often leads to salt-encrusted soils, climate change reduces available water supplies, and the need for water outstrips the ability to store it. But the results are consistent. The society's living standards eventually decline, and then people have to move on.

Throughout the West, the strategy of the Users has been to perpetuate the very approaches to irrigation that have proved unsuccessful in the past. In the last sixty years, millions upon millions of dollars have been spent to defeat aridity: from Fort Peck Reservoir in Montana to the Central Arizona Project in Arizona; from Grand Coulee Dam in Washington to the Staked Plains of Texas. But all of the dams, canals, sprinklers, and ditches have succeeded only in irrigating an area half the size of Wyoming, and only a portion of that could be termed cost effective. Technology has not solved the irrigation problem—only rescheduled it.

Grazing in the semiarid West is a tenuous proposition at best. Some of the higher-elevation areas produce excellent forage, but at the lower elevations, a cow would be well advised to pack her lunch in advance. To make grazing work successfully, well-conceived and well-managed grazing systems are critical. Riparian areas (the green areas in bottomlands and often the only source of water) are the keys to success. Unfortunately, these areas are highly susceptible to damage by livestock, as stream bank trampling and overgrazing can change the way the entire drainage system functions. The loss of the riparian area's ability to store water and act as a buffer against infrequent flooding leads to a lack of productivity for the entire watershed. Yet it is the riparian areas that have suffered most from the hooves of domestic livestock.

Forests, too, are not immune to the grip of aridity. Lodgepole pine is the dominant species on the majority of timber-producing lands in the West, and in these environments lodgepole pine grows slowly and it grows short—not a good combination when board-foot volume is the desired product. Commercial forest land on many sites in the West averages 8,000 to 10,000 board feet per acre. Volumes in the Pacific Northwest commonly reach ten times that. In the Southeast, pines produce similar per-acre volumes to lodgepole, but they do it in a third of the time.

Foresters often speak of the "regulated forest," in which each acre pulls its weight and is periodically harvested for a "nondeclining, even flow" of wood products. This is a forester's view of the perfect world. However, random natural events such as fire and insect epidemics

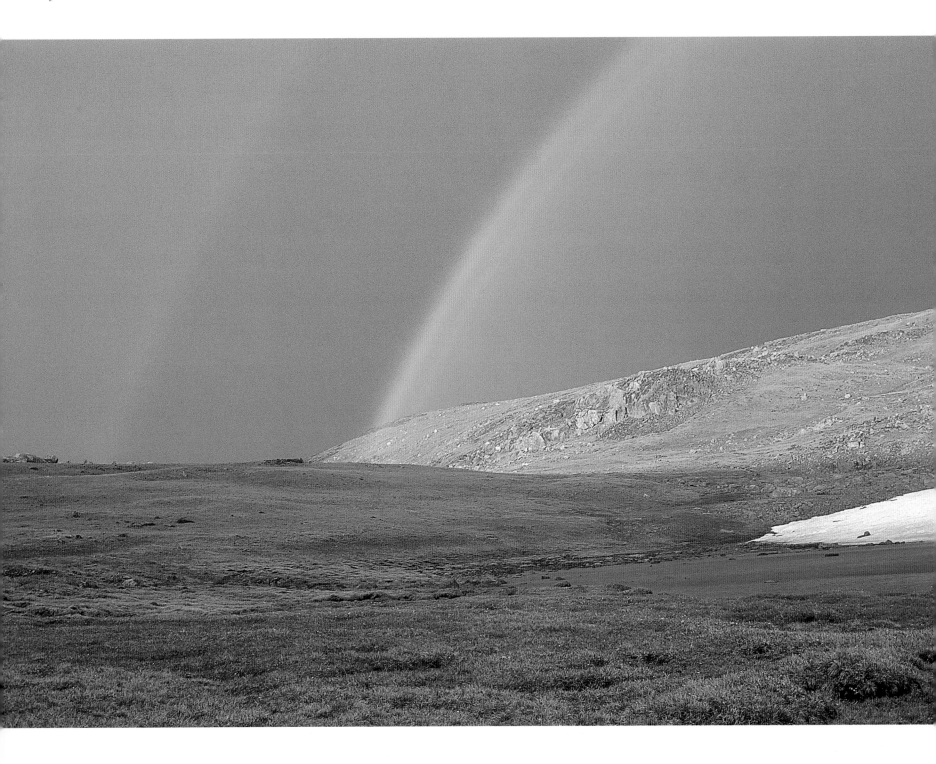

work against the regulated forest and occur on schedules and at intensities that often thwart man's control capabilities.

From a utilitarian standpoint, the regulated forest may be a commendable approach for regions that can sustain a high rate of wood production. However, the intensity of management required to convert a "wild" forest to a regulated one, even on productive sites, demands large investments of time and money and causes adverse effects on other forest resources, such as wildlife habitat, watershed function, and diversity of plant species. It is a concept that might well succeed if it could be achieved with a magic wand, but continuing to pursue that goal in the Intermountain West is akin to continuing Coronado's search for the Seven Cities of Cíbola.

From cloud seeding to monster dams, Users have made heroic efforts for more than a hundred years to make the desert bloom—and they have solidly hit the intractable wall of aridity every time. John Wesley Powell's visionary concepts, even if implemented, would not alter the fact that the West is a desert. Powell knew that success lay in adaptation rather than mastery. The West will never compete with other regions in the production of commodities that are dependent on moisture and vegetation. It is time we stopped trying. Sustainable economies can only be achieved if aridity is viewed as a constraint rather than a challenge, and our expectations are adjusted accordingly.

The second truth concerns government and public lands. The federal government supports the West . . . period! From high dams to low grazing fees, the feds have made it possible for life in the West to continue. The word "subsidy" is often used by Huggers to describe the relationship between the government and Users. In the strictest definition of subsidy, money is not always exchanged. But few could disagree that government policies make virtually every facet of life in the West immeasurably easier. And the lifestyle that is federally maintained is most often that of the User. The federal government builds dams; it kills predators; it collects minimal royalties from the sale of public minerals; it builds free logging roads; it maintains grazing fees below those of the private sector; it buys and stores surplus crops; it contributes to rural electrification; it builds highways; its lands draw tourists; and it maintains a work force that contributes tens of millions of dollars to local economies. All of this enables most Users to perpetuate their cherished myth of "rugged individualism." Perhaps the greatest government subsidy of all is the one to the User's psyche.

But above all, the government is the landlord. The public lands (national forests, national parks, BLM lands, military reservations, and wildlife refuges) make up about 80 percent of the West. That these lands belong to all of the citizens of the United States is often a source of resentment to many Users, who feel that their proximity decrees a more legitimate title. Often, efforts by federal agencies to include a wide spectrum of the public in land management decisions is looked on by Users as the government treading on their "individual rights." In reality, the benefit of government presence in the West has been skewed toward the Users for years.

In the late 1800s, the federal government began selling western lands at bargain-basement prices, initially to railroads, and then to ranchers, farmers, and homesteaders. Granted, all these entities expedited western settlement, but even one hundred and thirty years later, Users are

Opposite:
Double rainbow, Beartooth Plateau, Montana

still reaping the benefits of these initial incentives. Many of the private timber lands that are being cut over in the West today were taken from the public domain and given to railroads. They have since been passed on to large timber companies, and the trees that cover them now provide a commodity to be traded between corporate boardrooms.

About the time the frontier was closing, the federal government established agencies to administer western lands it was unable to offload onto the private sector. This was the first of the so-called land "lockups" and incensed many Users, who saw an end to their looting of public lands. In reality, even if it was not business as usual, business was still pretty good. While the agencies had a role in protecting the public lands from industry's heavy-handed practices, they also were charged with the "development" of those same lands. This meant working closely with the various User groups the agencies were supposed to keep an eye on. In many instances, this role developed into that of a "silent partner" in the industry agenda. Many agency professionals, schooled in resource management, became philosophically aligned with the various Users. The BLM aligned itself with the grazing and mining industries; the forest service with the timber industry; the park service with the railroad industry. All formed symbiotic relationships, blurring the line between the dual roles of protection and development within the agencies. This, in addition to the Users' ability to control western politics, led to a situation in which the Users have been very much in the saddle when it comes to control of western resources.

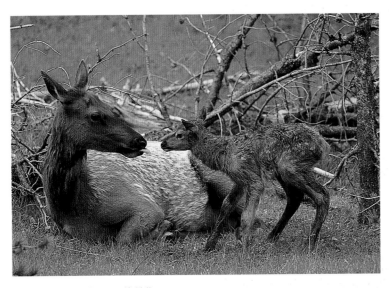

Elk cow and newborn calf, Yellowstone National Park

Yet, make no mistake about it, the presence of federal agencies in the American West has been overwhelmingly positive. However imperfect their management may have been, without it things would have been considerably worse. Resources that are in marginal condition today might long ago have disappeared if allowed to be exploited by private management. This is another, albeit indirect, benefit to the Users. The resource protection provided by agency management has prevented other "traditional" Users from going the way of the beaver trapper and the buffalo hunter.

The last constant in the American West, and perhaps the most perplexing, is outside control. In the 1950s, author Bernard De Voto referred to the West as a "plundered province." Recently, the West has been likened to a third-world country. Both statements may have more truth than fiction to them.

The West has never controlled its own destiny. It has been forever on a "boom-and-bust" roller coaster, responding to economic pressures dictated by power centers far removed from the region. Today, much of the Intermountain West fares no differently. Recently, timber companies have been harvesting their private lands ("liquidating assets," in their terms) at rates inconsistent with sustained yield, in an effort to ward off corporate takeovers. Anaconda Company, a mining company once synonymous with Montana, has bolted for South America,

leaving the Butte area as the largest Superfund clean-up site in the country. The legacy of corporate rule is not one of which we can be proud.

Nor is the cattle industry immune to outside control. Beef prices are set in the Midwest, and western ranchers adjust accordingly. Additionally, many ranches are owned by large national corporations and operated as tax write-offs. Those ranches still under family ownership are often forced to support the descendants of the original settlers. The ranches haven't grown in size or productivity, but more people are now dependent on the same level of output. Finally, the belated recognition of the adverse effects of livestock on riparian areas is bringing national environmental groups into the picture. The point is that ranching in the West, the historic mainstay of many local economies, is at the wrong end of a long line of tenuously interconnecting circumstances over which it has little control, but in which it has a great deal at stake.

Ironically, the Users have created the situation that exists today. For there has never been a shortage of the "Chamber of Commerce mentality" among western boosters. It began in the 1860s, when developers assured settlers that "rain follows the plow." It continues today as many towns are urged to hang onto their "traditional" economies, with the promise that the boom is again just around the corner. The quick fix of jobs and "prosperity" always finds willing junkies, but the withdrawal that occurs during the inevitable bust often leaves them with a greater dependence on the resources they recently used up. For, despite all of the tame politicians, all of the sympathetic agency management, all of the subsidies, all of the land available for development that the Users have enjoyed for the last hundred years, the traditional economies are still just bumping along, leaving a few people rich but keeping most folks surviving on hope. If the West had as much rain as it's had hope, it might begin to fulfill User expectations.

All this is not to say that the traditional land uses should disappear from the scene. They have written much of the West's history, and they can be involved in much of its future. But change is necessary. Users will have to abdicate the dominant role they have had since the 1800s and accept a lesser role in the future economy. Timber harvest is possible, though at a smaller scale, and structured for locally owned, more efficient mills. The livestock industry will always be a part of the West, although ranchers might have to spend more time managing fewer cows. The mining industry will have to accept the concept that reclamation is as important as extraction, and then meaningfully implement it on the ground. For in a real sense, it is not the land uses themselves that are incompatible with land capability, only the scale at which they have been carried out, and the practices employed to implement them.

So, today, the West remains a region defined by aridity, presided over by politically influenced federal bureaus, and held in economic bondage by interests that view it as a supermarket for raw materials. But the "rugged individualists" who make up the vast majority of its Users will spend most of their lives trying to conquer first aridity, then federal management, and will meekly accept the dictates of outside control. Aridity is immutable; public ownership is forever. Thus, the sole opportunity the West has to maintain a stable, self-determining society is to reduce its dependency on outside control.

The alternative to traditional uses most often touted in discussions about the future of the West is the recreation and tourism industry. Several towns have already made the switch from extracting resources to showcasing them and have seen their economies stabilize and grow in the process. Areas such as Jackson, Wyoming, and Sedona, Arizona, have been tourist centers for years, but there are others that have recently begun the transition with varying degrees of success: Pinedale and Dubois in Wyoming; Moab and Park City, Utah; Stanley, Idaho; and Durango, Colorado. From a purely economic standpoint, the shift to mining pocketbooks and herding tourists has often led to more stability than scratching holes in the ground or punching cows.

Although recreation and tourism do provide the West with an alternative to the extractive economies, they are not a panacea. Subject to the same restrictions of scale that govern the traditional industries, the values that drive the various recreation experiences can be compromised by overuse, just as much as by overuse of timber, water, or forage. For the inevitable sequel to tourism is development. Many of those folks that spend their two weeks touring the national parks return home with the idea of establishing the family beach head in Moab, Utah, or Montana's Gallatin Valley. Many are successful. Today, the apron of sprawl surrounding many western towns resembles a mini Long Island in the early 1950s. It is the most visible symptom of the next land-use crisis.

Although not as offensive as open pit mines or overgrazed riparian areas, unchecked development leads to its own array of problems. Building levees to "protect" valuable floodplain property will eventually redefine a river just as surely as if it were dewatered for irrigation. Widely separated houses, scattered across sagebrush hillsides, will not deter deer from moving downhill when the snows get deep—especially when those same houses provide ornamental vegetation as an alternate food source. But more densely arranged housing developments in narrow valley bottoms, with their attendant roads, fences, dogs, and horses, will block migration routes that elk need to access their winter range. Sewage pollutes rural waters just as readily as urban waters, but in the West it can also affect the lake or river upon which the local sport fishery depends. The rustic architecture of log homes with shake roofs nestled among the towering pines is popular as a symbol of symbiosis with the environment. Such houses, though, are also death traps when the inevitable forest fire restarts the plant succession cycle. The cost of protecting homes often exceeds the capabilities of the agencies and municipalities charged with that task. On the Colorado Plateau, in particular, just finding a water supply adequate for the population is an immense problem. All of these are real situations being faced by western communities today. They are no less serious than overharvesting a watershed, acid-mine drainage, or riparian areas that offer little flood protection.

Not all of the problems associated with recreational development are resource based. There are social ones as well. The open space that attracts many urban refugees to the West is often compromised by the time they arrive. Others have had the same idea, and the immigrants are likely to find themselves looking at new scenery but facing the same old problems: air pollution, traffic, overcrowded schools, escalating land prices, higher taxes. And no job. For those arriving in the new West still face the same dilemma as those arriving in the old: the need to sustain a

Opposite:
Lichen, Sawtooth Mountains, Idaho

living within the capability of the land. That capability hasn't changed, but the need to support a growing population, while at the same time shifting away from the traditional land uses, has created much uncertainty in many western communities.

The downside of "recreational" economies is real. Finding solutions to the problems created by development is just as necessary to the future West as finding acceptable ways to harvest timber and graze riparian areas. But many Users cite the downside of alternative economies as a reason to maintain the status quo. That approach should be left to ostriches. The demographics of the West are changing, and that alone will force a shift in local power structures. New values will dominate old towns. New alliances will form, and old ones dissolve, as there is a scramble for position in a new hierarchy.

One of the ironies in today's West is that, while it is no longer a frontier and must distance itself from the frontier mentality, the West still fulfills that need for many people in the United States. With no new frontiers readily accessible, we pump longevity into the old one. For in the thinking of many Americans, the West is as much a state of mind as it is a piece of topography. Fed from birth on a steady diet of cowboys, mountain men, wild animals, and seemingly endless opportunities for hunting and fishing, most urbanites still cherish the myths that proclaim the West as the last frontier. From John Wayne to Thelma and Louise, the entertainment industry has generously perpetuated these myths in the American psyche, and millions of people visit the West each year to live out their atavistic dreams. They come to hunt and fish; to ski and snowmobile; to camp and hike. They come to art festivals and dude ranches; they go on float trips and on horse trips; they volunteer to work on ranches, and they work for federal agencies. But most come just to see it. And they come because wherever they live, they are unable to get what the West has to offer: space, distance, solitude, wilderness, grandeur, adventure.

Wilderness provides a number of the values that people come to the West to experience. This is easily the most volatile and emotional issue between Users and Huggers and has been the flash point in any number of battles. Wilderness deserves to be preserved. It has shaped much of the American character; it serves as a yardstick against which to measure our civilization; it provides renewal for those who wish to experience it; and it demonstrates our respect for the earth. As a society, it speaks well for us that we have set wilderness aside, after so many previous societies have let that opportunity slip away. As the present rolls into history, we will be the better for it.

These somewhat esoteric reasons for wilderness are lost on most Users. They would rather cry "lock-up" and make the argument that wilderness costs jobs because it doesn't produce logs and tons of ore and barrels of oil. In fact, in the last fifteen years, the western counties with the most stable economies are those with the most wilderness. Users seem to have trouble realizing that wilderness is part of a scenario that provides long-term stability to local communities by creating jobs such as guides and outfitters that are within the capability of the country rather than jobs that attempt to redefine it.

The bottom line is that the days of the endless supplies of raw materials are over, if indeed they ever existed. Users will advocate technology (fertilizers, cattle steroids, new logging

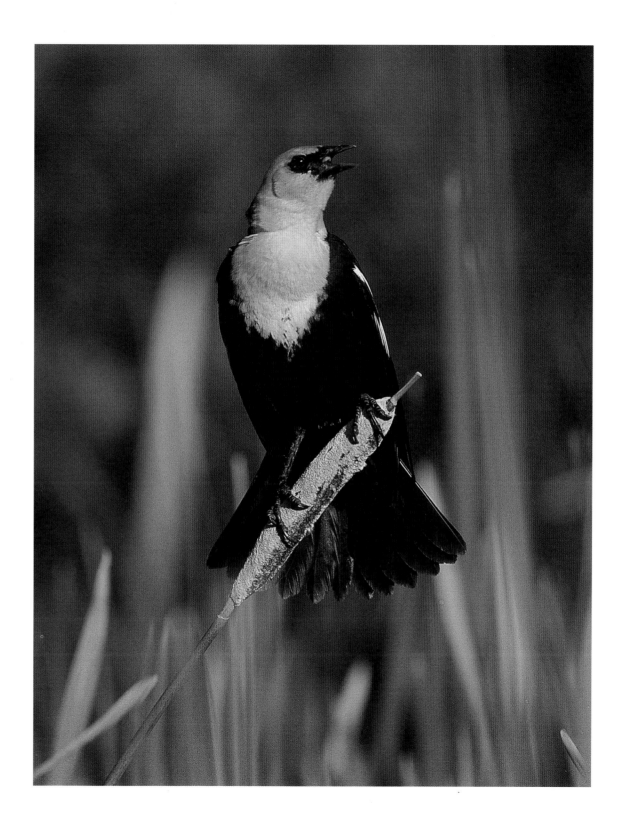

*Yellow-headed blackbird, Beaverhead
National Forest, Montana*

systems) to "solve" the problem, but that is making the same mistake as believing dams offer protection against droughts. Rather than leading us down the same tired path, technology would better serve the West by contributing to diversity rather than sameness, by encouraging economies of scale rather than growth. For the hard reality is that resources within the Intermountain West, including both commodities and amenities resources, are finite. The concept of the earth as a supermarket should have gone extinct with the passenger pigeon. Nobody's restocking the shelves.

Before speculating about the future, perhaps we should look backward to gain insight. For somebody was here first. Scientists now believe Native Americans walked across the Bering Strait to the North American arctic from Siberia as much as 20,000 years ago. Between then and A.D. 1500, new arrivals populated two entire continents, increased their number to between 57 and 112 million people, and created a range of societies from hunter-gatherers to agriculturalists. Although diverse in custom and culture, their societies were marvelous adaptations to the many environments of North America. Far from being passive, these First Americans were also North America's first land managers. Fire was widely used as a rudimentary tool for wildlife management, minerals were mined to produce tools and ornaments, and some form of agriculture was practiced by many groups throughout the continent. Although alternating intertribal warfare and cooperation was a way of life for most cultures, there was a unifying theme in the basic tenets of their approach to the supernatural world.

Native American spirituality arises from the land. While there is no single religion throughout the continent, a common theme among native peoples is that the earth itself is sacred. All parts of the earth, including the plants and animals living upon it, are part of that spirituality and are treated with respect. While it is true that various tribes, clans, and families often associated themselves with a particular region or plot of ground, ownership of land according to European-American beliefs was, and still is for many tribes, a completely foreign concept. The basis of Pan-Indian religion is spatial rather than temporal—a sense of place rather than a journey to the promised land. Time itself is not linear, but circular. Observing the cycle of the seasons, the migrations of animals, and the various powers represented by the six directions are all seen as ways of staying in rhythm with the earth.

The arrival of Europeans in North America introduced an entirely different philosophy to the continent. Rather than being the spiritual basis for life, land was seen as a commodity. Instead of the earth being a giver, man became the taker. The French took furs, the Spanish took gold, and the new Americans took land. More significantly, they all took souls, as converted "heathens" became scalps on the belt of Christianity. Conflict was inevitable, and so was the outcome.

From the island of San Salvador, where Columbus landed in 1492, to the freezing windswept plains of Wounded Knee, South Dakota, site of the last major battle of the Indian Wars, 1890, the European-Americans relied on advanced technology, deadly diseases and, eventually, overwhelming numbers to wrest a continent from its native inhabitants. The struggle was fierce and bloody, but the result was never doubted. Although the fledgling United States

Opposite:
Frosty morning on the Gibbon River,
Yellowstone National Park

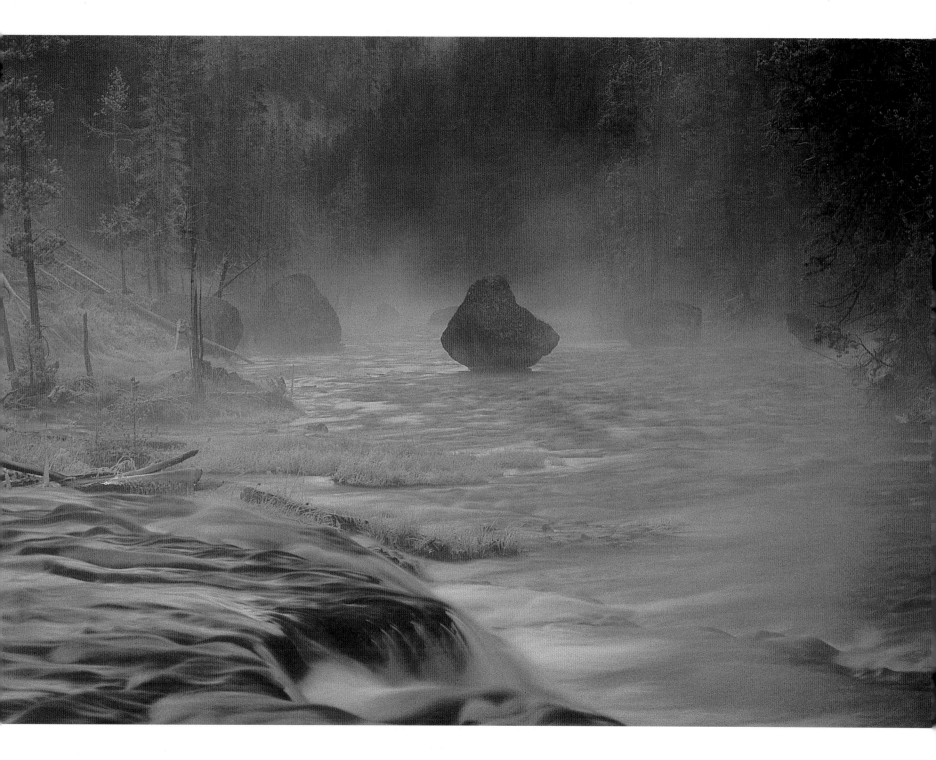

under President George Washington initially tried to treat the Indians with "utmost good faith," the expansionist mindset on the western edge of the new nation would settle for nothing less than virtual genocide. That mindset followed the frontier westward, and by the time Manifest Destiny was "taming" the American West, complete subjugation of the Native American was national policy. Many Users who, today, feel their lifestyle and culture are threatened by immigrants from other parts of the world might gain some perspective by remembering the policies of their forefathers.

Ironically, the legacy of our public lands has its origins in the deceitful way in which they were acquired. After we purchased much of the trans-Mississippi West from European nations that had discovered a "New" World, we still had to solve the thorny problem of those who, after living on the land for centuries, still believed they had a right to it. "Conquest" is not really the right word to describe our takeover of the West, as our battlefield record was nothing to brag about. However, at treaty making we were virtually undefeated. The terms of many treaties were extremely beneficial to the Americans, and terms that benefitted Native Americans were eventually ignored. By dividing tribal leadership, offering low value annuities, and perpetrating outright fraud, the United States dispossessed the Native Americans and took control of the West. Much of the region was soon passed on to settlers by way of the Homestead Act, and to railroads to expedite settlement. The rest—today's National Forests, National Parks, BLM lands—were turned down as worthless by early Users. Now they are the very core of our land heritage.

However, our victory may yet prove to be hollow. Although we've gained dominion over a continent, there is still some question as to whether we've learned how to live with it. By conquering the land but not realizing our relationship to it, we may well have sacrificed the sustainability necessary for long-term success. By reestablishing our relationship to the land, we do not preclude technology, nor are we forced to accept a lower standard of living. Instead, we must view technology and living standards from the context of our place in the universe, from a philosophy of renewal instead of depletion. Such a philosophy would establish the National Park System, not make a dust bowl of the great plains. Such a philosophy would prevent human-induced extinctions, not stand by and watch the last salmon runs of the Columbia River dwindle to nothing. Such a philosophy would create adaptive technology, not allow acid rain to sterilize lakes and smog to obscure the Colorado Plateau. We readily accept Native American symbols for our sports teams and point with pride to the "Indian" names on the map. Can we not also adopt their far more substantial offerings?

Despite the white man's disheartening history in the West, a new way of approaching the contentious issues surrounding natural resources offers some promise. "Ecosystem Management" is the buzzword for an emerging philosophy that applies to regions still containing a high percentage of wildlands. Ironically, the two words represent the poles of opinion, and both Users and Huggers are currently vying to put their own spin on the final definition. Consequently, ecosystem management is being touted as everything from letting nature run its course to a veil for business as usual. The answer, of course, lies somewhere in between.

Despite the uncertainty, the ecosystem "tapestry" may well be woven from a number of common "threads." These "threads" may be described in the following way:

THE DEFINITION THREAD sees an ecosystem as the dynamic interaction among plants, animals, and their physical environment. Ecosystems have flexible boundaries and occur in many sizes. An isolated glacial lake is an ecosystem, as is the geographic area known as the Northern Rockies. Small ecosystems aggregate upward to form larger ones. The glacial lake is a component of the alpine ecosystem, which is a component of the mountain ecosystem, and so on. As size increases, ecosystems begin to be named geographically. For example, the alpine ecosystems, riparian ecosystems, forest ecosystems, lake ecosystems, and sagebrush ecosystems in the vicinity of northwest Wyoming and southwestern Montana all combine to form the Greater Yellowstone Ecosystem.

THE PROCESS THREAD sees an ecosystem as a specific place only in the sense that it defines the arena in which natural processes operate. Consequently, ecosystems can only be sustained if the myriad processes that govern the interaction among plants, animals, and their physical environment continue to function. The killing of cougars on the Kaibab Plateau in the 1920s suspended the predation process, causing deer numbers to multiply. The subsequent decline in forage and vegetation led to an increase in soil erosion, and finally to an overall reduction of the ecosystem's productivity. The loss of one system affected the function of many.

Ecosystems are also dynamic. In the natural world, the most obvious constant is change. Many factors (weather, food supply, fire, disease) are continually imposing stress on ecosystem processes, forcing them to adjust to shifting conditions and to each other. A healthy ecosystem can absorb these stresses and continue to function. For example, a gradual increase in precipitation due to a changing climate will lead to greater vegetation density within a region's watersheds and along its riparian corridors. Consequently, valley slopes and stream channels are better protected from the increased runoff and erosion is not excessive.

Jack Ward Thomas, current chief of the U.S. Forest Service and the first biologist to head the agency, has said that ecosystems are not only more complex than we think; they are also more complex than we can think. So true. For there is a synergism within and among the processes that define ecosystems, and the whole is always greater than the sum of its parts.

THE HUMAN THREAD sees people as a component of ecosystems, and any scenario that seeks to separate the two is certain to fail. However, human beings are unique in that they are the only ecosystem component with values. Products of education and experience, the values of individuals within a society determine its actions. Given humankind's innate intelligence and its mastery of technology, those actions are often powerful enough to affect the processes that determine ecosystem sustainability. The effects can be either positive or negative, depending on the values that drive them. In the space of eighty years, we have eradicated and then restored the wolf. In the space of forty years, we have dammed the Colorado River and then attempted to revitalize its flow. In both cases, from an ecosystem perspective, we've gone from less responsible to more responsible actions. To a certain extent this shift in values represents a growing awareness of the consequences of disrupting ecosystem processes. History demonstrates,

however, that society's values are often elusive, making the human thread the most delicate in the tapestry.

But the tapestry of ecosystem management is well worth weaving. Despite the attempts of Huggers and Users to define it in their own image, the principles that drive the philosophy make too much sense to abandon. Although our ability to "manage" as we have in the past is restricted by a lack of knowledge and the limits of technology, we can still recognize where processes aren't functioning and give them a nudge in the right direction. For example, where fire suppression has created excessive fuel loads in forest stands, those loads might be reduced by thinning the forest or by prescribing fire when conditions are favorable. By these actions we would be restoring fuels to more natural levels, and ecosystem processes could again function in a sustainable manner. On the other hand, to use large-scale timber harvest with its attendant roading as a surrogate for fire in an attempt to improve "forest health," would likely guarantee more watershed problems than a wildfire. Clearly, one action would be responsible, the other reckless. Perhaps "ecosystem tweaking" would be a better term for the new philosophy. For in a real sense, successful ecosystem management closely parallels the old adage that says: Change what you can, accept what you can't, and have the wisdom to know the difference.

So what can be done to initiate and maintain a shift toward an economy not wholly dependent on the traditional extractive industries, while at the same time not compromising critical amenity values? How can ecosystem management be made to work?

First, comprehensive local planning could become a dominant force. A great deal of power resides with local governments, civic organizations, conservation districts, local environmental groups, neighborhood organizations, and federal agencies. As these groups work together, that power mushrooms. Legislated solutions to resource problems, at both the federal and state levels, have been only marginally effective. They have created a framework of laws that provides necessary guidance but is not flexible enough to deal with all contingencies. Local action, supported by a knowledge of local conditions, is a powerful way to synthesize ideas and implement solutions. The cornerstone for discussion must be a definition of land capability that ensures functioning natural processes and sustainable ecosystems.

Successful local action is difficult. All facets of the issue must be represented, and that in itself is often a major hurdle. Users and Huggers, many of whom have been sworn enemies for years, must face each other on the same piece of ground. It is an exasperating, often excruciating exercise. There is no cookbook for guidance, and success or failure is almost totally dependent on personalities. However, if a group is tenacious enough, if discussion replaces rhetoric, then results can be achieved. The first sign of progress occurs when reality displaces perception. On the one hand, Users realize that their past actions have harmed watersheds or wildlife. Just as often, Huggers are forced to admit that not every timber sale, mine, or livestock herd signals ecological

apocalypse. As the process continues, Users become aware that, in some places, their activities are not compatible with maintaining natural processes, while Huggers realize there are ways of using resources that protect those processes. Slowly, as trust is built, solutions can be crafted.

Attempts at cooperation have shown some success in a number of places throughout the West. In 1992, on the Henry's Fork River in eastern Idaho, close to 70,000 tons of sediment were dumped into the river system as a result of two separate incidents involving dams. Widespread community concern for the lack of communication among federal and state agencies led to the passage of the Henry's Fork Basin Plan by the Idaho legislature. As a result, the Henry's Fork Watershed Council was formed, bringing together both environmentalists and water users to coordinate the plan's recommendations among the citizens and agencies within the basin. The council has successfully diffused many of the tensions associated with river management. In Moab, Utah, a town that has had to deal with expansive growth fueled by a mushrooming tourist industry, three federal agencies, three state agencies, and three county governments have formed the Canyon Country Partnership. They have defined an ecoregion using watershed boundaries and have sought to coordinate the science and data gathering within those boundaries. Further, they have selected their major issues and established working groups to explore alternative solutions for those issues. The biggest success so far has been that, in the words of the superintendent of Arches National Park, ". . . representatives from the nine entities are sitting down regularly, addressing each other by their first names, and discussing common issues."

Some members of the livestock industry are beginning to see the benefits of ecosystem management. A number of ranches, notably the Pitchfork Ranch near Meeteetse, Wyoming, and the Gray Ranch in southwestern New Mexico, have reworked their approach to grazing domestic livestock. The common thread that runs among them is that they manage for water and wildlife first, and then livestock. On the Beaverhead National Forest some ranchers are moving their cows based on the amount of stream bank alteration instead of the traditional forage use, thereby allowing damaged riparian areas to recover. By first creating a functioning system, and then integrating livestock within its constraints there are ways to maintain this "traditional" use on the land.

The next step in maintaining a sustainable economy might be to add a course to the curriculum of western school districts that deals with the physical capability and land-use history of the region. Central to the course would be the concepts delineated in Wallace Stegner's *Beyond the Hundredth Meridian,* Walter Webb's *The Great Plains,* Aldo Leopold's *Sand County Almanac,* and Wendell Berry's *The Unsettling of America.* The generation that is in school today will be the generation that either successfully implements ecosystem management or is forced to live with the consequences.

Potential alternatives for sustainable economies could be developed in brainstorming sessions. There are a host of possibilities. Ranchers might be given the choice of either running livestock on their public allotments or managing them for wildlife and leasing the hunting rights. This is currently being done successfully on some private lands. The creation of new national parks is possible. The Gravelly/Snowcrest/Centennial complex in southwestern

Montana, for example, could be a wildlife preserve that would surpass Yellowstone National Park. If it were created along the lines of the great wildlife preserves in Africa, the local economy would be stabilized and enlarged for decades. Timing reservoir releases for fisheries rather than irrigation would increase floating and fishing opportunities on many rivers. Water leasing is an emerging idea in the West, and individuals with senior headwater water rights hold many of the cards. Small manufacturing operations that use resources on a sustainable scale need to be developed and nurtured. The house log industry is an excellent example of a timber-extractive operation that is sustainable. Additionally, value-added products from lodgepole pine, such as furniture, are beginning to be developed and marketed. Advances in telecommunications have made it possible for people to live anywhere and still operate a business. These people will be encouraged to settle in the West by the amenities the region offers. User fees on public lands are often talked about as a source of local revenue. These are but a few ideas, and they all fit under the ecosystem management umbrella.

Finally, many of the laws that govern natural resources need to be critically revaluated. Many of today's laws were enacted in the late 1800s, before the closing of the frontier. They were passed in order to facilitate settlement of a region where seemingly endless resources supported relatively few people. Today, a growing population is trying to get by on a diminishing resource base, and the existing legal structure has yet to recognize the difference. Additionally, legislation who supposedly supported reform, such as the 1872 Mining Law, was often written by those who needed reforming the most. At the time of enactment, the present laws were radical steps forward; today, however, increasingly complex demands on resources, coupled with growing scarcities and often degraded conditions, render these statutes obsolete.

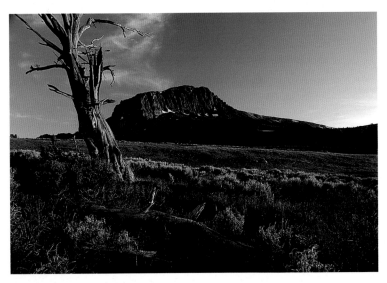

Black Butte in the Gravelly Range— the last remnant of an ancient volcano.

There is no single solution. No new industry will appear on the horizon that is capable of sustaining the economy of the entire region. No existing industry can be subsidized enough to be anything more than a maintenance operation. There are, however, many potential answers. Each one will provide another piece of an entirely new puzzle depicting the West. The border of the puzzle has already been completed. It represents the constraints dictated by geology, precipitation, vegetation, and wildlife, within which all other pieces must fit. The interior puzzle pieces have yet to be placed. The "traditional" pieces, large and blocky in previous puzzles, but now smaller and more irregular, will be part of the picture. New puzzle pieces will interlock with the traditional ones, more sharply defining the final image. Today, although many of the pieces are on the table, some are still in the box. It's anybody's guess how long it will take to position them, to try all the combinations, to set some temporarily aside, and to see finally what the picture looks like.

In the recent past, our propensity to rewrite the definition of rivers, to manage vegetation as a commodity rather than a community, to compromise the diversity of habitats, has led to a reduction in the overall productivity of the land. By single-mindedly focusing on forests as timber, on grass as cow food, on rivers as irrigation water, on minerals as a quick buck, and on open space as potential subdivisions, we have made some people rich, while making us all poorer. Each of these "resources" serves other functions, and their interaction creates a balance that defines productivity for the entire region. This productivity is not increased if more red meat is grown at the expense of riparian areas that no longer can protect against floods; it is not increased if an area's timber is harvested to the extent that it reduces the viability of wildlife habitat; it is not increased if an ore body produces gold at the same time it releases toxic metals into a river; it is not increased if a river is totally drained to increase crop yields; and it is not increased by subdivisions that eliminate wildlife winter range. These actions have reduced the productivity of the West, and in so doing may have closed out future options for sustainable economies that are more in concert with maintaining the necessary balance.

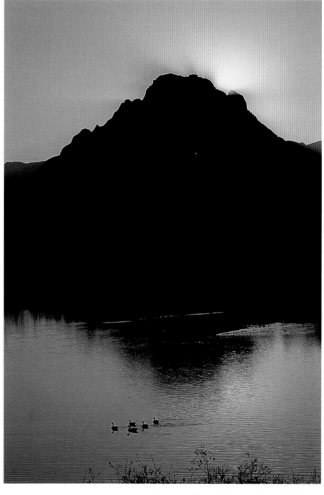

Sunset, Mount Moran, Grand Teton National Park, Wyoming

A poet once wrote that the West needed "men to match my mountains." Those men—miners, loggers, boosters—have come and gone. They have left little of substance and taken much of value. They have used the West for profit and ignored its worth. Today's paradigm, in the words of Wallace Stegner, is that the West needs "a society to match its scenery."

The West will always have its share of Chamber of Commerce boosters who are still plowing and waiting for rain. There will always be the embittered rancher banging his head against federal bureaucracy, the farmer who thinks he needs just one more field under irrigation to make up for declining precipitation, the logger who thinks that lodgepole pine at 9,000 feet is truly a renewable resource, and the developer who will sell condos in floodplains. These are the West's true mythic individuals. And they should be treated as such, as living replicas of the *End of the Trail* sculpture. The future of the West rests on the hope that the remainder, the vast majority, of its citizens are wise enough to know that operating within the capability of the landscape determines the success of the economy.

FURTHER READING

I have painted the natural history of the American West with an extremely broad brush. Space would not permit any greater detail for so vast a subject. But far more fascinating stories lie within that detail: Why is there a 400-million-year gap in the geologic record of the Grand Canyon? How do mountain goats survive the winter at timberline? Why has the State of Idaho legislated two Snake rivers? Why does a river meander? What mountain peak sends its meltwater to three different oceans?

Below is a selection of books that will take the reader deeper into the mountains and mesas that lie just over the horizon.

Geology

The "Roadside Guide" series offers the best introduction to geology for the layman. There is one published for each state, and they are generally available in bookstores throughout the West.

The U.S. Geological Survey publishes a "Geological Survey Bulletin" for each national park, which describes the features and evolution of the landscape for that park. They are available at visitors centers.

Rising From the Plains and *Basin and Range* (Farrar, Straus, Giroux: New York, 1986, 1980), both by John McPhee, are excellent treatments of western geology.

The Colorado Plateau: A Geologic History (University of New Mexico Press: Albuquerque, 1983) by Donald Baars is a well-written, readable chronological history of the Plateau's geology.

Water

Cadillac Desert (Viking Press: New York, 1986) by Marc Reisner has become the bible for western water issues. *Rivers of Empire* (Pantheon Books: New York, 1985) by Donald Worster is also worth reading.

Tim Palmer has written a number of books on rivers throughout the country. His *Snake River: Window to the West* (Island Press: Washington, D.C., 1991) is especially illuminating for the Northern Rockies.

The story of the Colorado River has been told many times. *A River No More* (University of Arizona Press: Tucson, 1969) by Phillip Fradkin and *The Story that Stands Like a Dam* (Henry Holt: New York, 1993) by Russell Martin are two of the best treatments.

Downriver (Sierra Club Books, San Francisco, 1992) by Dean Krakel chronicles a trip down the Yellowstone River, and *Run, River, Run: A Naturalist's Journey Down One of the Great Rivers of the West* (Harper and Row: New York, 1975) by Anne Zwinger does the same for the Green River.

Canyon (University of Arizona Press: Tucson, 1992) by Michael Ghiglieri is an excellent treatment of whitewater rafting in the Grand Canyon.

The Place No One Knew (Sierra Club Books: San Francisco, 1963) combines Eliot Porter's magnificent Glen Canyon photographs with the journals of John Wesley Powell.

A more technical treatment of rivers and how they work can be found in *A View of the River* (Harvard University Press: Cambridge, 1994) by Luna Leopold.

Vegetation

Comprehensive treatments of regional vegetation are generally found in scientific journals or research papers. Recently however, writings on the growing branch of natural science known as biodiversity provide insight into the connection between a region's vegetation and its health. *Ghost Bears* (Island Press: Washington, D.C., 1992) by Edward Grumbine, although set in the Pacific Northwest, provides an excellent introduction to biodiversity. *Defining Sustainable Forestry* (Island Press: Washington, D.C., 1993) by Gregory H. Aplet, et. al., and *Seeing the Forest Among the Trees* (Polestar Publishers: Vancouver, Canada, 1992) by Herb Hammond both outline alternative ways to realize sustainable economies from forest products.

The Greater Yellowstone Ecosystem (Yale University Press: New Haven, Connecticut, 1991), a compilation of recent writings on the land-use issues surrounding Yellowstone National Park by Robert Keiter and Mark Boyce, contains a section dealing with fire ecology and vegetation management.

There are many guidebooks and identification guides to the vegetation of both the Northern Rockies and Colorado Plateau. The Audubon Society Nature guides, published by Alfred A. Knopf, Inc., are perhaps the best. *Deserts* (Alfred A. Knopf: New York, 1985) by James A. McMahon and *Western Forests* (Alfred A. Knopf, 1985) by Stephen Whitney include information on the areas covered in this book.

Wildlife

The various guidebooks and identification guides available for wildlife are perhaps the best sources of the basic information concerning species and their life histories. *Birds of the Northern Rockies* and *Mammals of the Northern Rockies* (Mountain Press Publishing Co.: Missoula, 1984, 1986), both by Tom Ulrich, are good examples of this type of book. *The Mammals of the Intermountain West* (University of Utah Press: Salt Lake City, 1988) by Samuel Zeveloff offers a more in-depth treatment of each species, and covers the fauna of both the Northern Rockies and Colorado Plateau. The Audubon Society nature guides mentioned above also contain valuable information on the wildlife of the region.

Much of wildlife writing is directed at single species. *The Grizzly Bear* (McGraw Hill Book Co.: New York, 1982) by Thomas McNamee, *A Beast the Color of Winter* (Sierra Club Books: San Francisco, 1983) by Douglas Chadwick, and *Of Wolves and Men* (Charles Scribner's Sons: New York, 1978) by Barry Lopez are excellent treatments of individual animals.

Photographer Michael Francis and animal behaviorist Dr. Valerius Geist have produced three books, *Mule Deer Country, Elk Country, and Wild Sheep Country* (NorthWood Press: Minocqua, Wisconsin, 1989, 1991, 1993), each of which details the life histories of the animals in text and photographs.

Ghost of the Forest (Northland Press: Flagstaff, Arizona, 1988) by Michael Quinton, *The Uncommon Loon* (Northland Publishing: Flagstaff, Arizona, 1991) by Terry McEneaney and Michael Quinton, *The Twilight Hunters* (Northland Press: Flagstaff, 1988) by Gary Turbak and Alan Carey, and *The Trumpeter Swan* (Northland Press: Flagstaff, 1983) by Skylar Hansen each combine text and photographs to portray the life histories of animals and birds of the Intermountain West.

Along the Trail (Lowell Press: Kansas City, Missouri, 1979) by David Sumner and Danny On, provides an overview of the ecosystems of the Northern Rockies in text and photographs.

General Reading, Issues

The late Wallace Stegner has been the most eloquent spokesman for the American West in the last forty years. Of his many works, *Beyond the Hundredth Meridian: John Wesley Powell and the Second Opening of the West* (University of Nebraska Press: Lincoln, 1953), *Wolf Willow* (University of Nebraska Press, 1955), *The American West as Living Space* (University of Michigan Press: Ann Arbor, 1992), and *The Sound of Mountain Water* (E.P. Dutton: New York, 1980) are perhaps the most germane to the discussion here.

Edward Abbey's writings have defined the Colorado Plateau for a generation. *Desert Solitaire* (Ballentine Books: New York, 1968), *The Journey Home* (E.P. Dutton: New York, 1977), and *One Life at a Time, Please* (Henry Holt and Company: New York, 1988) are perhaps the best of his works dealing with the canyon country.

In *The Easy Chair* (Houghton Mifflin Co.: New York, 1955), a collection of the essays of Bernard DeVoto from the 1940s and 1950s, the section entitled "Treatise on a Function of Journalism" documents the efforts on the part of commodity interests to dismantle the public lands through the political process.

In recent years, a number of books have dealt with the changes taking place in the American West. *An Unsettled Country* (University of New Mexico Press: Albuquerque, 1994) and *Under Western Skies* (Oxford University Press: New York, 1992), both by Donald Worster, *The Legacy of Conquest* (W. W. Norton Co.: New York, 1987) by Patricia Nelson Limerick, *Under an Open Sky* (W. W. Norton, 1992) by William Cronin, George Miles and Jay Gitlin, *Sagebrush Country* (University of Arizona: Tucson, 1989) by Phillip Fradkin, *Last Refuge* (Harper Collins: New York, 1994) by Jim Robbins, *Saving all the Parts* (Island Press: Washington, D.C., 1993) by Rocky Barker, *Crossing the Next Meridian* (Island Press, 1992) by Charles Wilkinson, and *Playing God In Yellowstone* (Atlantic Monthly Press: Boston, 1986) by Alston Chase, all provide different perspectives on the conflicts among natural resources, traditional lifestyles, and physical limits that swirl around the contemporary West.

Beyond the Range Wars: Toward a West That Works (Gibbs Smith Publishers: Layton, Utah, 1995) by Dan Dagget describes ten ranching operations throughout the West that are successfully employing ecosystem management principles.

Grand Canyon: Toward a Geography of Hope (Northern Arizona University: Flagstaff, 1995) is the proceedings of the symposium celebrating the 75th anniversary of the National Park.

Photography

Many "How To" nature photography books have been published in the last decade. Among the best are *The Nature Photographers Complete Guide to Professional Field Techniques, Focus on Nature, and Landscape Photography,* (Amphoto: New York, 1984, 1991, 1994), all by John Shaw; *The Audubon Society Guide to Nature Photography* (Little, Brown & Co.: Boston, 1990) by Tim Fitzharris; *Nature Photography* (Prentice-Hall Inc.: Englewood Cliffs, NJ, 1981) by Stan Oslonski; and *The Art of Photographing Nature* (Crown Trade Paperbacks: New York, 1993) by Martha Hill and Art Wolfe.

Photographing the West (Northland Press: Flagstaff, Arizona, 1980) and *Photographing the North American West* (Pacific Search Press: Seattle, 1987), both by Erwin and Peggy Bauer, offer excellent guides as to where to go and what to photograph.

ABOUT THE PHOTOGRAPHS

The photographs in Mountains and Mesas were made with Minolta equipment, using lenses that range from 20mm to 600mm. Polarizing filters were occasionally used. Films vary from Kodachrome 25, 64 and 200 to Fuji's Velvia and Provia. All photographs were made with a tripod, and a Pentax spotmeter was used to determine many exposures. Animals are wild and in their native habitats. No game farm or otherwise controlled animals were photographed. Similarly, no computer enhancement or alteration of any of the images have been done.

INDEX

Page numbers in *italic* refer to photographs. A "t" refers to table.

ABOUT THE AUTHOR AND PHOTOGRAPHERS

Pete and Alice Bengeyfield started doing nature photography as a hobby and began submitting pictures for publication as they improved. Their photographs have been published in *National Wildlife,* Sierra Club calendars, and *Outdoor Photographer.*

Pete is a hydrologist for Beaverhead National Forest. His B.S. in Forestry and M.S. in Hydrology are from West Virginia University, and he has twenty-five years' experience in natural resource management in the West with the Forest Service, the state of Montana, and private industry. He has published articles in *Outdoor Photographer* as well as in many regional books and publications.

Alice Bengeyfield has taught elementary and special education for twenty years and now teaches the fifth grade in Dillon, Montana. A native of West Virginia, she received her B.S. from West Virginia Wesleyan. She is an AIDS educator for the state of Montana.

The Bengeyfields live in Dillon, Montana. They have a daughter, Shannon, who is nineteen and a student at the University of North Dakota.

Luna B. Leopold is Professor Emeritus of Geology at the University of California, Berkeley. Former Chief Hydrologist for the U.S. Geological Survey and the winner of the National Medal of Science, he is one of the world's leading authorities on river hydraulics and geomorphology. Most recently, he authored *A View of the River,* published by Harvard University Press.